Boyle Family

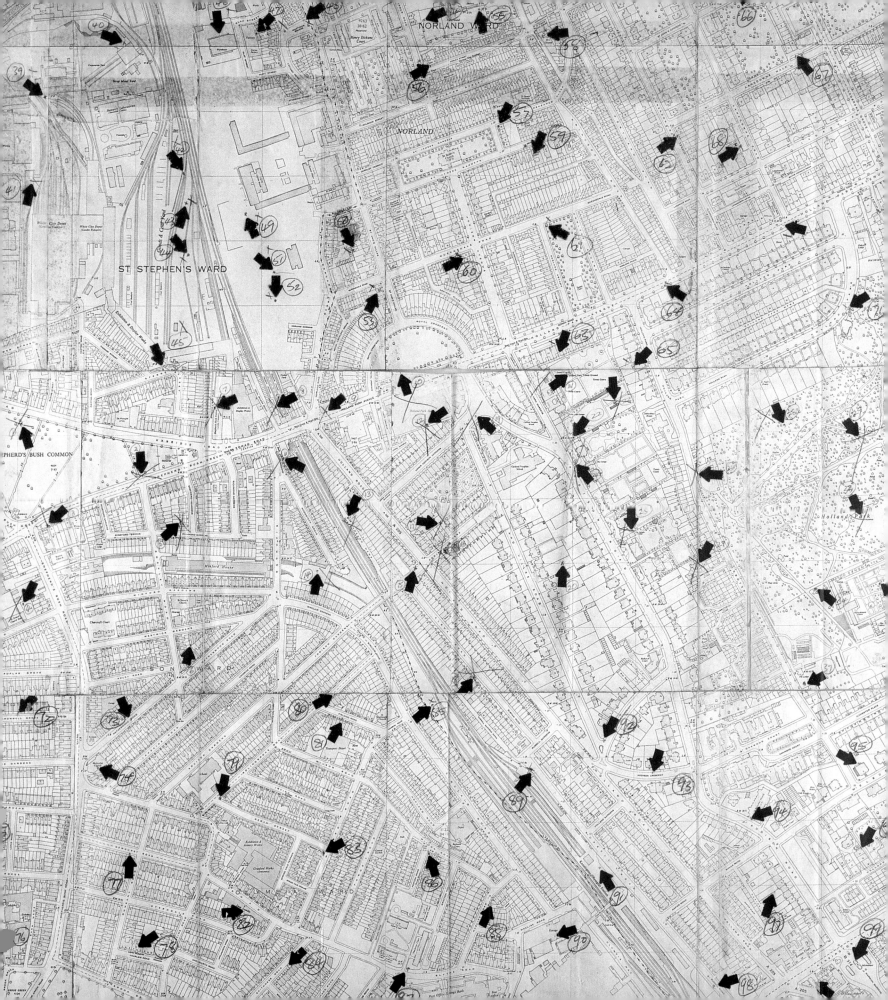

Patrick Elliott · Bill Hare · Andrew Wilson

BOYLE FAMILY

National Galleries of Scotland · Edinburgh · 2003

Published by the Trustees of the National Galleries of Scotland
for the exhibition *Boyle Family* held at the Scottish National Gallery of Modern Art
from 14 August to 9 November 2003

Text © Trustees of the National Galleries of Scotland and the authors
Works © Boyle Family

ISBN 1 903278 43 0

Designed by Dalrymple · Cover by Vertigo Design
Typeset in Minion and News Gothic
Printed in Salisbury by BAS Printers

Cover: *Chalk Cliff Study*, 1987

Frontispiece: map showing random selections for the *London Series*, 1966–7

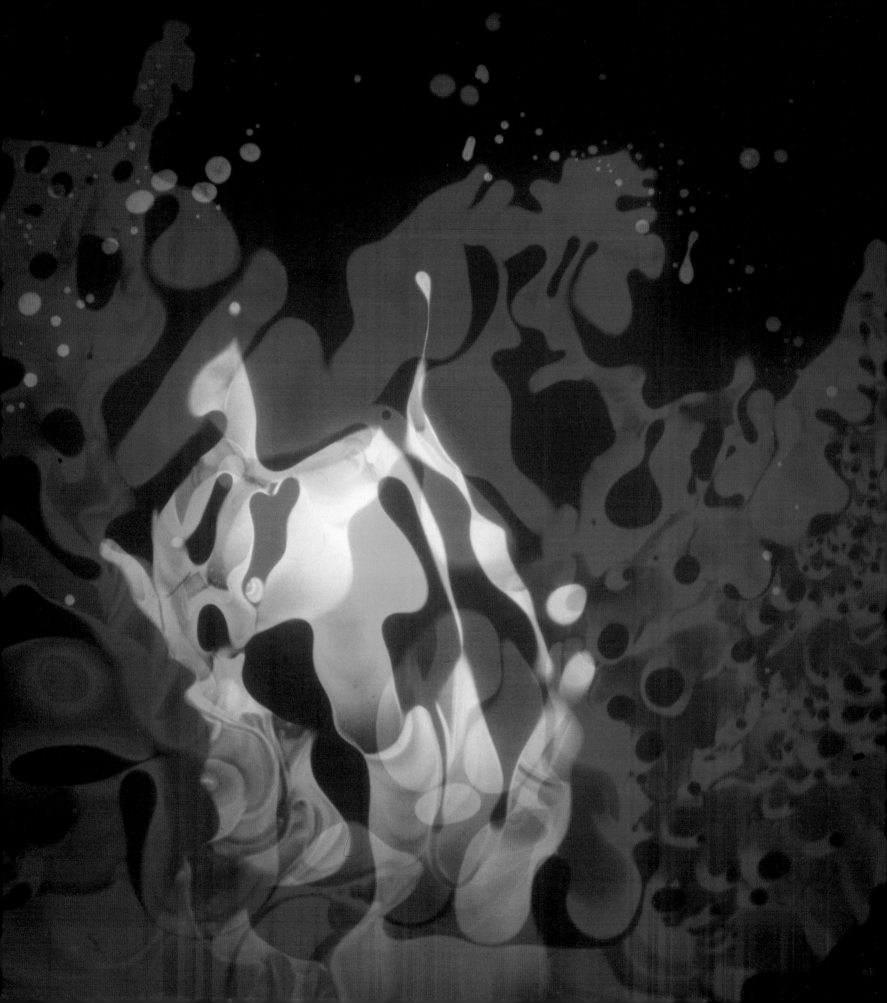

Foreword

This retrospective exhibition marks the fortieth anniversary of Mark Boyle and Joan Hills's first exhibition, which was held in London in the summer of 1963 and then transferred to Edinburgh. Since then, Boyle Family (Boyle, Hills and their children Sebastian and Georgia) have made and exhibited work all over the world. Remarkably, though, this is their first major retrospective exhibition, and this publication is the first detailed account of their work to have appeared in more than twenty years. Their 'earth pieces' are justly famous, and this exhibition offers a magnificent *omnium gatherum* of these randomly selected portions of earth, ranging from the Australian outback to the frozen wastelands of Norway, from the pavements of New York city to the mountains in Sardinia. The exhibition also offers the first opportunity to see Boyle Family's work in its totality, including: assemblages dating from the early 1960s; films, projections and documentation of the events of the 1960s; body works from the late 1960s and 1970s, such as massively enlarged electron microscope photographs; and large-scale earth pieces dating from the 1980s. Although they have worked in a number of different techniques and media, we hope the exhibition will demonstrate the extraordinary consistency in their work, and their devotion to reality in all its guises. We also believe that the show will highlight the important contribution Boyle Family have made to British art. They have combined film and performance, pioneered a host of casting techniques – which prefigure various developments in recent British art – and also pioneered art that explores the body. They also have the unusual distinction of operating as a family group: they are the successors to the Tintorettos in Venice and the Passerottis in Bologna.

We extend our gratitude to Boyle Family for their unstinting support in the preparation of this exhibition. This has included making new work; excavating their stores and archives to find assemblages and films which have not been seen for decades; responding to countless queries; and tracking down works in private and public collections. We would also like to thank Patrick Elliott, for organising the exhibition and editing the catalogue; Christine Thompson for seeing it through production and Andrew Wilson and Bill Hare for their perceptive essays. For loans we are grateful to: Wim van Krimpen, Director, and Franz Kaiser of the Gemeentemuseum, The Hague; Kathrine Ringnes, Henie Onstad Kunstsenter, Høvikodden; Donald M. Hess; Léonard Cuénoud, Hess Collection; Sean Hignett; D. Thomson; Dr Annette Lagler, Director of the Ludwig-Forum für Internationale Kunst, Aachen; Sir Peter Moores; Susan Jenkins, Director of Art, and Annelise Smith, Registrar, Compton Verney House; Hansjörg Mayer; Sir Nicholas Serota, Director, Tate, and Catherine Clement, Senior Loans Registrar, Tate; The Hon. Mrs R. Waley-Cohen; Prof Dr Christian von Holst, Director, Staatsgalerie Stuttgart; Dr Ulrike Gauss, Head of Department of Prints, Drawings and Photographs, Staatsgalerie Stuttgart; Prof Dr Gudrun Inboden, Curator, Staatsgalerie Stuttgart; Mrs Keller; and the private collectors who have lent works, but wish to remain anonymous. We would also like to thank the numerous members of staff of the National Galleries of Scotland who have assisted with this project. We also thank the Henry Moore Foundation for their financial support towards the staging of the exhibition.

SIR TIMOTHY CLIFFORD
Director-General,
National Galleries of Scotland

RICHARD CALVOCORESSI
Director, Scottish National Gallery
of Modern Art

Opposite: **1** Aldis projection from *Son et Lumière for Earth, Air, Fire and Water*, 1966

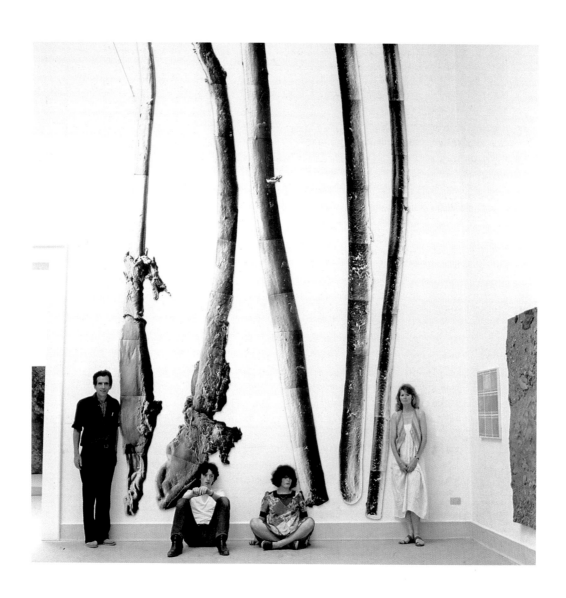

2 Boyle Family with mosaic of electron microscope photographs of hairs, Venice Biennale, 1978.
From left to right: Mark Boyle, Sebastian Boyle, Georgia Boyle and Joan Hills.

We may marvel at the verisimilitude of Boyle Family's 'earth sections', but that realism is a by-product of their goal, rather than the goal itself. The project Mark Boyle and Joan Hills embarked upon in the late 1950s, and which they have continued in collaboration with their two children ever since, is to make art that represents the world with the minimum of artistic intervention. They do not want to exclude anything. They do not choose their subject matter, they do not have a style, they do not think in terms of composition. Their work is neither ironic nor metaphorical, and it offers no social comment or allegory. The early works look much like the recent ones, and the size of all of them is fairly standard. The aspect of authorial choice, so central to the art of the past, is almost entirely absent from their work (*almost* entirely, because there are certain subjects they cannot readily deal with, such as water and grass). 'As far as I can be sure, there is nothing of me in there' is how Mark Boyle has described his relation to the work.[1] We do not know how they make their work, nor do we even know who makes it since they are a collaborative group and they could potentially work independently of one another, or at least in pairs. Boyle Family could still be operating in 100 years time, and the only change would be that their work would mirror the changing nature of the world (more concrete, less wasteland, perhaps).

In his first published statement, made in 1965, Mark Boyle said that 'My ultimate object is to include everything in a single work … In the end the only medium in which it will be possible to say everything will be reality.'[2] He added that he wanted people to look at reality – by which he meant, everything and anything – with the same degree of attention they might devote to a good film. For some years, from the early 1960s to the early 1970s, Boyle and Hills did exactly that, working in the medium of 'reality'. In 1964 they invited an audience to attend an event in London, led them through a rear entrance marked 'Theatre' and sat them in front of a curtain. They pulled back the curtain to reveal a shop window giving onto the street outside.[3] People outside stared at the people inside, who in turn stared back. The event turned audience into actors and actors into audience, muddling up the idea of a passive spectacle. In another event, conceived in 1963, Boyle, who was threatened with prosecution because a nude model had appeared in a notorious 'Happening' he staged in Edinburgh that year, decided to obey the judicial oath and literally tell 'the whole truth' – in other words, recount everything he could remember – in the belief that it might have some bearing on the case.[4] In their small, understated way, these events – born in the spirit of 1960s counterculture – probed the nature of the artist, the viewer and reality. The earth sections, which Boyle and Hills began making in the mid-1960s, share that same mentality. They present, as it were, the 'whole truth', or as near as Boyle Family can get to it.

Boyle Family are four artists: Mark Boyle and Joan Hills, and their children Sebastian and Georgia Boyle. They work collaboratively and have done so since the late 1960s, when the children were old enough to participate. Hills was born in Edinburgh in 1931 and Boyle in Glasgow in 1934. Hills had wanted to study painting, but with opposition from her father, she enrolled, instead, at Heriot Watt College in Edinburgh, to study building construction and structural mechanics. She remained there for two years, before transferring to the Architecture Department at Edinburgh College of Art. In 1951, a few months into her new course, she married, left the college and moved to Suffolk where her husband worked. Her son, Cameron, was born in 1952 (he worked on some Boyle Family projects in the 1960s and 1970s but went on to pursue an independent career). That same year, Mark Boyle enrolled at the University of Glasgow to study law (his father was a lawyer), then left the following year to join the army. In 1956, Hills and her husband split up. She returned to Edinburgh with her son, and enrolled on a painting course, while also taking beauty classes with a view to setting up her own business. Hearing of accommodation available in Harrogate, she moved there early in 1957 and opened her own salon in the front room of her flat. She made the back room into a studio where she continued painting.

In the mid-1950s Boyle was a regular in the Scots Guards, eventually moving to Northern Command Headquarters, outside Harrogate, where he organised supplies for the Ordnance Corps. He recalls that he spent most of the day writing poetry. Boyle's goal as a writer was to let nothing escape his grasp, to capture everything: the sound of traffic passing, the smell of coffee, a newspaper headline, a conversation overheard, an idea forming in his head. This desire to include everything has been the central preoccupation in his art ever since. The problem was to keep his senses open to all the sights and sounds which were competing for his attention, yet still retain some sense of discipline in terms of writing. Boyle liked to write in cafés, and often went into Harrogate to write at a newly opened coffee bar. One day, in 1957, the owner introduced him to Joan Hills, a fellow Scot who lived above the café. Boyle, who was at that moment in the middle of writing, struggled to keep his focus, to make her an element in the poem he was working on and keep his eyes and ears sharp for other things. But he soon gave up and concentrated on her instead. Boyle and Hills recall that 'We started talking, went out for a meal, and spent the evening arguing about what we were going to do for the rest of our lives. We formally decided it wasn't love at first sight but agreed that we would work together, making an

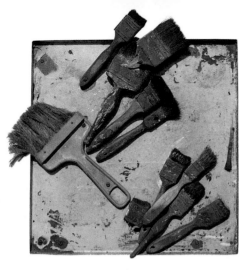

left to right

3 *Painting with Paint-tin lids, c.*1961. Oil and paint-tin lids on board, 95 x 35. Private collection, France

4 *Assemblage*, 1963. Paint brushes as found on enamel tray. Boyle Family collection

5 *Bed Piece*, 1963. A large assemblage which concerned different ways of presenting reality. It contrasted various forms of representation (photographs, paintings, television, etc.) with 'reality'. Activity in the next room became part of the assemblage via a hole in the wall. Boyle and Hills's fold-down bed – 'the vehicle for birth, sex and death' – was also included.

art that would be relevant by the virtue of the fact that nothing would be rejected.'[5] Six weeks later, they were living together.

In the few moments of spare time that Hills had, she painted. Boyle was interested in art, but had no formal training. He tried her paints, finding inspiration in the demolition sites behind their flat. In 1959 a local businessman who had seen him at work, asked him if he was an artist and wondered if he could, perhaps, see some of his work. Boyle replied that he was, indeed, an artist (the first time he had made such a declaration) and fabricated a story that a selection of his works was, by chance, coming down from Scotland the following week, and could be seen then. Boyle and Hills thereupon bought paints at Woolworth's and spent a week painting furiously. Their works were hung in the flat, and although Hills had painted half of them, they decided not to complicate matters and kept to the story that he was the artist and she ran the beauty salon. The pictures were similar enough in style to make the tale credible. They sold eight or nine works at £5 each, enabling Boyle and Hills to pay the rent. The collector continued to buy from them.[6] It was always assumed that the paintings were Mark Boyle's work, and it would have been too problematic to tell the collector that he had bought the work of two artists, not one. The issue of joint authorship has been a feature of their careers, but they insist that they never thought about it. They just worked together: neither party was dominant. From the initial concept of the hanging of the exhibitions it was in every way an indivisible, joint enterprise. Boyle has stated:

I have to admit that at this time the billing was not really an issue for us. Our primary objective was to make our work. Secondly we wanted to survive. Survival meant that every now and then we had to sell a piece for £50 or so and that that money was going to have to keep us for 2 or 3 months. I can assure you that under these circumstances, if the art world wants to believe in a single, preferably male, obsessed, artist, you don't quarrel with them. You just try to put it right as best you can. We never felt that it was our place to insist.[7]

From the 1970s, Sebastian and Georgia (born in 1962 and 1963 respectively) took an increasingly significant role. Although curators and collectors knew the works were produced collectively, they continued to exhibit under Mark Boyle's name, finding it hard to break the established pattern. It was not until 1978 with the exhibition *Mark Boyle und Joan Hills Reise um die Welt* (*Mark Boyle and Joan Hills' Journey to the Surface of the Earth*) at the Kunstmuseum, Lucerne, that the collaborative nature of their work was recognised. In 1985, on the occasion of an exhibition at the Henie-Onstad Kunstsenter in Norway, they officially became *Boyle Family*.

Inspired by James Joyce, whose dictum was that it was 'a grander destiny' to starve in Paris rather than in Dublin, Hills, Boyle and Cameron left Harrogate for Paris in the spring of 1960. They stayed in small hotels in the centre of the city for about three months. At this stage, Mark Boyle's primary interest was still poetry. When they ran out of money, they were repatriated by the British Embassy. They moved to London, initially staying in a friend's flat, then renting in Regent Park Terrace, and subsequently moving to a flat on Hanson Street in the West End. Hills worked as a chef in a South Kensington restaurant. Improbably, Boyle got a job in the Ministry of Defence, but he soon exchanged this for a job as a waiter in the same restaurant as Hills: the evening hours meant that they could see more of each other and write and paint during the daytime.

In 1961 Boyle was painting from small tins of oil paint, which he rested on the hardboard he used as a palette. Sometimes the tins would get stuck, and Boyle and Hills soon came to the conclusion that these homemade palettes, with their accumulation of paint, tins, lids and brushes, were more interesting than the paintings themselves [**3 – 4**]. This led naturally to assemblage work, which Boyle and Hills began in the summer of 1962. Having little money, they were particularly attracted to the demolition sites that extended across huge swathes of west London: these provided the raw material for their assemblages, which were themselves fixed to wooden panels, also found on the sites. Rubbish acted as a potent anti-art, anti-establishment metaphor, but it also had a practical attraction in that it was free and widely available and, unlike bronze casting and marble carving, required no specialist equipment. A number of artists in America and Europe were making junk assemblages by this date. In the USA Robert Rauschenberg, Jasper Johns, Allan Kaprow and Jim Dine were making junk constructions, and in Europe, artists such as Arman, Daniel Spoerri, Jean Tinguely, Niki de Saint Phalle and John Latham were working in a similar vein. This neo-Dada, anti-art movement owed an enormous debt to Kurt Schwitters, who had made junk constructions several decades earlier,[8] though its antecedents can ultimately be traced to Picasso's wood and metal constructions made in the years immediately before the First World War. More generally in British art and cinema, urban decay had become a popular subject in the late 1950s and early 1960s.

The early constructions by Boyle and Hills incorporate bits of junk that they found and took back to their flat: bicycle wheels, twisted metal, cans, wire and so on. They composed these materials within simple wooden box frames and on doors and other pieces of board: a collection of bakers' trays proved a particularly fortuitous find. Boyle was still writing poetry (three

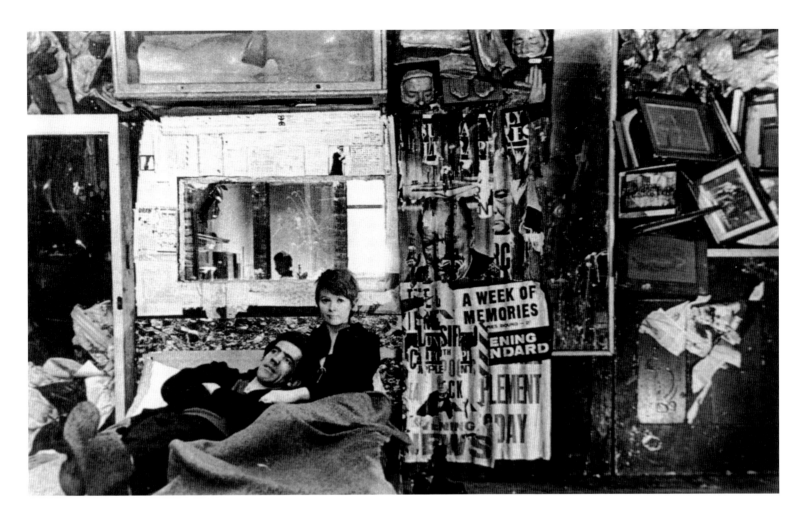

were published in *The Paris Review* in 1963) and his interest in words spilled over into their assemblages: a number of them feature signs or words painted onto the junk elements. From this time, Boyle wrote less and became more concerned with junk assemblages. Having read Freud's *Interpretation of Dreams*, he became increasingly self-conscious about the words he was using in his poems – and the more self-conscious he became, the less spontaneous and magical the results seemed to be. At first, though, the junk pieces had a buried symbolism, which carried through from the poetry. Most were concerned with the themes of birth, sexual climax and death. These were the moments, Boyle said, when the human mind was completely unselfconscious, when life was not a performance. As such they concerned that earlier theme, employed in the poetry, of unconscious, automatic response, which in turn had its origins in Dada and Surrealism. Some of the assemblages were given suggestive titles: '*Mine Eyes have seen the Glory…*', 1963, a large triangular relief featuring a print of Christ, bedsprings and various bits of junk [**24**], called for the viewer to complete the line: '*…of the Coming of the Lord*'. The sexual reference was probably lost on many viewers. Other reliefs featured funereal plastic flowers, syringes and old prints. Boyle and Hills also had a keen interest in music and sought to introduce musical counterpoint by overlaying images. These junk reliefs featured in their first solo exhibition, credited to Boyle alone, at the Woodstock Gallery, off Bond Street in London in July 1963. It was called *Erections, Constructions and Assemblages*, and included twenty constructions with titles taken from hymns (*Crown him with Many Thorns; The Lord God Made them all*, etc.).

Nothing sold. In these years Boyle and Hills, and most of their contemporaries, saw art as a passion rather than a profession.

In the spring of 1963, Hills visited her family in Edinburgh and took photographs of the junk reliefs to show to Jim Haynes, whose paperback bookshop had become the focus of the underground art scene in the city. Haynes was impressed, and suggested she contact Richard Demarco, the director of the new Traverse Theatre Club, which was due to open that summer. Upstairs the new theatre had a gallery, and on the evidence of the photographs, Demarco offered the space to Hills and Boyle. In August they borrowed a van and drove to Edinburgh with about a dozen junk reliefs, plus Cameron and Sebastian (Boyle sat on the tailgate all the way because the doors would not close) and installed the works themselves. The exhibition caused a sensation. Writing in *The Scotsman*, Sydney Goodsir Smith commented that Boyle was 'a Glasgow constructionist who erects his assemblages (or vice versa) out of such ready-to-hand but subsequently bashed objet trouvés as old lamps, bits of prams or bicycle, any old thing that turns up. He assembles them very cleverly, presumably for his own amusement, and then gives them high-sounding religious titles which I found rather unpleasant.'[9] The critic of the *Glasgow Herald* observed that 'His material is old bicycle wheels, tin cans, Victorian engravings, and other objects which used more commonly to be found in dustbins than on Gallery walls. However the Museum of Modern Art in New York has given the accolade to these "erections, constructions and assemblages" as Mr Boyle describes them.'[10] At the exhibition Boyle and Hills met the young American impresario, Ken

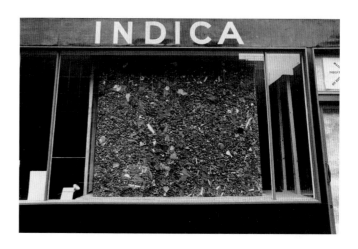

left to right

6 Mark, Sebastian, Joan and Cameron, Queensgate, London, 1963

7 Indica Gallery, July 1966, with *Hammersmith Reach Study* 1965

8 Installation at Indica Gallery, July 1966

9 Boyle Family and Soft Machine outside Barrie Halls, Edinburgh Festival, 1 September 1967

Dewey, who invited them to collaborate on an 'event' which would take place on the last day of the Edinburgh Festival's International Drama Conference, held at the McEwan Hall (see Andrew Wilson's essay, pp.45–7).

During this period, Boyle and Hills were covering the walls of their flat in Queensgate, west London, with assemblages. One of these works, *Bed Piece*, was a giant construction in the manner of Kurt Schwitters's *Merzbau* environments. It covered one whole wall of their flat. The intention behind the piece was to show the different ways in which reality is represented, for example in photographs, texts, casts and reproductions, and contrast them with the reality of birth, sex and death, which takes place in the bed, and the reality of family life that could be seen through the hole that they punctured through the wall. When they moved to Lansdowne House near Holland Park underground station in 1964, they reconstructed it [**5**]. In these early years in London they moved frequently, largely because their landlords took fright at the enormous constructions that slowly engulfed their flats. When they moved out of the Queensgate home in 1964, they staged an event called *Suddenly Last Supper* [**54–9**]. Friends who had no idea the Boyles were being evicted were invited to a party at which random films and disintegrating slides were projected onto a variety of surfaces including the naked body of a woman. When the show ended, they found that the Boyles had vanished, together with all their furniture and effects, leaving them alone in an empty flat.

In August 1964 Boyle and Hills showed again in Edinburgh, in an exhibition organised by Demarco and the Traverse Art Gallery, at the Bank of Scotland in George Street.[11] They showed twenty assemblages (the elaborate titles had been dropped in favour of the generic title, *Assemblage*), again under Boyle's name. Demarco's assistant had written to Boyle, requesting a statement and a list of exhibitions, but Boyle politely asked her not to publish such information: 'Please don't think I'm being awkward, I just feel that this is more or less irrelevant if not actually opposed to the nature of my work.'[12] The exhibition prompted their first serious review, by David Irwin in the *Burlington Magazine*. Irwin wrote:

The only really serious neo-Dadaist (if this is not a contradiction in terms) in the Traverse exhibition was the young Glaswegian Mark Boyle, now resident in London. Particularly in his visually unpleasant erotica and more macabre subjects – such as the broken assemblage of glass eyes, broken spectacles, wax eye and nose, and Old Master drawing reproduction – Boyle seems to be extending the range of Dada expression, and without being too much influenced by Dada's justly famous grandson, Rauschenberg.[13]

The wax eye and nose, which Irwin referred to, were fragments of broken

heads Boyle and Hills had found in a basement room when staging their event at the McEwan Hall. They also showed works composed of broken picture frames, jammed into boxes with mirrored backs [**26**]. These, Boyle said, were an attempt to show glimpses of reality through art. In October 1964 they had another exhibition at the Traverse Art Gallery, once more showing twenty assemblages. The three Edinburgh exhibitions and the *Big Ed* event (see pp.45–7) attracted a considerable amount of publicity, ranging from TV interviews to heated arguments with art critics. One work sold from the mixed exhibition to Lord Harewood, the director of the Edinburgh Festival.

During 1964 there were some important developments in their work. First, instead of selecting and collecting matter and composing it onto boards or doors, they began to select specific portions of junk from the demolition sites, and recreated them exactly as they had found them. *Norland Road Studies* [**27–8**] are examples. Using a grid device to map the junk surface, they carefully transferred all the surface debris, piece by piece onto a board and fixed it down, either with screws or glue. Then, one day, on the same site off Norland Road in the Shepherd's Bush area of London, they came across a grey plastic surround which had once held a television screen in place. It was lying on the ground, and they noticed how extraordinary the earth and detritus looked, framed in this way. For a while they tried placing the television surround on other areas, but none of their compositions rivalled the portion that had presented itself by chance. Since chance had worked so well, they decided to throw the frame across the site, and to their surprise, every time they threw it, the frame isolated striking areas of earth and junk – striking in that they were unpictorial in the conventional sense. These anonymous rectangles of ground were extraordinary precisely because they were so anonymous, so artless. The random nature of the enterprise seemed to be its strength. In the same way that Boyle had sought, in his poetry, to avoid excluding anything and had wanted chance to play a significant role, so he and Hills had found a parallel way of doing this in their three-dimensional work. The idea of incorporating chance into the artwork dates back to Dada and Surrealism, but it re-emerged in the early 1960s. Niki de Saint Phalle made a celebrated series of paintings in which she stuck pots of paint onto picture surfaces and, together with her friends, shot bullets at them. Piero Manzoni, Alberto Burri, Daniel Spoerri with his *tableaux pièges*, and Yves Klein, adopted other random methods.

This new approach to finding a subject brought its own problems. Instead of landing on loose junk and debris, the television frame often landed on miscellaneous patches of bare earth. Transferring sizeable pieces of junk

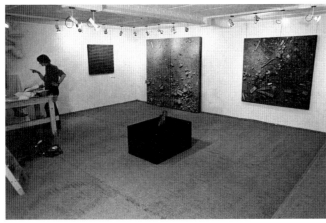

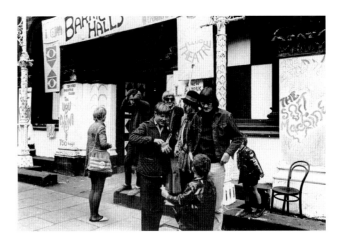

was straightforward, but transferring the ground onto boards was infinitely more complicated, since it meant mapping every tiny stone, splinter of wood and cigarette end. Boyle and Hills found a resin used as an adhesive in the construction industry, which they could spread onto the boards and into which they could press the surface material.[14] Moreover, the resin could be coloured, to match the ground surface. A number of contemporaries had used resins and plastics in the early 1960s – Arman in France, and British sculptors such as Philip King and William Tucker who used polymer plastics – but no one had done anything like this before. The new technique was employed in a series of reliefs made beside the Thames at Hammersmith Reach in 1965, and culminated in works such as *Shepherd's Bush Study*, 1966 [**29**]. At this time Boyle was engaged in a number of events at the Institute of Contemporary Arts, and was mentioned regularly in the *ICA Bulletin*. He also featured in the first issue of a new journal produced by Stephen Willats, *Control Magazine*, and there stated: 'From the beginning we are taught to choose, to select, to separate good from bad, best from better … I believe it is important to accept everything and beyond that to "dig" everything with the same concentrated attention that we devote to what we consider to be a good painting or a good film.'[15]

Although these new works featuring debris embedded in the resin duplicated the areas of earth to a very precise degree, Boyle and Hills were limited to sites where the ground was flat. While the actual earth surface might undulate, the resin-covered boards were resolutely two-dimensional. Each brick, piece of wood and tiny stone had to be placed next to another, like fragments in a mosaic. At first they tried to spread the resin in thicker patches, but this did not work. The solution to this problem was radical and took Boyle and Hills into completely new territory. They decided they would try somehow to fix the surface in its original three-dimensional state – to make works that were simultaneously both real and replicated. They made their first experiments with new techniques in May and June 1966, at Camber Sands, near Rye in East Sussex. In one way the sand would be a difficult subject to cast since it was fugitive, but at the same time it consisted of an endless amount of loose debris, and so the top surface could be transferred. Through trial and error, they found that this could be done with resin and fibreglass.

This brings us to the matter of technique. How are these works made? Casting from life is an age-old method. Sculptors normally cast through a reverse process: a mould is taken from the original object and a cast taken from this 'negative' will produce a duplicate of the original. It appears, though, that Boyle Family do not use this technique, or if they do, they ally it

to other methods. They are notoriously reluctant to discuss their techniques – which in any case have developed over the years and apparently change according to the nature of the surface. Outsiders are not admitted to their studio; even cupboards and car boots are quickly checked in case curious visitors get a chance to look inside them. What they may do (and they will neither confirm nor deny this) is paint a very thin layer of the resin onto the surface, and when this shell has dried and hardened, remove it. This thin layer would act like aspic, preserving all the surface dust and debris. It could then be painted from behind with coloured resin. Loose debris such as dust, dirt, grass and so on could be reattached to the surface. It is likely that larger forms such as bricks are cast separately and fixed on. The thin resin 'skin' would be strengthened with fibreglass. There must be a good deal of 'post-production' work, involving prosaic materials such as car-body filler and Humbrol paints. They acknowledge that their techniques are always evolving, and they also state that a considerable amount of work has to be destroyed. They are insistent upon the fact that they can never take a surface for granted: a flat area of pavement may be more difficult to replicate than a ploughed field. Some pieces take years to make; some are worked upon long after they have been exhibited. Boyle Family are reluctant to discuss their methods because they think that discussion of technique is distracting. The aura of myth and mystery surrounding their work must also appeal to them. Not only is it unclear how these works are made, but it is also unclear how they operate as a foursome. Does one specialise in mixing colours and another in applying dirt? They originally described the pieces as being composed of earth on fibreglass, but stopped doing this when Japanese customs officials objected to the importation of foreign earth. After this the works were described simply as 'painted fibreglass'. This has now evolved into 'mixed media, resin, fibreglass'. Whatever the truth is behind their methods, the more one looks at the work, the less one understands of its making, and the Boyles are keen to keep it that way.

During the month at Camber Sands in 1966, the Boyles managed to make just two or three successful beach pieces, although there were dozens of failed attempts. When they returned to London they began to use similar techniques on urban sites in the immediate area of their flat at 225 Holland Park Avenue (known as the *Shepherd's Bush Series*). In July 1966, these cast works – billed as 'presentations' – were shown alongside earlier junk pieces and the resin-based assemblages, at the Indica Gallery in Mason's Yard, London, just off Piccadilly [**7–8**]. The Indica Gallery achieved great notoriety in the London art scene in the mid-sixties, though it operated for less than two years. The gallery's inaugural show was of a group of contempo-

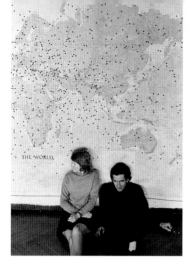

10 Joan Hills and Mark Boyle with the *World Series Map*, 1969

11 Detail of the *World Series Map*, 1969

12 Mark and Georgia Boyle working in The Hague (*World Series* site), 1970

rary French artists. Boyle and Hills were given the second slot, under Boyle's name.

The poster for the exhibition consisted of a sheet of paper with a square cut out of it and a text stating 'Presentation by Mark Boyle at the Indica Gallery'. These sheets were given away and began to appear all over London, framing walls, pavements, buses and hedges. This was a miniature variant of the *Street* event which Boyle and Hills had staged two years earlier, when they led their audience into a 'Theatre' which turned out to be a shop window. Another performance staged in London in 1965, *Any Play or No Play*, saw Boyle invite the audience in the stalls seats onto the stage, then announce to the audience in the balcony and upper circle that they were watching a performance by the stalls audience. We can see a common theme emerging in the various activities in which Boyle and Hills engaged, namely a desire to study and present rather than to comment and reshape. They just wanted to show things as truthfully as they could, in a non-judgmental, non-hierarchical way, and with the least possible interference. This neutrality was, however, a provocative act in itself, making the viewer conscious of the act of looking.

The exhibition at the Indica Gallery prompted an article by Jasia Reichardt, then assistant director at the ICA, who had first recommended Boyle's work to John Dunbar, the Indica Gallery owner. The first major essay on Boyle (Hills was not mentioned), it included the following artist's statement: 'I am not trying to prove any thesis and when one is concerned with everything, nothing (or for that matter anything) is a fair sample. I have tried to cut out of my work any hint of originality, style, superimposed design, wit, elegance or significance.'[16] Reichardt observed that the sites were selected at random by throwing a carpenter's right-angle into the air, and furthermore that Boyle was selecting the general location of that patch of land at random. He had acquired a big map of the Shepherd's Bush area of London, where the family lived, and, with friends, threw darts at it to select the sites (frontispiece). The idea, as ever, was to remove the conscious, decision-making process, so that no site or subject would be privileged over another. Reichardt also noted that Boyle wanted to make all the earth surface replicas a standard size, so as to avoid the issue of having to choose.

The map, which stretched from Shepherd's Bush to Notting Hill, with their flat more or less in the centre, was used to select sites for the *London Series*, which they began in 1967. The most accessible sites indicated by the darts were roads, pavements and parks (they subsequently tackled rooftops and bulky three-dimensional matter such as fencing). In an effort to avoid traffic and trouble, they tended to do the site work very early in the morn-

ing, often on Sundays. To diffuse arguments, Boyle had a card printed, stating that he was director of the Institute of Contemporary Archaeology. Handed out with nonchalant authority, the cards had a bewitching effect on public and police alike (Boyle Family have never once had to abandon a site because of complaints). The large pavement work that is now in the Tate collection, *Holland Park Avenue Study, London Series* [**31**], was made in two parts and on close inspection it is evident that the road part was made in dry conditions, while the pavement part shows traces of raindrops. Boyle and Hills embraced such serendipitous accidents.

Boyle Family developed their strategies in the early 1960s (they may talk about an absence of strategy, but that of course is a strategy in itself) and their work, and the mindset behind it, parallels that of other artists working around the same time. While Boyle Family share the goals of American superrealist sculptors such as Duane Hanson and John de Andrea in that they wish to depict reality as accurately as possible, there are major differences. Whereas Hanson selected his figures with great care, choosing the downtrodden and the ultra-normal to comment on contemporary American culture, Boyle Family want to include everything and make no personal comment at all. Their work has some parallels with Land Art (Robert Morris and Robert Smithson, for example), but the connection is more syntactical than actual. Their documentary approach brings their work into the orbit of conceptual art. The American artist, Douglas Huebler, began using maps in 1968, tracing diagrams on the maps and then travelling to the sites and placing markers there to reconstruct the diagram in actual space and, around the same time, On Kawara began mapping his own movements and making precise lists of everything he did. Both were incorporating the random nature of chance into their work. The visual correspondence is almost nil, but conceptually Boyle Family have a good deal in common with Sol LeWitt, who sought to eliminate all subjectivity from his work. Their early work shares something with the Fluxus group, and something with the French Nouveaux Réalistes, but their mature work does not. Like the Pop artists, Boyle Family present things that are familiar to us all, and sometimes seem to allude to the throwaway society by depicting detritus, but they are not interested in composition, pop culture or irony. In the great Venn diagram of modern art movements, Boyle Family stand on the edges of several overlapping circles, but end up in a compartment all of their own. Oddly, someone they do have a lot in common with is Andy Warhol. Just as Warhol would tape his aimless dinner conversations and set his film camera rolling, no matter what the subject, so the Boyles have a detached, even-handed approach to the world around them. They register things as they are.

13 Joan Hills and Mark Boyle at Camber Sands, 1969

14 Sebastian and Georgia Boyle at Camber Sands, 1969

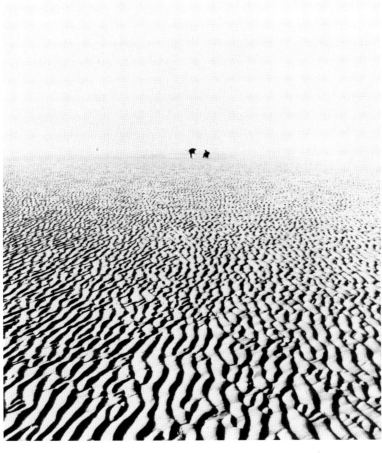

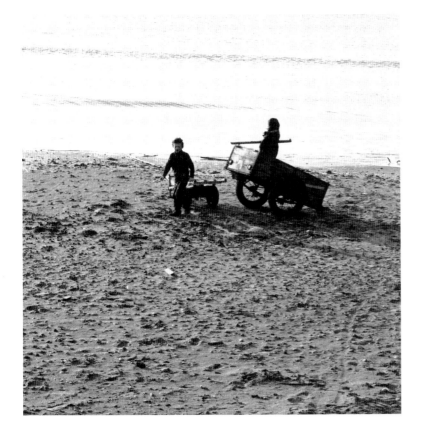

In August 1968, Boyle and Hills took their project to its logical conclusion. Their flat in Holland Park Avenue was due to be demolished and there seemed little point in starting a new *London Series* in a different part of the city. Wanting the new project to be as objective as possible, they decided they should make random selections from the whole Earth surface. This was the beginning of their *World Series*. Having bought the largest map of the world they could get – they found one measuring 9 × 13ft (275 × 397cm) at Stanfords in Covent Garden – they invited friends to a party. The invitation, sent in the post, included a dart, though some were confiscated by the Post Office. When they arrived at the party, guests were blindfolded and led into an upper room by Georgia and Sebastian. The guests threw their darts at the unseen target, which unbeknownst to them turned out to be the map, and then joined the party. About 230 sites were chosen in this way, by guests and anyone who visited the flat in the following weeks.[17] Darts landed all over the world, both on dry land and in the sea [**10**, **11**, **84**]. Boyle declared that the object of the project would be to 'Take the actual surface coating of earth, dust, sand, mud, stone, pebbles, snow, grass or whatever. Hold it in the shape it was in on the site. Fix it. Make it permanent.'[18] But that was just one element in the project. He also stated their desire to record a broad range of data found at each site. This included taking film, sound and smell recordings, collecting air, water, insect and plant life, and recording the movements of people in the nearest populated area. In an interview at the time, Boyle declared that 'this is a lifetime project. It could take 25 years.'[19] (In fact it has taken far longer and is still continuing.) He described the project as an 'Earthprobe', an allusion to the lunar probes in the Apollo 11 programme, which saw Man walk on the moon in July 1969. Boyle Family's own omnivorous project, does indeed have that same sense of 'boldly going' into the unknown.

In June 1969, their exhibition *Journey to the Surface of the Earth* opened at the Institute of Contemporary Art in London. This was the first 'solo' show held at the ICA's new home on the Mall, following the move from the Dover Street premises. Billed as a collaboration between Boyle, The Sensual Laboratory and the Institute of Contemporary Archaeology, the exhibition featured seven very large pieces from the *Shepherd's Bush* and *London Series*, including an enormous 10 × 30ft (305 × 915cm) presentation of a cobbled area in Russell Road, west London. Boyle and Hills had wanted, somehow, to replicate the sounds and smells of each earth-piece site, to be reactivated at the touch of a button, but this proved impossible. The exhibition did, however, feature sound and light works, and several events. The Sensual Laboratory and the Institute of Contemporary Archaeology were light-hearted

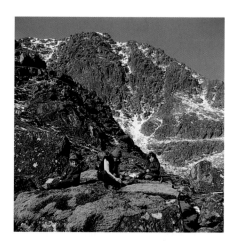

institutions with no particular membership (though they made the Sensual Laboratory into a registered company), and their main purpose was to signal the help of friends such as Des Bonner, John Claxton, old colleagues from the restaurant where they had worked, and also Cameron Hills and his school friends. Sixteen people helped on the Russell Road piece. The Sensual Laboratory referred to the light, film and slide events. One of these events was an electroencephalogram (an instrument that records and displays the electrical activity in the brain, using electrodes attached to the scalp) of a couple having sex on stage: this was projected onto a thirty-foot-long screen [**72**]. The big map of the world also featured in the exhibition, and visitors were blindfolded and invited to throw darts at the unseen target. Eventually one thousand sites were selected.

At the ICA exhibition the Boyles met J.L. Locher, a young curator from the Gemeentemuseum in The Hague, and he invited them to show in his museum. By chance, a dart thrown at the world map had landed on The Hague, so they made it the first of their *World Series* sites early in 1970. The darts were big enough to obliterate whole cities and islands, so to select their sites with precision, they subsequently bought more detailed maps and threw darts at them. They would then go to the spot indicated by the dart, throw their carpenter's right-angle, and make their 6 × 6ft (183 × 183cm) replica of the portion of earth. In The Hague their random method selected a muddy track featuring tyre marks and a piece of piping [**85**]. The projects are not limited to a single piece, but, if time permits, involve making several related works. These include making a vertical section of the earth's surface, earth pieces showing the elemental forces at work (for example, rock strata or ice melting), as well as recordings, photographs and maps, and collecting loose debris (including animal life) on the random site. These various works were exhibited at the Gemeentemuseum in May 1970: unusually, due to lack of wall space they showed the earth piece on the ground [**104**].

Although the sites were normally selected at random, they were sometimes chosen with particular care. The *Sand, Wind and Tide Series* (also known as the *Tidal Series*) for example, is a series of fourteen casts of the same square of beach at Camber Sands, after each tide, over a week-long period in November 1969 [**39–52**]. Each cast registers the different sand patterns – which look much like fingerprints – created by the rising and retreating tide. They first had to select an area which was within the tidal range, but gave them maximum working time, and secondly, had to ensure that they could relocate the same square of beach with certainty. Towards the end of their work at Camber, it snowed and they decided to make some snow casts. The sites were selected by firing arrows with Cameron Hills's

archery bow. All the works were made at the Kit Kat Café, on the beach front at Camber, which was closed for the winter months and became their temporary studio [**15–16**].

Following the exhibition at The Hague, the Boyles set off for Nyord in Denmark to make their second *World Series* piece. Once more, this coincided with an exhibition of their work, this time in Copenhagen. For simple funding reasons, their *World Series* pieces have often coincided with exhibitions. They were invited to show at the Henie-Onstad Kunstsenter in Høvikodden, near Oslo, in 1972 and immediately prior to this, made four *World Series* pieces in Norway. One of the darts had landed in the frozen wastelands of the Vesteralen islands, off the north-west coast of Norway [**17**]. Undeterred, they set off in their battered, converted ambulance. Their principal *World Series* work was a moss-covered patch of Arctic ground. As part of their overall project of recording 'elemental forces' at each of the sites, they also made five smaller works, at daily intervals, of adjacent patches of melting snow (the *Thaw Series*). In Norway they went to three other sites indicated by the darts: a forest near Elverum, the Jottenheimen mountains on the Ostre Slidre Valley, where they made a snow study [**86**], and a forest at Skarberget. This last site gave them the problem of incorporating sapling trees into their earth surface.

The Boyles did not confine themselves to the surface of the world, but on the occasion of their ICA exhibition in 1969 developed a parallel project, *Body Works*, in which they made a microscopic survey of the surface of a human being. Taking photographs of Mark Boyle's front, back and sides, sites were selected at random with darts, fragments of skin removed, and these were photographed through an electron microscope. This approach produced some extraordinary images of a moon-like surface studded with bizarre, egg-like forms (they turned out to be beads of sweat [**38 a&b**]). In 1973 they made a second, related project, the *Skin Series*, in which tiny, randomly selected patches of skin were removed and used as negatives to make enormous photographic enlargements [**18**, **88–9**]. Another project which related tangentially to the earth surface pieces was Joan Hills's *Seeds for a Random Garden* [**33–6**]. Conceived in 1966, it involved selecting squares of ground at random by throwing a dart at a map, and then gathering seeds from that area. Variations on the theme included inviting guests who attended their exhibition openings to each bring a seed, and collecting windblown seeds in mesh. The seeds were then planted in portable seed boxes 'without the slightest consideration for beauty, utility, edibility, scent, or horticultural interest', and exhibited.[20] Hills also produced packets of the seeds for sale at a random price, to be determined by the buyer.

left to right

15 & 16 Joan Hills and Mark Boyle working on the *Tidal Series* in
the Kit Kat Café, Camber, 1969

17 Georgia, Mark and Sebastian Boyle, Vesteralen, Norway (*World
Series* site), 1972

18 Site Map of Random Selections for the *Skin Series* 1973.
Collection Henie-Onstad Kunstsenter, Høvikodden, Norway

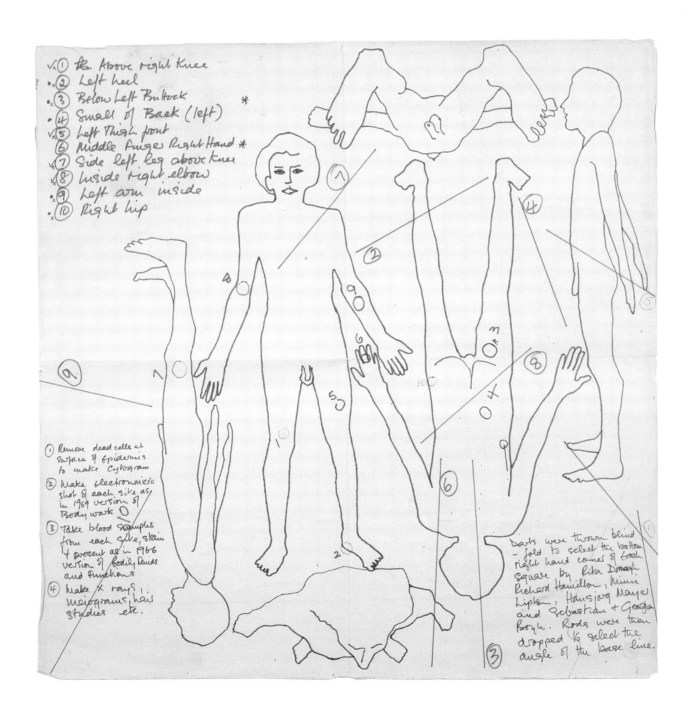

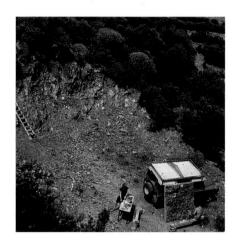

19 Joan Hills and Georgia Boyle at Bergheim Mine, Germany (*World Series* site), 1974

20 Joan Hills and Mark Boyle, Sardinia (*World Series* site), 1978

18

Boyle and Hills extended their study of man with two related projects: *Requiem for an Unknown Citizen* and *Multi Human Being*. These projects concerned human beings in social situations and considered society as a multi-cellular organism. *Requiem* involved reclassifying the London Yellow Pages into systems such as the nervous system, the digestive system and the reproductive system of the city. Boyle and Hills then went to randomly selected examples of each system (a café, a graveyard, a hair salon) and made hidden film and tape recordings. The films were subsequently projected at different speeds whilst actors performed the events in real time to the recorded sounds from the sites [**82–3**]. The logistics of this enterprise soon became too complicated, and after two performances, in Rotterdam in 1971, Boyle and Hills gave up events and performances and limited involvement in the work to the family alone.

Subsequent *World Series* projects included an opencast coal mine in Bergheim, Germany in 1974 [**94–5**] and a motorway construction site in Switzerland in 1978–9 [**100–1**]. In 1978 they made a thorough *World Series* investigation of a site in Sardinia [**20**, **99**]. Their random selection methods located a ploughed field, and they also made vertical section studies, several elemental studies on a nearby cliff face, electron microscope photographs of insects and a series of *Human Density Photographs*, which showed the movement of people in a nearby town. Fluids taken from Mark Boyle's body were also preserved on the site, and later photographed microscopically. These works were included in the Boyles' exhibition at the British Pavilion in the Venice Biennale that year (this remains the only occasion when Scottish artists have been Britain's sole representatives). The Swiss site, on the banks of the Rhine, by Vaduz, included the most exhaustive documentation of any *World Series* site so far. The Boyles' handwritten checklist of work completed noted: 'Surface Study, Vertical Section, Elemental Studies, Insects (Spider, Grasshopper, Beetle, Wood Louse …), Social Studies (Road Crossing, Travel Agent, Restaurant, Post Office …), Bodily Fluids, Hairs, 360° photograph' etc.[21] The insects and vegetable matter were taken back to London, photographed by specialist laboratories and enlarged to a vast scale. While the Boyles have continued to make *World Series* works over the years, the financial and logistical complexities involved in travelling to a distant location, together with all their materials, has meant that they have averaged just one *World Series* project a year. In recent years the *World Series* projects have tended to focus on the earth pieces rather than on the collection of other objects and data.

Alongside the *World Series* project, Boyle Family have always worked on other series and projects within Britain and abroad. One such project, centring on a lorry park in west London, proved particularly fruitful. In 1974 Mark Boyle asked permission to take pictures on the site and the owner, who needed photographs for a planning enquiry and thought that Boyle was a professional photographer, agreed to let him do whatever he wanted provided he took certain shots. This element of fortune led to a major series of earth pieces made over several years. The site offered free and convenient access without fear of disturbance, and it also offered Boyle Family a range of surfaces on which to test and hone their skills and techniques (nevertheless, the sites were still selected by throwing the right-angle). Boyle Family have consciously tried to extend their practice with surfaces they have not previously tackled. They believe in learning through trial and error and the knowledge they acquire on these pieces equips them to cope with the majority of surfaces they encounter on their *World Series* sites. So now, with a certain amount of initial research, they can be fairly confident that they can deal with a site before they journey out to New Zealand, Japan, Spain, the Outer Hebrides or wherever.

There are, still, immense practical and logistical problems involved in making the *World Series* works. In Denmark in 1970 they struggled in vain to make an underwater piece, siphoning off the water and then rigging up a complicated pump system, but it all proved in vain. In a remote corner of Japan, they found that their site was a paddy field which, despite their best efforts, they were unable to cast. In the Negev Desert in Israel, in the early 1990s, their site turned out to be at the heart of a military zone, crawling with tanks. They managed, nevertheless, to make the work, though they were eventually invited to move on. One can only imagine the problems involved in shipping the works back to Britain and dealing with customs officials. In New York their random selection method led them to block off three lanes of a four-lane road, though surprisingly no one questioned their authority. Using their Institute of Contemporary Archaeology cards, traffic cones and signs, workmen's overalls, clipboards and chutzpah (they talk vaguely about preserving the appearance of the landscape for the fictive institute) they invariably get the job done. Boyle Family tend to work almost in secret, calling no one in advance; their approach is very different to that of Christo, who involves politicians and hundreds of helpers to realise his grand designs. If galleries and museums get involved it becomes too complicated; if they are recognised and have to enter into discussion, the work gets spoiled. The quick-drying nature of their materials means that each work requires total concentration. They never cheat. Boyle Family are a democracy consisting of four strong-willed, independent artists (they refer to themselves as

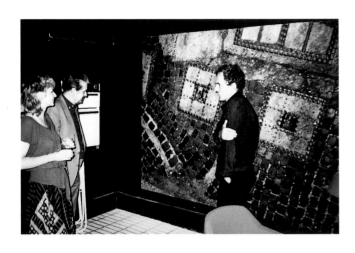

21 Joan Hills, Francis Bacon and Mark Boyle with *Cobble Study with Drains*, c.1981

22 Boyle Family, 2003

'four feuding autocrats'), and they would never allow one of the members to shift the right-angle a little to the left to frame a more appealing patch of earth or to throw it again because the first site was too difficult. But they are realists too, and they occasionally accept commissions on the absolute condition that they select the site by their usual, random methods. This has happened, for example, with commissions from the Museum of Contemporary Art in Hiroshima, from the city of Glasgow and also with the *Liverpool Series*.

Until the late 1970s, Boyle Family worked mainly on the 6 × 6ft (183 × 183cm) scale, though some of the earlier ones are 8 × 8ft (244 × 244cm) and others are smaller. The square format seemed suitably neutral, and the works could be hung any way up. But the size of a piece can often depend on purely practical matters. In Israel they produced works just 6 × 4ft because they could not rent a larger van, and some of their snow works are small because they were physically incapable of carrying larger ones away across the snow. They began making 12 × 6ft (366 × 183cm) works in 1979, as part of the *Lorry Park Series* and with others made in Australia. The change happened for no particular reason other than that they were keen not to be beholden to any set of rules, least of all their own. These larger works can be presented either vertically or horizontally though they tend to show the 10ft works vertically and the 12ft works horizontally. In 1977 they made their first triptych, of a rock face in Scotland, and since then they have made a number of diptychs and triptychs. Another change, embarked upon in 1987, is a shift towards more fully three-dimensional forms, some of which can be nearly a metre deep. Whereas in previous works they had attached large pieces of actual debris to the surface of their works, in the late 1980s, they began to cast these items in resin or fibreglass and attach them. The light weight of the resin meant that they could affix much larger forms, such as the oil drum and girder in *Study of a Demolition Site with Slabs of Reinforced Concrete, Rusty Oil Drum and Twisted Girder* [**119**] from the *Docklands Series*.

The matter of co-authorship is interesting. The ideal of the autonomous, usually male, artist, began to show cracks in the 1960s and to dissolve in the 1970s. A number of anonymous groupings emerged: Art & Language, Gilbert & George and Ulay / Abramović for example. Although for some time the Boyle works were attributed to Mark Boyle alone, he emphasised on numerous occasions that all the works were co-produced with Joan Hills and then with Sebastian and Georgia. Marketing the work under Boyle's name was a purely commercial decision as collectors seemed more comfortable dealing with a single individual. The development of

Boyle Family had another economic effect on their work. A commercial art gallery will often take fifty percent commission on the price of a work. This is hard for a single artist to accept, but virtually impossible to live with when four artists are involved. The pieces are, after all, very labour intensive, often being made over a period of several years, and Boyle Family are not prolific. Consequently, Boyle Family normally sell their work directly to collectors, and this in turn means that their work is rarely seen in public, to the point that they have acquired an almost mythical status.

For Boyle Family, the world is one enormous and endlessly fascinating objet trouvé. Anything and everything are fitting subjects for their art: nothing should be omitted. It is not a matter of self-expression or aesthetics, indeed the fact that four of them work together cancels any notion of the self. Apart from technical improvements, they avow that there is and should be no stylistic development in their work. In fact, their works should have no style at all. The works are simultaneously the height of artifice, as the viewer is hoodwinked into believing that he or she is looking at the real thing, and yet they negate the artistic process since no aesthetic judgements are involved. Boyle Family stand in the centuries-old tradition of trompe l'oeil, yet their work has a strong conceptual bias. It is not even clear if they are painters or sculptors: the point is that it does not matter. If the role of the artist is to shape or change the way we see, then Boyle Family are artists par excellence. Once one has seen their work, it is hard to look at the world in the same way again.

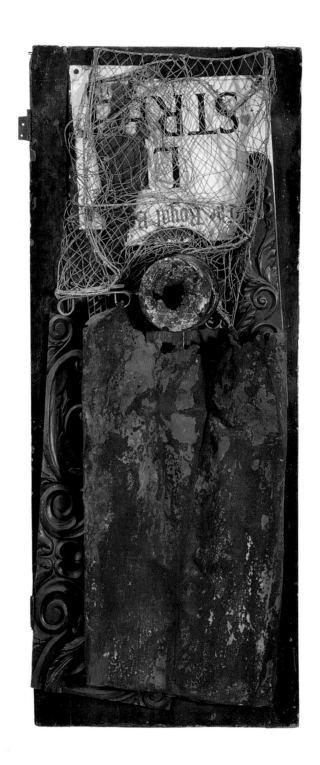

23 *Assemblage* 1963

Mixed media on door · 169.7 x 71 · Boyle Family collection

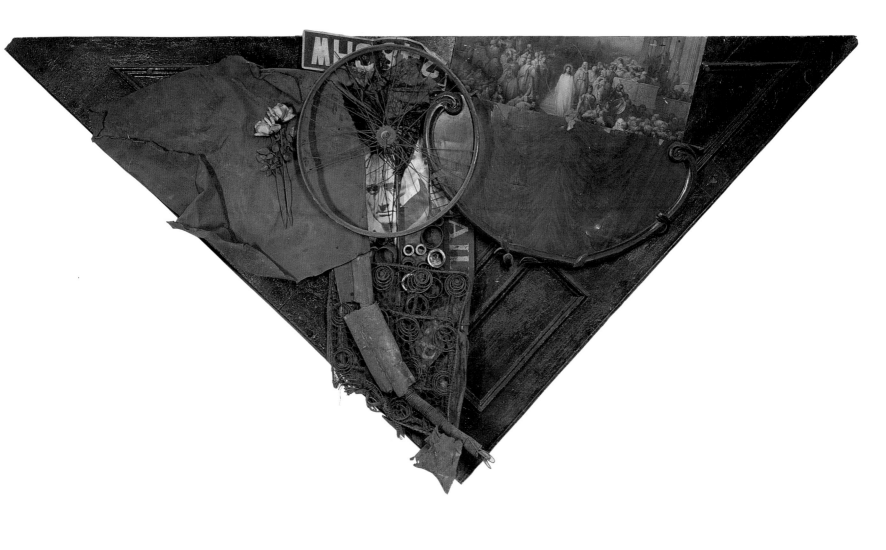

24 *Mine Eyes Have Seen the Glory ... , 1963*
Mixed media on wood · 150 x 297.5 · Collection Sean Hignett

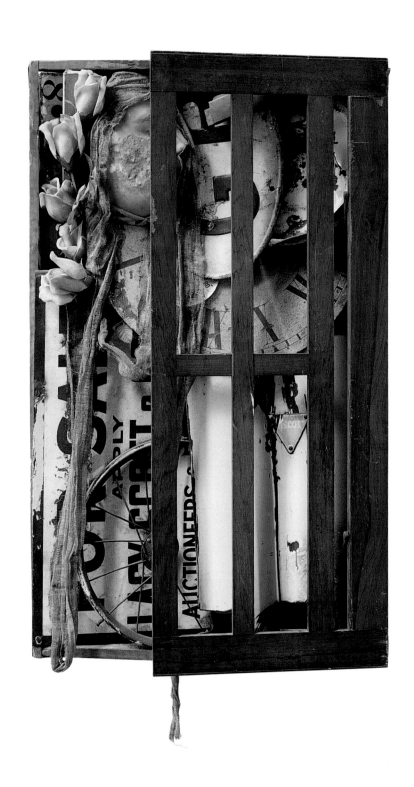

25 *Assemblage*, 1963
Mixed media · 72.4 x 43.7 · Boyle Family collection

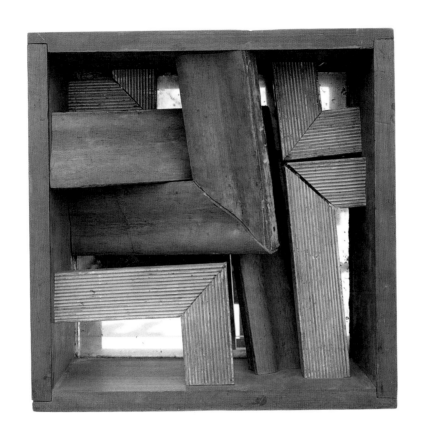

26 *Assemblage*, 1963–4
Mixed media · 28 x 27.8 x 15 · Boyle Family collection

27 *Norland Road Study (Red Lino and White Stiletto)*, 1964
Mixed media on board · 98 x 99.4 · Boyle Family collection

28 *Norland Road Study (Blue Bag)*, 1964
Mixed media on board · 81.5 x 59.5 · Boyle Family collection

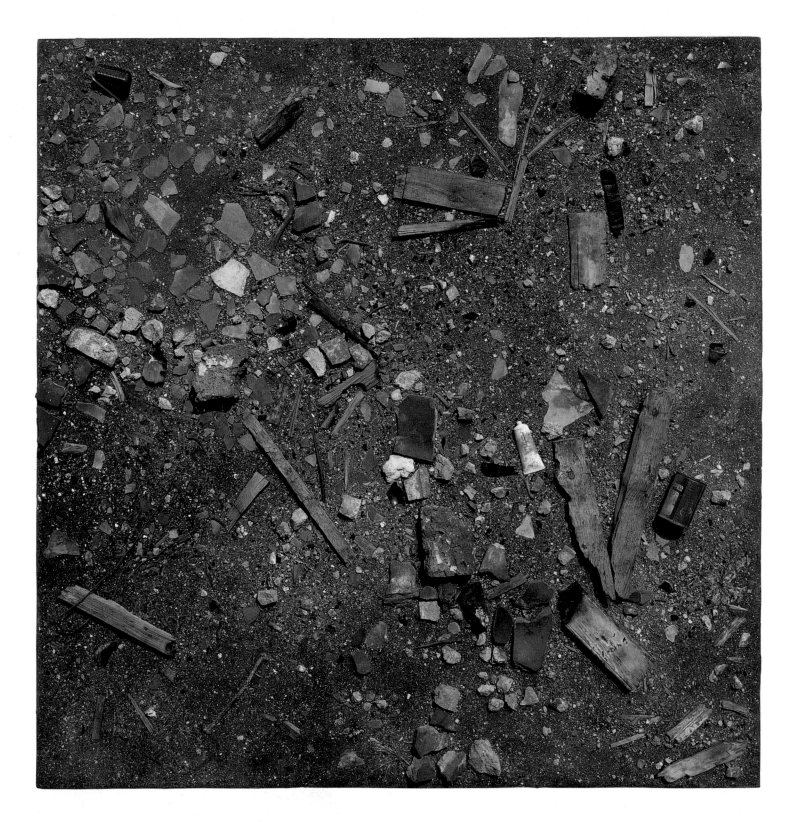

29 *Shepherd's Bush Study*, 1966
Mixed media and resin on board · 153 x 153 · Collection Hansjörg Mayer

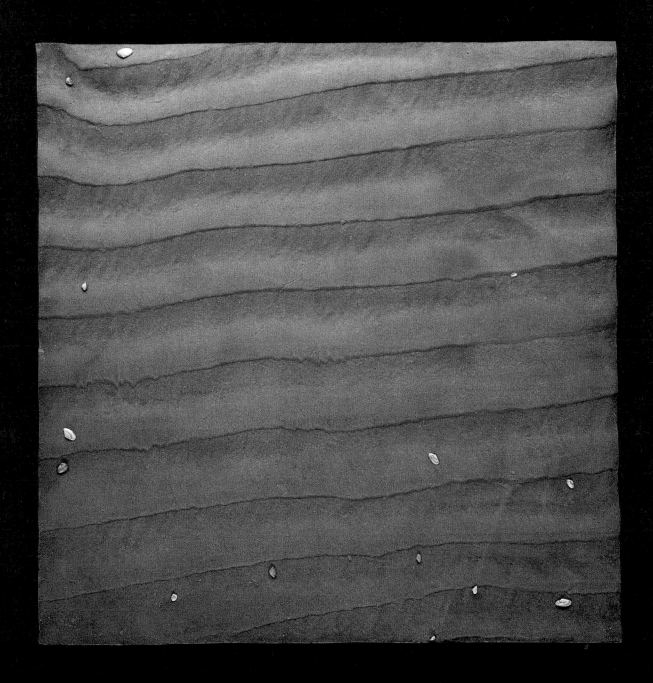

30 *Beach Study, Camber Sands*, 1966
Mixed media, resin and fibreglass · 89 x 89 · Private collection

31 *Holland Park Avenue Study, London Series,* 1967
Mixed media, resin and fibreglass · 238 x 238 · Tate · purchased 1969

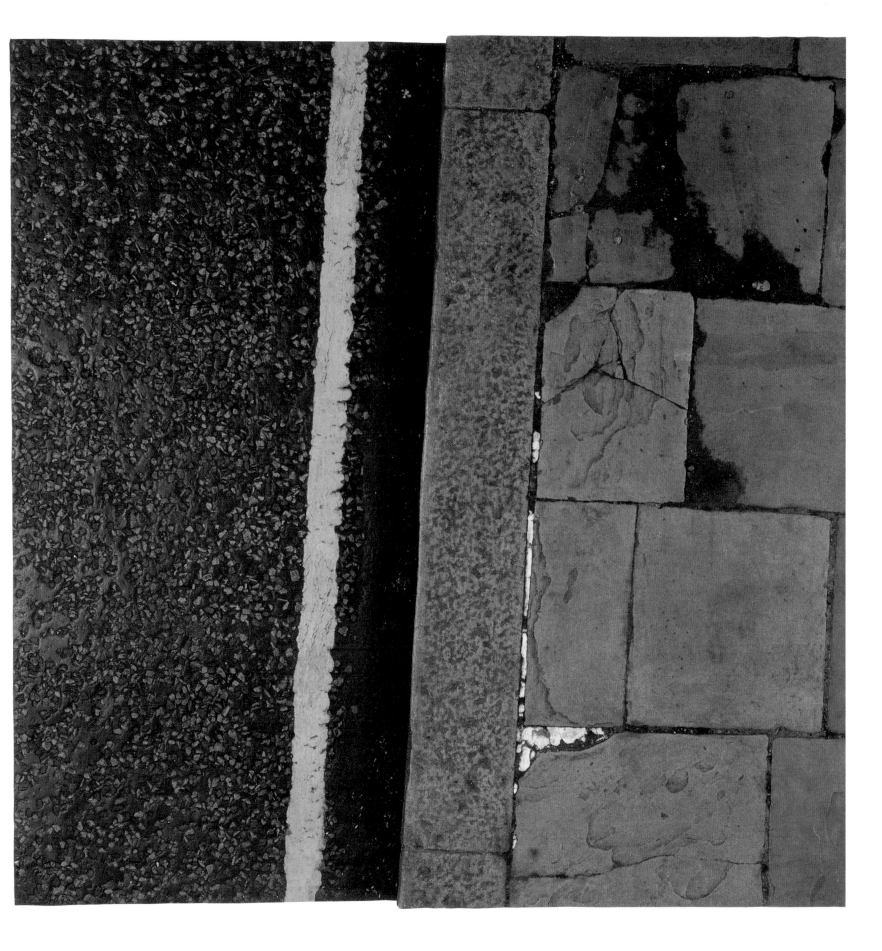

32 *Addison Crescent Study, London Series, 1969*
Mixed media, resin and fibreglass · 247 x 244 · Scottish National Gallery of Modern Art, Edinburgh

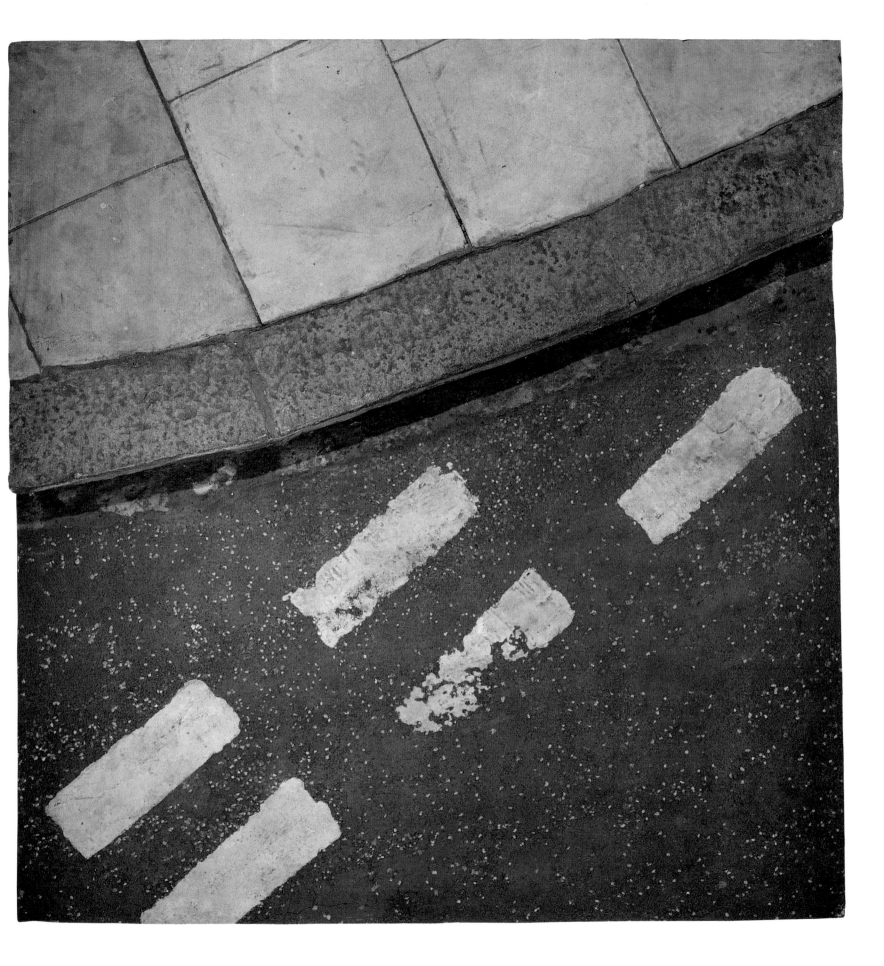

Meticulously selected at random, without the slightest consideration for beauty, utility, edibility, scent, or horticultural interest, we are now able to offer from various random sites and from the Sensual Laboratory's random nurseries in the Hebrides, London, Norfolk and Sussex.

Joan Hills
Seeds for a random garden

RANDOM HARVEST. Seeds collected periodically from a series of squares selected with a dart, thrown blindfold into a large scale map, and a square frame thrown down on the spot in such a way that no personal selection, conscious or unconscious, could operate. Series Commenced 1966.

HARVEST FALLOUT. 30 empty seedboxes put out by Joan Hills in the London random nursery on 1st October, 1969 were brought in, one each day throughout October. Any seeds were packeted.

BLOWN SEEDS. A find mesh net was hung vertically in the London random garden and periodically the seeds caught in the mesh, or in the collection trough below, were collected and packeted.

WATERBORNE SEEDS. A net of fine mesh was placed in various (randomly selected) areas of water (lake pond and sea). It was taken up at intervals and examined for seeds (Autumn 1969).

NOTTING HILL HARVEST FESTIVAL. Seeds from one of a hundred sites selected at random from the Notting Hill/Shepherds Bush area of London.

URBAN GLEANINGS. Seeds collected following various routes during which Joan Hills would stop at pre-determined intervals and gather a seed from the nearest plant (continuing series).

SEEDSMANS MEDLEY. For this Medley Joan Hills bought one of each packet of seeds stocked by a local seedsman mixed them together annd then divided and packeted them.

FROM THE RANDOM NURSERIES. Random selections from the sensual Laboratory's random nurseries in London, Sussex, Norfolk and the Hebrides.

FORTHCOMING
Earthprobe. Collections of seeds from each of 1000 sites selected at random from the surface of the earth.

A SEED FOR JOAN'S GARDEN. Members of the public attending the openings of Journey to the surface of the Earth exhibitions will be admitted on production of a seed for Joan's garden. These seeds will be divided randomly and packeted.

SOWING RECOMMENDATIONS.
1. Seeds may be planted in sterilized earth in pots or seed boxes or planted out (under glass initially) in beds of sterilized earth.
2. Seeds may be sown on a square site selected at random from any area.
3. Seeds may be scattered at random from the air.
4. Random seeds will be planted on each of the 1000 sites of journey to the surface of the Earth packets of seeds are available in exchange for a contribution to the funds of the Sensual Laboratory. Amount to be chosen at random by donor.

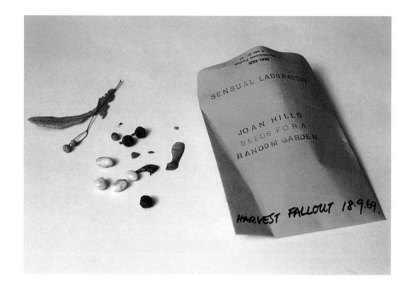

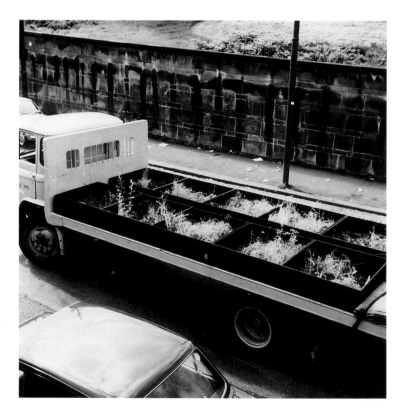

33 Joan Hills, Explanation of variations of *Seeds for a Random Garden*, 1966–9

34 *Seeds for a Random Garden*, 1969

35 *Seeds for a Random Garden* being delivered to Kelvin Hall, Glasgow, 1973

36 Joan Hills collecting seeds for *Seeds for a Random Garden (Urban Wilderness Series)*, 1971

37 *Study of Seagrass, Camber Sands,* 1969
Mixed media, resin and fibreglass · 106.8 x 106.8 · Boyle Family collection

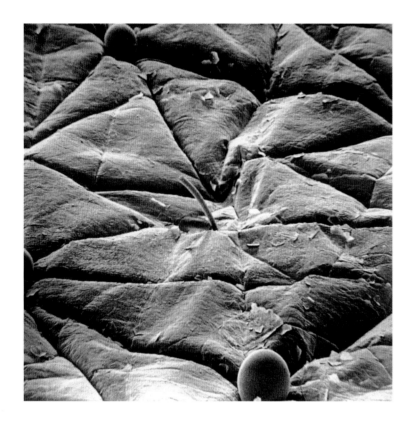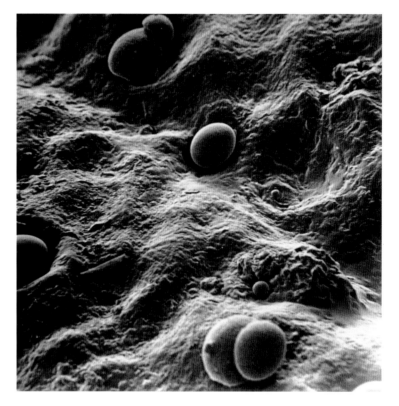

38 a&b Electron microscope photograph of randomly selected square of Mark Boyle's skin,
from *Body Work*, 1969 · Boyle Family collection

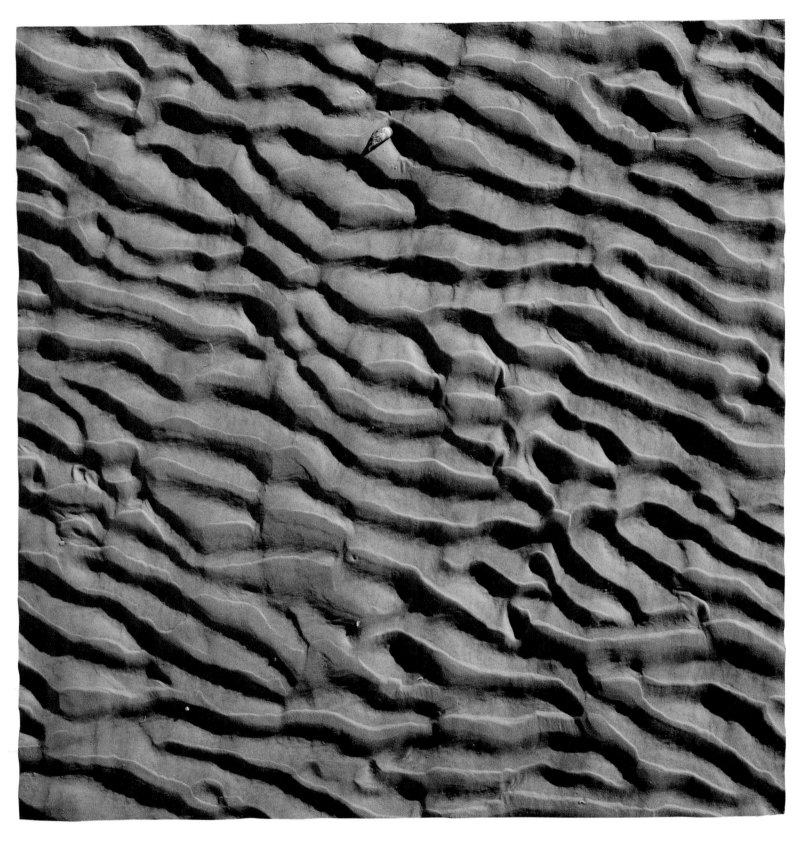

39–52 *Tidal Series*
All mixed media, resin and fibreglass · 150 x 150 · Compton Verney House Trust (Peter Moores Foundation)

39 *Tidal Series*, am 1/11/1969

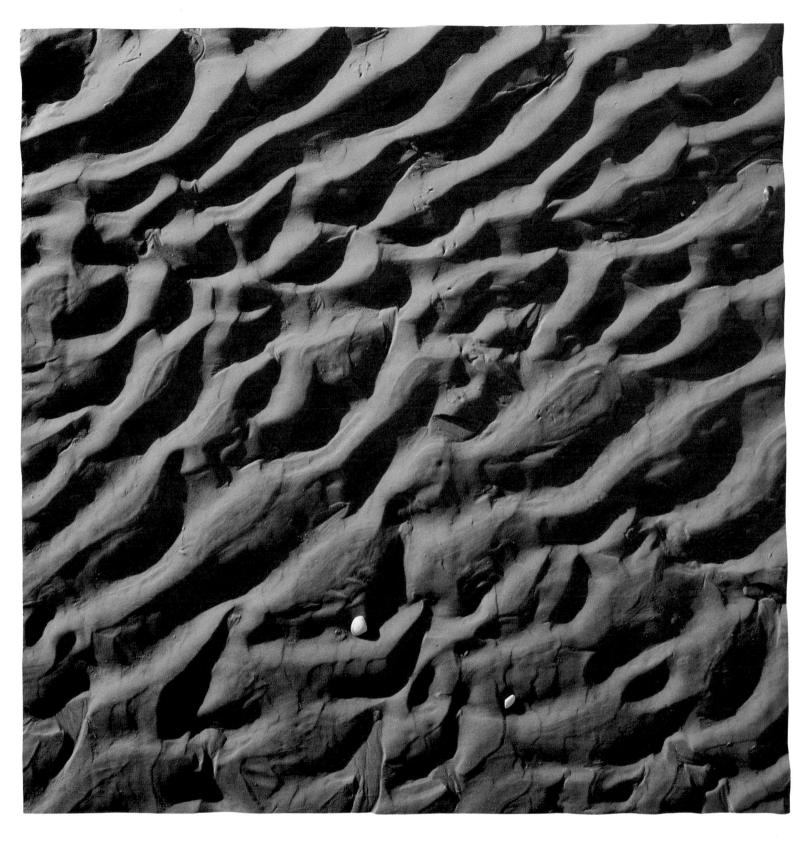

40 *Tidal Series*, pm 1/11/1969

41 *Tidal Series, am 2/11/1969*

42 *Tidal Series*, pm 2/11/1969

43 *Tidal Series*, am 3/11/1969

44 *Tidal Series*, pm 3/11/1969

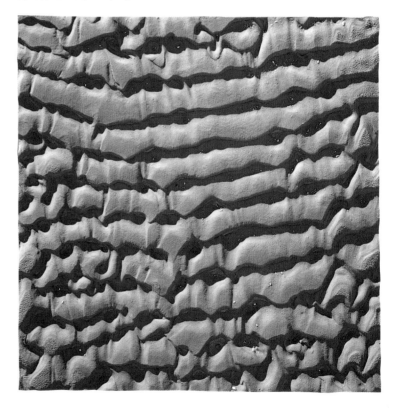

45 *Tidal Series*, am 4/11/1969

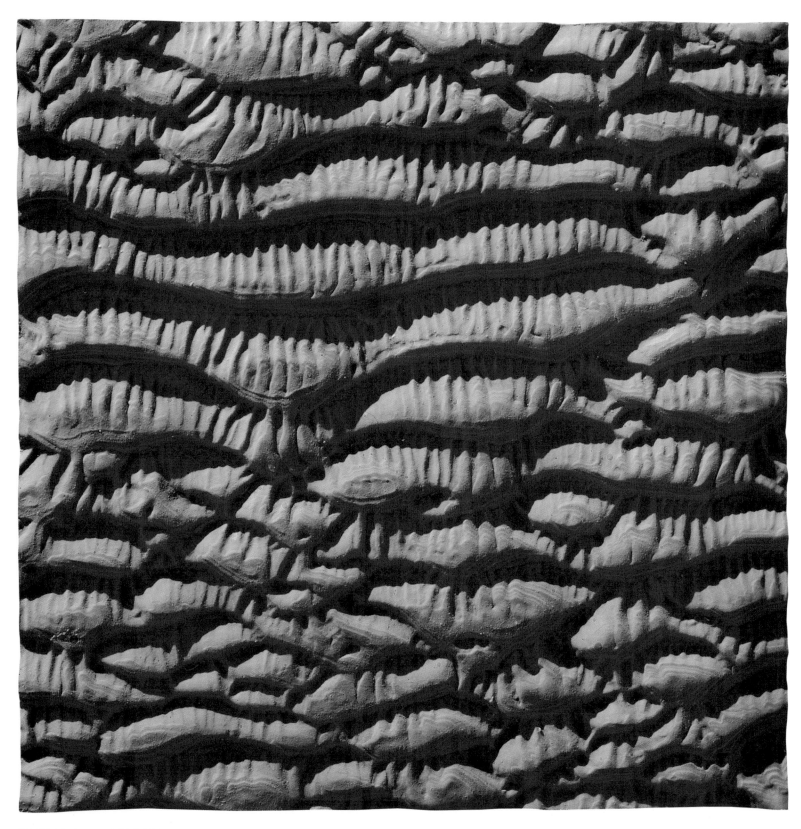

46 *Tidal Series*, pm 4/11/1969

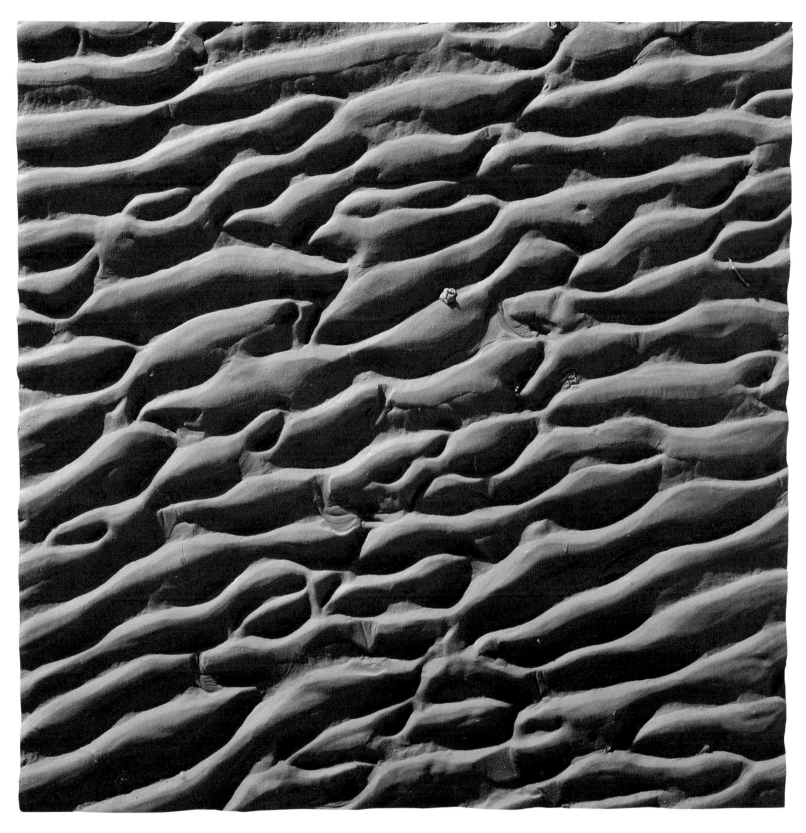

47 *Tidal Series*, am 5/11/1969

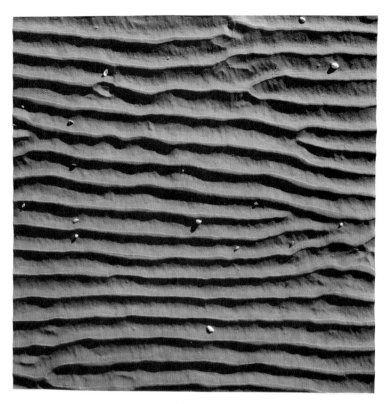

48 *Tidal Series,* pm 5/11/1969

49 *Tidal Series,* am 6/11/1969

50 *Tidal Series,* pm 6/11/1969

51 *Tidal Series,* am 7/11/1969

52 *Tidal Series, pm* 7/11/1969

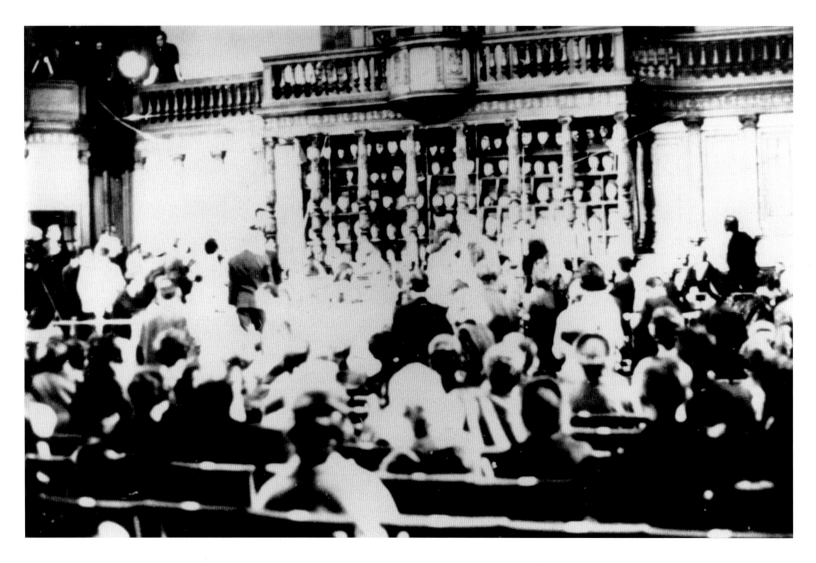

53 The finale of *In Memory of Big Ed*, McEwan Hall,
Edinburgh, 7 September 1963. Joan Hills, heavily pregnant
with Georgia, holding Sebastian in her arms and Cameron by
the hand, walked past the platform pointing out the important
theatre people and the collection of phrenological heads as
though they were all exhibits in a museum of the future.

Towards an Index for Everything The Events of Mark Boyle and Joan Hills 1963–71 Andrew Wilson

The most complete change an individual can effect in his environment, short of destroying it, is to change his attitude to it.

MARK BOYLE, 1966[1]

Mark Boyle and Joan Hills's first exhibitions in London and Edinburgh in the late summer and early autumn of 1963 presented assemblages made from junk objects found in the urban wastelands of an inner city London still pockmarked by twenty-year-old bomb sites. The work forged a new realism not as a Pop art celebration of the everyday, but through the isolation of what had been discarded and thrown away: markers for the unseen textures of life. Given the ephemeral nature of what was laid down and fixed in these assemblages, it is hardly surprising that Boyle and Hills would quickly move away from the presentation of objects and embrace the totality of life as material for their work – a totality that Boyle had previously addressed in his poetry. Their first such publicly staged event was *In Memory of Big Ed* – the first Happening in Britain – created in collaboration with director, Ken Dewey, and playwright, Charles Lewson, on the final day of the International Drama Conference at the Edinburgh Festival on 7 September 1963. Rather than produce images of, or metaphors for something else, Boyle and Hills could from this moment claim to present the actual material of the world as art.

The conference, organised by publisher, John Calder, traded on the controversy caused by his International Writers' Conference the previous year. It had witnessed both William Burroughs and Alexander Trocchi offer a ringing call to arms to a nascent counterculture; that, as Trocchi declared, 'Modern art begins with the destruction of the object. All vital creation is at the other side of nihilism. It begins after Nietzsche and after Dada.'[2] Calder, under the chairmanship of Ken Tynan, had gathered together a broad, international, cross-generational selection of playwrights and directors for the drama conference,[3] but according to Dewey, although it presented all the currents and conflicts of modern theatre to a daily audience of about 2,000 people, 'the strength of the conference was that rather than talk of drama distractedly, everyone was actually *having* drama and living through all the strenuous pressures of communication.'[4]

The Happening planned by Dewey,[5] Lewson, Boyle and Hills for the final day of the conference exemplified this sense of 'having drama', and for their part Boyle and Hills were anxious to use the material of the conference in making *In Memory of Big Ed* so that it might throw the conference back at both the delegates and audience. It is in this respect that Dewey later described this Happening as 'straight reportage of a situation'.[6] Following the morning's discussion, 'The Theatre of the Future', which had commenced with Joan Littlewood's explanation of her Fun Palace collaboration with the architect, Cedric Price, the director, Charles Marowitz, started *In Memory of Big Ed* by giving a nonsense lecture on the meaning of Samuel Beckett's play,

Waiting for Godot. Marowitz was increasingly heckled by Lewson. After a short while Lewson started to climb over the seats in the auditorium to get to the stage, and when he reached it he pushed Marowitz away from the microphone, and the sound went dead. Mayhem ensued. According to Marowitz, the event, which lasted less than seven minutes, 'had intended to disperse attention and create a number of different areas of interest … No one knew precisely what was happening nor where.' Certainly the action, as it has been described variously by Boyle, Marowitz and Dewey, did not so much unfold as declare itself in a spatially disjointed and disorienting way. Amplified sound of cable-pullers at work, organ sounds and cut-up fragments of conference speeches, coincided with the appearance of a large sculpture bust (the words 'Big Ed' were scrawled across its forehead in red lipstick) which was lowered from the end of a rope at the back of the platform before smashing onto the floor below. A naked woman (a life-class model from the art school) was pulled on a trolley across the organ loft balcony above the platform;[7] the actress Caroll Baker, who was on the platform, stared at Allan Kaprow who was seated at the back of the hall. She took off her fur coat and climbed down over the seats in the auditorium, but before reaching him and then running out of the hall, two men shouted 'Me! Can you hear me? Me!' A bagpiper crossed the high balcony reaching the other end of the hall and, as all the sounds stopped, a blue curtain behind the stage platform fell to reveal shelves containing a collection of phrenological heads that Boyle had discovered in the hall's stores [**53**]. To one side of the platform was a huge screen bearing Jean Cocteau's poster of Orpheus (the conference's symbol), over which was hung a sheep's skeleton; Hills, heavily pregnant with Georgia, and carrying a radio, then mounted the platform with her sons Cameron and Sebastian. She pointed out to them the heads at the back of the stage as well as the theatre people on the platform as if they were walking through a museum of the future, while a voice recorded earlier from the conference insistently declared 'I love the theatre'.[8]

The conference's afternoon discussion was taken up with an intense argument about the merits of the Happening. The majority of delegates, led by Tynan, deplored what they saw as little more than an arbitrary and childish interruption to the conference proceedings. However, both Littlewood and Trocchi were loudly supportive of the event. Trocchi 'spat the word "Dada" back into Tynan's face and exclaimed that critics could not simply explain away new forms in art by bundling them into ready-made classifications. Martin Esslin pointed out that the Happening had forced the conference to distinguish between what was real and what was contrived and, therefore, had exerted a healthy influence.'[9] Esslin's interjection is

54–9 *Suddenly Last Supper*, 1964. An event marking the eviction of Boyle Family from their home. Burning slides and Joan Hills's random films were projected onto a variety of screens, which were then destroyed. This sequence shows Botticelli's *Birth of Venus* being projected on to the body of a woman. The slide burned in the projector and through the disintegrating image of the idealised woman, Venus, emerged the real woman. Real and fascinating. At the end of the event, the audience found themselves in an empty flat, Boyle Family and the performers having disappeared with all their possessions, including the light bulbs.

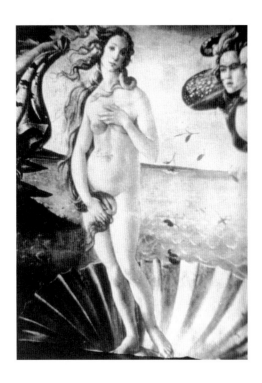 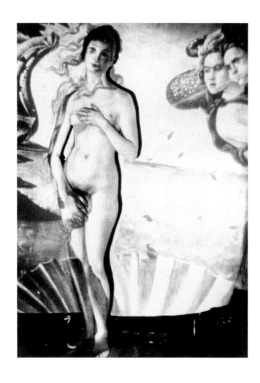 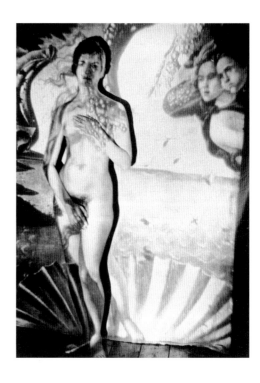

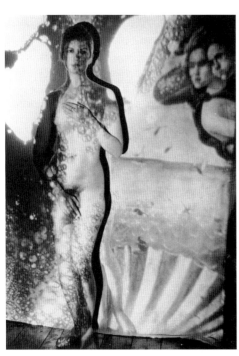 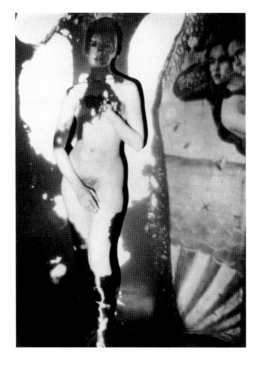

60–1 The shop and view from the shop in *Street*, 1964. Mark Boyle and Joan Hills led a small group of people up Pottery Lane in west London. They entered a grimy back door marked 'Theatre' and sat on a row of chairs facing a curtain. When the curtain opened they found themselves looking through a shop window into the street. The event consisted of everything that happened in the street while they watched.

revealing. As he was the critic who had coined the term 'Theatre of the Absurd' to describe the work of Samuel Beckett, Arthur Adamov, Eugène Ionesco, Jean Genet, Harold Pinter and others, he recognised the connection between it and *In Memory of Big Ed*. In both, the world is presented as being difficult to decipher, our place in that world as being without any purpose, and humanity as being continually troubled, bewildered and obscurely threatened. In London, Boyle and Hills had both been working in a restaurant near the Royal Court Theatre and professed a great interest in the Theatre of the Absurd. Together they constructed 'anxiety objects'[10] – ridiculous and threatening events that they staged in the restaurant or in the Underground to the consternation and amusement of the passers-by drawn into the action.

Significant to any theorising of the Theatre of the Absurd was the much earlier example of Antonin Artaud's creation of the Alfred Jarry Theatre in the late 1920s and his Theatre of Cruelty. Artaud held that theatre should 'no longer be a strait-jacketed thing, imprisoned in the restricted area of the stage, but will really aim at becoming action, subject to all the attractions and distortions of events, over which random happenings resume their rights … The Jarry Theatre will endeavour to express what life has forgotten, has *hidden*, or is incapable of stating.'[11] This 'becoming action' or 'having drama' informs the manner in which Boyle and Hills were aiming to create a total work, a work that might include everything and encourage us to see the world with fresh eyes.

There is no division of hierarchy between the assemblages and the events like *In Memory of Big Ed* or those of the following year: *Suddenly Last Supper*, *Street*, *Exit Music* and *Bags*.[12] One assemblage, first constructed in Queensgate in 1963 and later reassembled in their next flat beside Holland Park tube station, exemplifies how both the events and the presentations of assemblages inhabited the same space. *Bed Piece* consisted of a folding bed with a hole through the wall to the next room where ordinary family life was lived, and this became part of the assemblage [**5**]. Hills describes it as 'a big assemblage that we actually slept in. Birth, sex and death: the bed was the vehicle for all of them'.[13] Around the bed were arranged different sorts of objects providing different layers of reality while emphasising that any representation of these life events as object – and thus all reality – is inadequate. Furthermore, this hierarchy of objects provided an image that was functional: the bed was used, as were the objects (some had been in *In Memory of Big Ed* and other events). One contemporary account of *Bed Piece* lists its components as 'realistic painting, statues, wax casts of diseased faces, two television sets (one positive, one negative), mirror, window

through the adjacent wall, and the bed itself. This and his other assemblages stressed the dichotomy between the aesthetic and the meaningful.'[14] What *Bed Piece* also stressed was that Boyle and Hills's life at this time was – as part of 'everything' – inseparable from their work. This can also be recognised in *Suddenly Last Supper*, which was presented when they moved from their flat in Queensgate, late in 1964 [**54–9**]. The event had a complex event score[15] involving light and film projection over a naked woman, various sound effects, the destruction of projected slides and the screens on which they were shown, and actors bowing and smirking at the end of the event. However, the hidden aspect of it was that, unknown to the audience, another Happening was going on under the cover of the one they were watching. During the event Boyle and his family moved all their possessions out of the flat so that when it had ended and the audience was leaving, the place was completely bare and Boyle Family had left the building.[16]

'The aesthetic and the meaningful' formed one duality in the work; another can be recognised between those events which are scripted (such as *In Memory of Big Ed*) and those in which a situation is set up so that life and the extraordinary epiphanies of the street take over. This is analogous to the manner in which Boyle and Hills threw a frame to the ground in a demolition site, isolating the elements that would become an assemblage in their first random earth studies. The frame was not deliberately placed as in a script, but randomly thrown so that life was presented back at them. Boyle and Hills envisioned in their work realities which revealed themselves through the action of chance. With *Street* and *Exit Music* of 1964 the audience is confronted with the city virtually unmediated by the artists, save for their framing structure. With *Street* [**60–1**], the audience was led down Pottery Lane, a west London street, to the back entrance of a building marked 'Theatre'. They made their way into a room where chairs faced some curtains. When these opened, the audience found that they were looking out through a shop window to the street, and whatever happened there was the event. *Exit Music* was another collaboration with Dewey and Marowitz in which the audience, after having arrived at the Strand Electric Theatre, was driven around London in a bus from which events could be observed – some were scripted and acted out by friends of Boyle, such as the Alberts who played billiards on the street, while other events were just daily life. As one critic observed, as the audience 'continued their journeys, they discovered more and more "happenings" in the street; all of these were, in fact, fortuitous. A fascinating kind of confusion ensues. Are we members of an audience watching scenes "laid on" for us or simply eye-witnesses at accidental events?'[17]

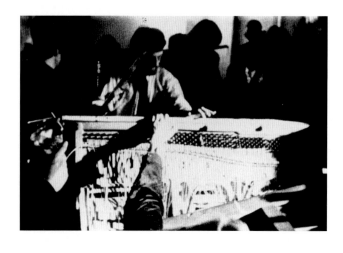

62 Piano being smashed and remade during the event *Oh What a Lovely Whore* at the ICA in Dover Street, London, 1965.

For Jean-Jacques Lebel, one of the chief European theorists and practitioners of the Happening, the status of the audience and what it watched was key (as it also was for the Theatre of the Absurd and had been for Artaud). In June 1964, Lebel, with the help of the theatrical impresario, Michael White, organised a two-day festival of Happenings at Denison Hall in Victoria, London,[18] for which he declared that 'the barrier between "artist" and "audience" is destroyed by forced involvement'.[19] Lebel's closeness to the Theatre of the Absurd can also be recognised in his belief that 'the Happening interpolates actual experience directly into mythical context. The Happening is not content merely with interpreting life; it takes part in its development within reality. This postulates a deep link between the actual and the hallucinatory, between real and imaginary.'[20] Boyle and Hills also embraced this feeling that the real and imaginary worlds fed into each other. Although their event for the festival, *Bags*, was scripted, it developed in a way that could not have been foreseen. In dim light, about ten mail sacks were pulled on trolleys onto the stage and then dumped. Gradually the audience realised there were people trapped inside the sacks. They fought their way out and threw off the chains that had been wrapped around them. The first person to free himself then wrapped himself in a larger chain, and he was followed by the next person and so on, until all but one were wrapped together by this one heavy chain. Boyle recalls, that from this point in the event:

the idea was that they would carry the one remaining person off – so it was scripted – out of the arena. But the thing that was not scripted and that no one could have guessed was that the chain was excruciating and many people had wound it round their neck and you could hardly move without making it hard for someone else … And suddenly this thing which had come out of French *trucerie* suddenly had a real significance and everyone felt it, and the audience knew this was not acting.

The throwing of a frame over a situation that was then given the means to develop in its own way (rather than being totally scripted) formed the basis for other events in 1965 and 1966: *Oh What a Lovely Whore* on 11 May 1965; *Any Play or No Play* on 7 September 1965; and *Dig* on 6 and 7 February 1966. For *Oh What a Lovely Whore* [**62**],[21] the first in a series of events that Boyle and Hills had been invited by Jasia Reichardt to present at the ICA, Boyle produced a text explaining his events in which he states that:

My ultimate object is to include every thing in a single work … In the end the only medium in which it will be possible to say everything will be reality. I mean that each thing, each view, each smell, each experience is material I want to work with … There are patterns that form continuously and dissolve; and these are not just patterns of line shape colour texture, but patterns of experience pain laughter, deliberate or haphazard associations of objects words silences on infinite levels over many years: so that a smell can relate to a sound in the street to an atmosphere noticed in a room years ago … I feel I must feed the concentration; that it is necessary to 'dig' reality, to uncover its infinite layers and variations … To a very large extent the theatre is created for and even controlled by its audience … The situation inside the theatre is beautiful. There is a complex of interweaving layers of reality that is not at all disturbed by a bad performer or a superficially dull play. It is very absorbing, particularly when a gesture is made in the direction of something like audience participation. I think even the stage struck must reach something near orgasm at the dramatic impact of an actor forgetting his lines. As my events are still connected in people's minds with theatre, I hope that at this series in the ICA we can avoid having an audience as such.[22]

The event, which the audience was invited to take over and perform themselves,[23] was a resounding success, to the extent that the rest of the series at the ICA was cancelled.[24] Although elements had been prepared – such as reels of film from which the audience cut random lengths that were edited together by Hills and her colleague, Dai Vaughan, and then projected,[25] and props produced, such as a piano – Boyle and Hills again could not have foreseen the end result. According to one contemporary account, the audience went *berserk*

they worked projectors and tape recorders, performed on numerous plastic instruments, painted by numbers, smashed a piano, took scripts from actors, acted with them or directed the performance, danced with ballet dancers, edited films and projected them onto walls, ceiling and people, directed a film of the proceedings, controlled the lighting, jumped on trampolines, prepared a press communiqué. They decided to build a new type of piano out of the pieces of the old. It began to be the centre of the event. It was smashed and re-smashed.[26]

More simply, for *Any Play or No Play*, Boyle called the stalls audience onto the stage of the Theatre Royal, Stratford East, and then raised the curtain. The audience on the stage was given no direction and the event lasted for about twenty minutes, during which they milled around listlessly handling some of the props.[27] For *Dig* [**63**], a group of people was invited to meet at the entrance to the ICA. They were then taken to a site in Shepherd's Bush and were encouraged to dig within a roped-off area. The place was a demolished ornamental garden statue factory, and about 200 statues and other artefacts were found and then later exhibited at Boyle and Hills's home.[28] One aspect of *Dig* was the creation of the Institute of Contemporary Archaeology (a sort of spoof Institute of Contemporary Arts), which emphasised

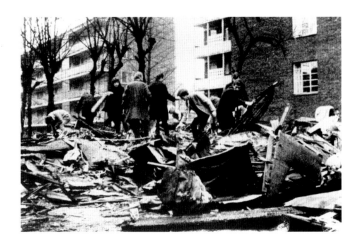

63 *Dig* (event), Shepherd's Bush, London, 6 February 1966. Boyle and Hills invited friends to the annual Dig of the 'Institute of Contemporary Archaeology' on the site of a burnt-down factory that made ornamental garden statues. About 200 statues and other artefacts were found and later exhibited.

that there was no hierarchy within their works and the objects and information they presented. Boyle and Hills present fragments of an unknowable whole. Just as archaeologists form theories about the patterns of history and the workings of ancient society from the fragmentary objects they unearth, and whether these objects are nondescript shards of rustic pottery or precious ritual objects, both can yield equally vital information. As Boyle explained at the time, the Institute of Contemporary Archaeology had 'taken the view that anything that exists is part of the contemporary environment, regardless of its condition, age or date of manufacture, so that an object is not unworthy of our interest because it happens to be old or damaged or picturesque'.[29] *Dig* refashioned the process of Boyle and Hills's early random earth study assemblages as a group event.[30]

Boyle and Hills's presentation at Indica Gallery in the summer of 1966, a few months after *Dig*, was a watershed in their development as artists. In 1962 they had no contact with the art world, while a year or two later they were presenting their events to a close-knit group of friends and collaborators that included Cornelius Cardew and his family, John Latham, Christopher Logue, Gustav Metzger, Jasia Reichardt, Michael White and Stephen Willats. However, from 1966 Boyle and Hills found themselves at one of the hubs of London's emerging counterculture. Indica Gallery was a partnership between Peter Asher (one half of Peter and Gordon and the brother of Jane Asher who was at the time Paul McCartney's girlfriend), Barry Miles (who had previously been manager of the paperback department of Betterbooks, ran Indica Books in the gallery's ground-floor space) and John Dunbar (recently married to Marianne Faithfull). Just before Boyle and Hills's presentation, Miles had moved the bookshop from the gallery to a much larger space at 102 Southampton Row in Bloomsbury,[31] and it was from this space that the *International Times* (*IT*) would first be published in October 1966. The gallery itself was located in Mason's Yard next door to the preferred nightclub of the moment, The Scotch of St James. In an adjacent block of flats lived William Burroughs (a friend of Miles – he had been living in London since 1965). The gallery's name was either an abbreviation of the title of its first two exhibitions *Indications 1 and 2* or taken from *Cannabis Indica*. This ambiguity, which charted a line between a bold utopianism or what Alexander Trocchi had earlier described as becoming 'Cosmonauts of Inner Space', would be a defining element of countercultural self-definition in London over the next couple of years, when attempts were made to remake society along with its surrounding languages.

One month after the presentation at Indica, Gustav Metzger invited Boyle and Hills to take part in the Destruction In Art Symposium (DIAS). For this

they staged two events: one on 1 September 1966, at the Jeanetta Cochrane Theatre to open the symposium, and another on 30 September, as part of its closing events at the Africa Centre. Destruction had been at the heart of Metzger's work since 1959, when he had first evolved the idea of an Auto-Destructive Art, and his approach to making art constituted a direct challenge, not only to the orthodoxy of the art world, but more importantly to the structures of society itself. His art was deeply radicalised by his political activism as a founder member of the Committee of 100 and he intended that its 'aesthetic of revulsion' should open people's eyes to the horrific realities of contemporary life. Auto-Destructive Art developed as a process for which the concept, means of expression and actual execution of the work were treated as unified events that took place in a socially-defined space. For Metzger, his work – whether painting with acid on stretched nylon, or as slowly corroding monoliths – was intended as primarily a public art, as monuments 'to the power of man to destroy all life'.[32] The cathartic intention of DIAS broadly reflected Metzger's own concerns in terms of 'social action'.[33] However, his intention with DIAS was also – while using the issues of destruction and violence as a leitmotif – to stimulate a much wider debate away from art's involvement with society and towards society itself (apart from political activism, Metzger had also involved himself in experimental architecture and science). The remit for DIAS was necessarily broad and inclusive, taking in 'atmospheric pollution, creative vandalism, destruction in protest, planned obsolescence, popular media, urban sprawl/overcrowding, war … biology, economics, medicine, physics, psychology, sociology, space research'.[34] Within these subjects DIAS approached destruction in a way that stressed temporal and spatial dimensions, alongside a compassion for the human condition and the significance afforded to ritual, leading to catharsis, through the attempt to rediscover those experiences of reality that had been repressed by society's conventions. Its historical significance can be seen by the fact that DIAS provides a marker for a particular moment which recognised that the concern for the objectified image was unable to engage convincingly with contemporary realities, and that the dynamics structured around the event offered a more favourable avenue for investigation – and not just for artists.

In this respect the decision to invite Boyle and Hills was astute. For the last three years they had been evolving towards the point in 1965 when Boyle had declared the desire 'to include everything in a single work'. Their experimentation with light projections since the early sixties had first been shown to a limited public in *Suddenly Last Supper*, 1964, for which a naked woman acted as a screen and Botticelli's *Birth of Venus* was projected onto her body [**54–9**]. The woman held the pose of Venus so when the slide was burnt, she

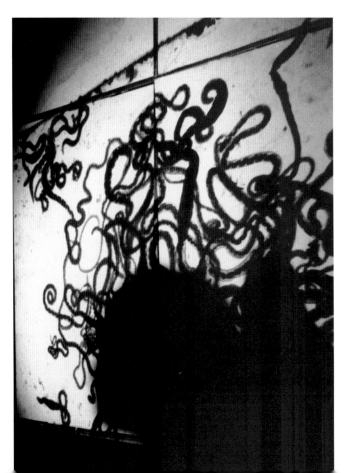

emerged through the ideal image, only finally to disappear by being painted black. For this event, not only were slides burnt, the screen was destroyed while random film offcuts were also projected, achieving a complex layering of reality and reference. These experiments bore fruit in a series of three *Son et Lumière* events on which Boyle and Hills had been working that year. For the launch of DIAS they presented the second in this series, *Son et Lumière for Insects, Reptiles and Water Creatures* [**64–5**].[35] The programme notes actually title it *Sound / Light for Insects and Water Creatures* and also clarify where the work stands in relation to their random earth pieces. The stimulus for the work arose from the beach studies made that summer, the first of which had been exhibited at the Indica Gallery. In the programme notes Boyle writes:

Joan Hills, John Claxton and I were working on the beach at Camber one day in summer when I noticed a labyrinth of minute tracks in the sand. At the centre an insect lay on its back. I thought, surely even in its death agony this fly could not have created all these tracks. I turned it over with a small stick to see if it was a fly or wasp and as I did so a number of smaller insects scuttled out of the corpse.[36]

The construction of random earth pieces was not concerned solely with the eventual presentation of the finished objects. It was also concerned with charting and presenting all aspects of the site – its social, biological and chemical make-up – that had been chosen and isolated at random, just as the work, taken as a whole, was intended to project a picture of the world and everything in it. All the measurements, sound and film recordings, photographs as well as each finished relief taken together constituted the work. It is not concerned with constructing a language of metaphor but, more exactly, a language of curiosity and metonymy, in which the part stands for the whole. Furthermore, the events underscore the relationship between the laboratory system within which all Boyle and Hills's work was being made and the random structure which informed its creation. This relationship between object and event was one that occupied all artists whose work can be seen in the context of an evolving counterculture in terms of transmedia or multimedia investigations.

Although invited to present *Insects, Reptiles and Water Creatures* at DIAS, Boyle and Hills's sympathy for Metzger's concern with destruction was not clear-cut. Boyle's statement for the event shows that he was more involved with expressing a totality of existence in which creation and destruction coexisted, rather than in just isolating destruction:[37]

I don't think I'm especially interested in 'destruction in art'. I'm interested in destruction as an aspect of everything. The intimations of violence and futility

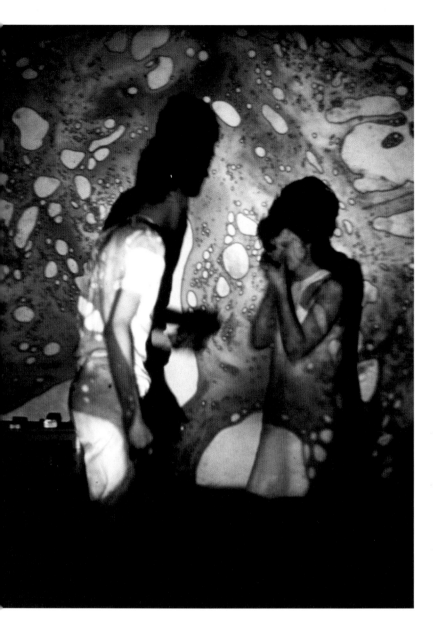

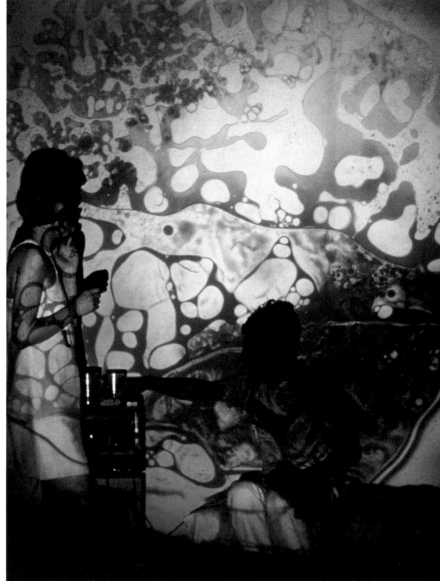

which figure so largely in the destruction movement attract my curiosity, but no more than, say pacifism, or the euphoria at a Conservative Party conference.

Things are created and survive only by the destruction of other things. In this sense, materially or formally, all art is destructive ... And I feel that my life and death are neither more nor less futile than the life and death of that tree or that fly ... we are going to take the opportunity provided in this theatre to indulge ourselves by watching and sharing with anyone who cares to stay Amoebas, Hydras, Daphnes Euglenas, Parameciums, Cyclops, Planarias, various larvae, wasps, sperm and anything else we find.

Originally we meant to go on all night ... so if the amoeba should decide to perform the ultimate act of auto-destruction, reproducing by splitting its self in two, or if we get particularly involved with any part of the presentation we may well watch it until the theatre closes, continuing the rest of the presentation some other time, aware that whether we watch or not the process of destruction / creation continues everywhere in our universe and in ourselves.[38]

These creatures were gathered from a variety of sources and then examined and projected alive using adapted slide and micro-projectors alongside an amplified soundtrack. The tiny creatures, worms and fish, would be projected, isolated from their habitat, and then shown greatly enlarged, swimming, swarming and squirming on screen, revealing that the process of life on all levels was one of 'destruction / creation'. This was put into high relief when a chamber of wasps was being projected as part of the event. The chamber's cooling system sprung a leak and as it filled up with water, the wasps started to fight each other to stay alive and away from the rising water level. As Boyle later related this event, 'Their mortal struggles and the entire process of drowning could be seen in enormously enlarged detail on the screen. It was a terrible spectacle.' Turning off the projectors or releasing the wasps would not have saved them, and 'because he was also aware that at the same moment everywhere in the world millions of other insects were dying a terrible death by being eaten by birds, poisoned by insecticides, caught by spiders, he let it continue. "So we watched till the end when they were all dead. And it was horrible."'[39]

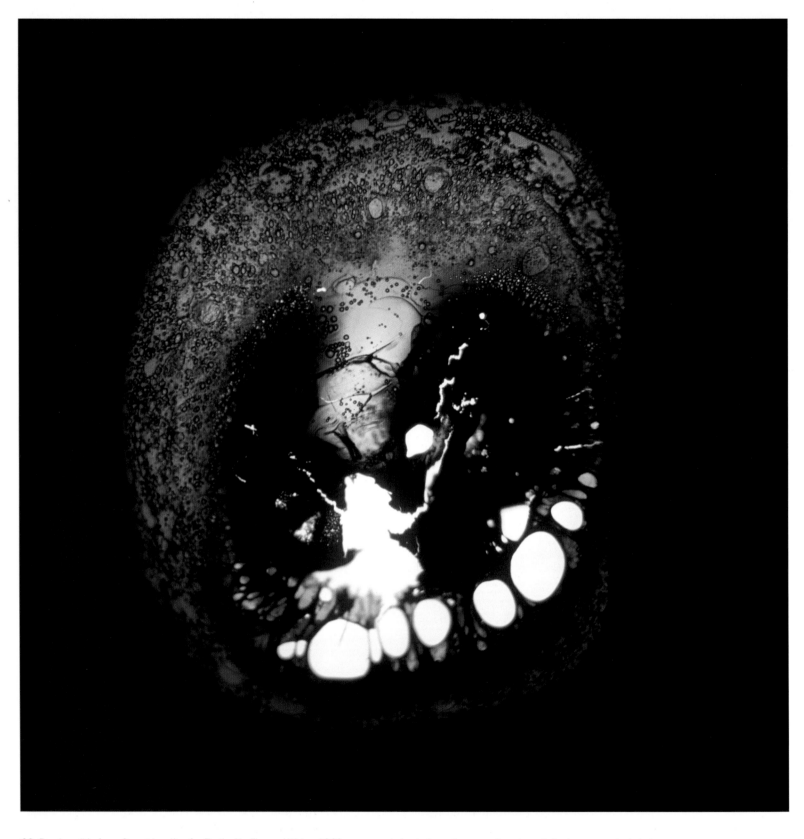

68 Burning slide from *Son et Lumière for Earth, Air, Fire and Water*, 1966. This event concerned physical and chemical change. Boyle and Hills had small glass containers made to fit their projectors so they could project chemical and physical reactions greatly enlarged. Performances included evaporation, corrosion, crystallisation, effervescence, combustion and disintegration.

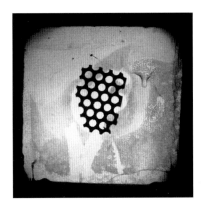 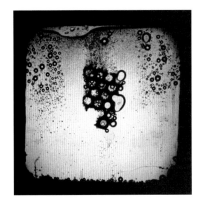 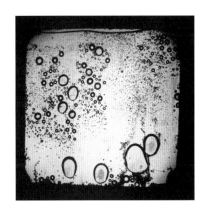

69–71 Zinc being destroyed by acid in *Son et Lumière for Earth, Air, Fire and Water*, 1966

For the closing event at DIAS, Boyle and Hills had collected portrait slides of all the participants in the symposium and the accompanying events (the symposium itself lasted three days, within a month-long programme of events). These portraits were then projected and incinerated so that one after the other all the Destruction artists were themselves destroyed on screen. This technique of projecting slides as they burnt had been one of the earliest that Boyle and Hills had adopted in 1962/3 while experimenting with the projection process. Boyle has described these early burns as providing 'surrealistic/pseudo-revolutionary' images – the slides which were burnt were commercially available slides of Beefeaters at the Tower of London, the Queen, Buckingham Palace, or the Trooping of the Colour. By 1966 such burns were more routinely made with fragments of black film which gave a much more spectacular and abstract effect. Nevertheless, by choosing to burn images of the DIAS participants (themselves included), Boyle and Hills were not only throwing the issue of destruction literally back in their faces, but also criticising the position that the personality of the individual artist was adopting within the presentation of such time-based work. This was a situation that Boyle and Hills's evolving philosophy could not accept. Where their first *Son et Lumière for Earth, Air, Fire and Water* harnessed everything in terms of the fundamental elements, and the second in the series *Son et Lumière for Insects, Reptiles and Water Creatures* represented everything that lives (creatures of the air, earth and water), so the third event in the series – *Son et Lumière for Bodily Fluids and Functions* – emphasised that 'we are part of that "everything" as well and we shouldn't exclude ourselves from it'. In moving from the world to humanity, Boyle and Hills's events were to culminate in *Requiem for an Unknown Citizen*, 1968–71, which they envisaged would 'star the entire human race in their conscious and unconscious aspect and their physical and social condition'.[40] *Requiem for an Unknown Citizen*, which was presented on just two occasions (both in Rotterdam in 1971), underlined that it was not only individual phenomena that were being isolated and examined in Boyle and Hills's work, it was also the relationships between things.

After DIAS, in November 1966, Boyle and Hills founded the Sensual Laboratory (alternatively known as Sense Lab) as an umbrella company for their event-based activities, and within a matter of months they also fell under the same management as Jimi Hendrix and Soft Machine. The Sensual Laboratory continued the public showings of the *Son et Lumière* series with performances of *Earth, Air, Fire and Water* at the first night of the UFO Club in London (23 December) and with *Bodily Fluids* in Liverpool (10 and 11 January) [**66–7**] and then in Bristol (10 February) and at the Cochrane

Theatre in London (first week in March). The events in Liverpool and Bristol accompanied presentations of earth studies at the Bluecoat Gallery and the Bristol Arts Centre that had been organised for Boyle and Hills by Dunbar. The inclusion of the *Son et Lumière* events again demonstrated that in terms of the creation of a total artwork, the objects were no more important than the events, and that both aimed to stimulate a complete sensory reaction in the audience. Jasia Reichardt explained at the time, 'the spectator is invited to look at something in a way to which he is not accustomed – to respond to and to examine nature in a critical way'.[41]

Earth, Air, Fire and Water reflected Boyle and Hills's earliest light-projection experiments in which the elements were heated so that their changing properties could be examined on a large scale. Subjects and materials they treated included: the melting of ice to the boiling of water; the burning of various types of plastics and other substances; the movement of air through liquids; evaporation; chemical reactions such as crystallisation or corrosion on elements standing for earth such as zinc [**69–71**]; the mixing of different chemicals to induce certain effects. These visual effects were shown alongside actual and recorded amplified sound. However, *Bodily Fluids and Functions* went further even than *Insects, Reptiles and Water Creatures* (which had replaced inanimate elements with living nature). This was not because the fluids (catarrh, snot, saliva, earwax, tears, urine, sweat, blood, sperm, gastric juices, vomit) were extracted from Boyle and Hills, or because the amplified sound was live, or even because one sequence called for a copulating couple [**72**]. Rather, it was because there was a strong link between the choice of fluids to be removed, the action of extraction, and the visual projection, all alongside the amplification of the sounds that accompanied extraction. The realisation could be both startling and beautiful: seeing tears crystallise or millions of sperm suddenly come into focus wriggling across the giant screen.[42]

The focus of these events was on the projected images and accompanying sound rather than on the action itself, although this could be both heard and seen by the audience. In character, however, they were very different from the superficially similar body art performances that were being enacted on the Continent, most notably by the Viennese Actionists (who had performed outside Austria for the first time at DIAS). Their aim was to achieve catharsis by initially encouraging feelings of shock and disgust in the audience. However, Boyle and Hills were driven by a desire to show everything in a way that negated the possibility of a cult of personality. Where they might make use of event elements that could shock (a copulating couple, or vomiting for instance), and that might induce catharsis in the viewer, they differed from

53

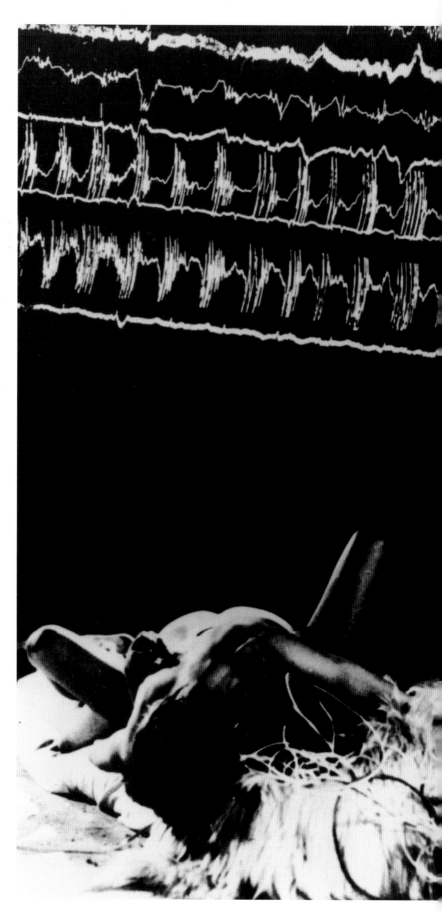

72 Couple having intercourse in the Roundhouse production of *Son et Lumière for Bodily Fluids and Functions*, 1967. Their heartbeats and brain rhythms were projected onto a thirty foot screen throughout the performance.

54

the Viennese artists by presenting these elements in the context of a larger whole. The element of shock in the Viennese work was presented through a heavily ritualised structure that also served to encourage a cult of personality around the artists. This was not the case with Boyle and Hills, and this would be made clear by their concern for social structures within *Requiem for an Unknown Citizen* – an event structured around the presentation of unknown people whose 'acting out' of slices of their lives is put under the microscope. Their works were also the result of an ambitious sense of curiosity, as Boyle later described the sperm sequence in *Bodily Fluids and Functions*:

Everyone that was there seemed to find the experience very moving. The dirt and the mystique, the secretness and the sacredness were washed away. For me, provided the participants are free, all sexual manifestations are marvellous and from that moment on I knew that it doesn't matter whether people are guilty or lascivious or pure or perverse or promiscuous the mechanism that drives them is unbelievably complex and ecstatically beautiful.[43]

Such sentiments reflected the milieu Boyle and Hills were now moving in. From December 1966 John Hopkins (Hoppy), a close friend of Miles, managed the UFO club, which occurred every Friday evening from 10.30pm until dawn the following day (the first two club nights were called 'UFO presents Night Tripper'[44]) at an Irish dance club on Tottenham Court Road called the Blarney. UFO (Unidentified Flying Object or Unlimited Freak Out, depending on your viewpoint) was set up as a fundraiser for *IT* for which Hoppy was on the editorial board, although the only people who ever made any money were the hippy drug dealers (there was no drink licence). As such, UFO soon became one of the main centres and meeting places of the London underground, just as *IT* could be seen as its parish magazine. It had evolved out of an earlier club run by Hoppy at the All Saints Church Hall in Notting Hill the previous year, as a fundraiser for the Notting Hill Free School in Powis Terrace of which Hoppy was co-organiser. The club at the All Saints Church Hall is now best known as a proving ground for the resident band, the Pink Floyd, and its light shows that they evolved and which echoed the process which had been developed by Boyle and Hills. Almost four months after the closure of the club on 19 November 1966, Hoppy described how the light show at the All Saints Church Hall had evolved following the arrival of two friends of his from Timothy Leary's centre at Millbrook:

One evening, Joel and Toni Brown, an American couple, brought their slide projector and gassed everyone by putting on a light show with the music. When the Browns returned to Millbrook NY, Jack Bracelin took over and

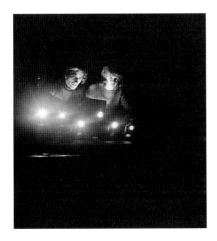

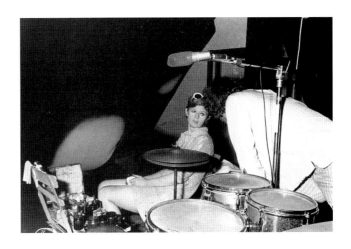

73 Mark Boyle and Joan Hills with light projections, *c*.1967

74 Joan with one of the members of Soft Machine, Saint-Aygulf, 1967

began to develop his own light show (which is now one of the attractions of the UFO allnighter) … by early November the Floyd had signed a management contract with Andrew King and Peter Jenner and had acquired 17-year-old Jo Gannon to work with their lights. Gannon quickly caught on and produced what is the basis of their light show now. Two projectors from the back of the hall illuminate the stage with multicoloured liquid moving slides. Occasionally, coloured lights flash on stage, or a movie is shown … Just before Christmas UFO opened on Friday nights with the Pink Floyd as main attraction. Hundred-watt amplifiers, ear-splitting vibrations, liquid light that takes your breath away.[45]

It is important to remember that until December 1966 Boyle and Hills only presented their light shows within an art context such as at the ICA or at one of their own events. Nevertheless, since their Indica Gallery presentation their work was being recognised more and more outside the art world. Hoppy, for one, had attended many of their light shows at the ICA and elsewhere, where they had sometimes accompanied experimental musicians such as Cornelius Cardew; Hoppy would not have missed the similarity between the Browns' psychedelic light shows and Boyle and Hills's more complex and developed light shows. As a result his invitation in December 1966 to Boyle and Hills to present their light shows at UFO has the ring of inevitability about it.

UFO was marked by the wide range of activities taking place. Apart from the bands appearing on the main stage, Bob Cobbing and David Curtis screened films, and as Miles recalls, 'each week there were poetry readings, jugglers and David Mairowitz acting out the latest part of his interminable dramatic production, *The Plight of the Erogenius*. In the early days the music was almost incidental, the club being more important as a social event. It was the village pump.'[46] In the centre of the space was a control tower from which the light shows and film screenings were operated, poetry read and records played between each group. The only footage to survive of Boyle and Hills's light shows at UFO is a fragment showing Soft Machine performing a poem for Hoppy on 2 June 1967, after he had been sentenced to prison for nine months for the possession of marijuana. Although this gives a taste of UFO's interior and the effect Boyle and Hills's light shows could have, it should be set beside Miles's description of an evening at the club in May 1967 – Procul Harum and Soft Machine were on the bill and Paul McCartney played an acetate of the recently recorded, but unreleased song, *Sgt Pepper's Lonely Hearts Club Band* – which gives a graphic insight into how Boyle and Hills's light show worked in this setting. During Soft Machine's set, Miles describes how the keyboard player, Mike Ratledge, 'hit a long discord and

held it. Boyle quickly poured some acid on a piece of perforated zinc in front of the projector and, as Mike held the discord, the acid melted the zinc into terrible distorted shapes, which were projected all over the band. At the end of their set they were joined on stage by Jimi Hendrix for a jam session.'[47]

A few months after UFO had closed in Tottenham Court Road, Peter Fryer's 'A Map of the Underground' appeared in *Encounter*. Not only did this position Miles at Indica and Hoppy at UFO at the centre of the underground (even though Hoppy was in prison), Fryer also categorically stated that 'the only original art form associated with the underground is the light-show, in which static and moving abstract coloured images are projected on screens, musicians and dancers … Mark Boyle … was the pioneer of this art form in Britain, and there are now at least twenty-three separate light-show specialists from whom equipment and operators may be hired.'[48] Boyle and Hills had been invited to make light projections at UFO on its opening night on 23 December 1966 – probably a presentation of *Earth, Air, Fire and Water*.[49] Following this presentation Hoppy asked Boyle and Hills if they could continue projecting all night. One of the bands they projected over was Soft Machine who, following the opening, at first alternated every other week with the Pink Floyd as house band. The projections were such a success that Hoppy later asked if Boyle and Hills could do their light projections every Friday evening at UFO. Not long after they were asked by Soft Machine if they could also provide light projections exclusively for them, and to these ends joined the band's management company.[50]

Until June, Boyle and Hills not only provided a light show at UFO between each band's set (and sometimes for each band, although increasingly many bands were beginning to get their own light shows anyway), but also supplied projections for Soft Machine concerts about ten times each month at other venues in London. These included the Speakeasy, Middle Earth, the Roundhouse, the 14 Hour Technicolour Dream (another fundraiser for *IT* at Alexandra Palace on 29 April),[51] the Theatre Royal at Stratford East, the LSE, as well as at Padworth Hall in Padworth, the College of Technology in Leicester, Canterbury Technical College and Bradford University.[52] This was a punishing schedule, but Boyle and Hills were not alone in providing light shows. Going hand in hand with the growing commercialisation of the underground from the late spring of 1967 (such as the creation of the Electric Garden – a supposedly hippy club that served alcohol – as a kind of copycat UFO, or Joe Boyd's increasingly commercial stewardship of UFO first at the Blarney and then, in September and October, at the Roundhouse) there was an avalanche of light shows hitting the scene in London. A compendious (and anonymously written) article published in *IT* in June 1967

75 Soft Machine and liquid light environment by
Mark Boyle and Joan Hills, 1967

76 Projection with Soft Machine, at the UFO club,
London, May 1967

Opposite: **77** Aldis projection from *Son et
Lumière for Earth, Air, Fire and Water*, 1966

catalogued the extent to which this situation had changed in just a matter of
months.[53] Although it stated that 'Mark Boyle is always doing a show at the
nearest freak-out, it is worth saying that he has been working and develop-
ing with slide projections over three years now', and that since 'Mark Boyle
started doing his light shows in UFO … everything just happened,' the focus
of the article was on the range of other practitioners and the equipment they
used. This included Bracelin's Fiveacre Productions at Happening 44 in 44
Gerrard Street, Supernova Lotus (who projected using 'evolving jelly'), the
Electric Garden light show ('twenty channel dimmer board, twenty-three
spotlights, three 16mm cine-projectors, twelve auto-dry slide projectors, two
liquid slide projectors, two overhead projectors') Keith Albarn and Partners
(the Kingly St Environment Co-op – 'mind-blowing total environment
organisers', with whom Boyle and Hills would work in July in France), The
Overheads (resident at the Roundhouse) and Peter Wynne Wilson (then
producing the light show for the Pink Floyd). Despite this competition,
Boyle and Hills's light projections were still recognised as among the best
and most innovative, and what is remarkable, given the frenetic pace of
activity at this time, throughout 1967 they were also evolving new projection
events away from the UFO circuit, not only with Soft Machine, but also with
the dancer, Graziella Martinez [**78–81**], as well as continuing to develop
their earth studies.

At the beginning of July, Boyle and Hills were providing the light projec-
tion for Soft Machine concerts in a translucent white plastic pavilion de-
signed by Keith Albarn at a festival on the beach at Saint-Aygulf in the south
of France. The money ran out after five performances. Although the so-
called Discotheque Interplay – beach, plastic pavilion, light projection and
Soft Machine – was a success, the festival itself was not and though it was
supposed to last for two months, Boyle and Hills along with Soft Machine
were stranded with no tickets to get home. After performing at parties for
Caroll Baker and Barclay Records, Boyle made contact with Jean-Jacques
Lebel who was producing Picasso's play *Desire Caught by the Tail* for two
weeks at his Festival of Free Theatre at nearby St Tropez. Boyle secured an
invitation for them all to perform on the same bill as Picasso's short one-act
play, as well as at venues, such as the Voom Voom Club in St Tropez. After
this, they all returned to Britain by 16 August.

In September, Boyle and Hills were performing light projections for Soft
Machine [**75–6**], and Martinez collaborated at the Edinburgh Festival for
their event *Lullaby for Catatonics*, a development from Martinez's perform-
ance alongside *Bodily Fluids and Functions*. At the same time, Boyle and Hills
were also doing light projections for Soft Machine accompanying a staging

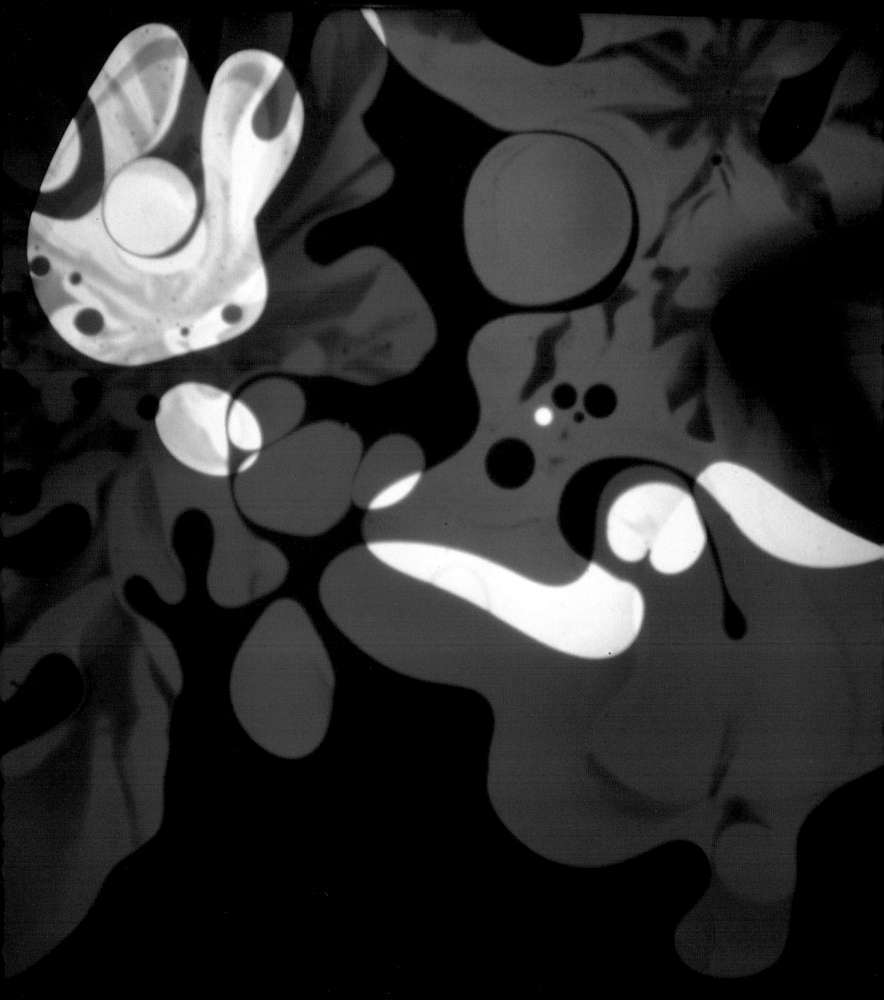

78 Graziella Martinez performing in *Lullaby for Catatonics*, a co-production with Soft Machine, Mark Boyle and Joan Hills, at the Barrie Hall, Edinburgh Festival, 1967.

Opposite: **79–81** Stills from *Studies towards an experiment into the Structure of Dreams*, 1967/8, a collaboration with the dancer Graziella Martinez which ran for over seventy performances at the Arts Lab in London.

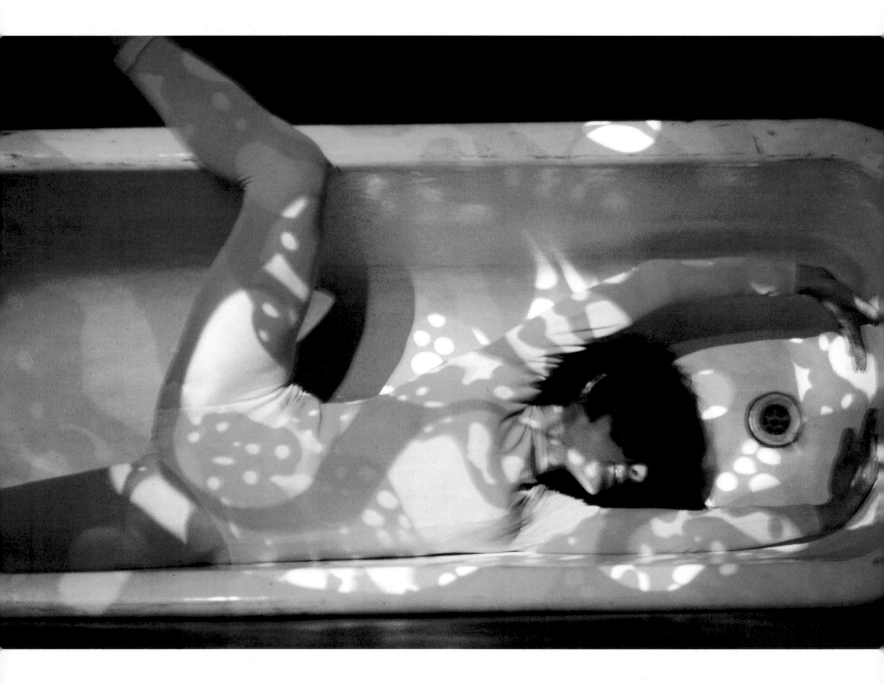

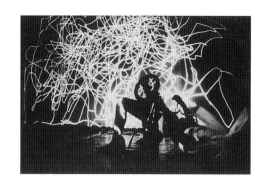

of *Ubu in Chains*. After reprising *Lullaby for Catatonics* at the Paris Biennale (where they won a prize for painting), Boyle and Hills with Martinez produced *Studies Towards an Experiment into the Structure of Dreams* at the London Arts Lab, which had been founded by Jim Haynes in July 1967 and, once UFO had closed in October, Arts Lab quickly became the central meeting place for the London underground. As Ronald Bryden remembered it the following year, after it had closed, 'It was simply a place: an old warehouse at the top of Drury Lane where Jim Haynes encouraged people to come, act, paint, talk, dance, drink coffee, watch or show films, or just fall asleep on the mattress-carpeted floor of the cinema in the basement.'[54] *Studies Towards an Experiment into the Structure of Dreams* ran for seventy performances that winter and was supposed to change as the performers' dreams and consciousness changed, but instead each performance of the event remained the same.[55] At the end of January, Boyle and Hills flew to San Francisco with Soft Machine to be the opening act for a ten-week tour of America with Jimi Hendrix.[56]

Just as Boyle and Hills's assemblages and events were distinct from the American Happenings movement of Allan Kaprow, Al Hansen, George Brecht and Dick Higgins, so too were their light projections very different from those found in America. The Americans, notably Glen McKay at the Winterland Ballroom in San Francisco, ordered the light effects to the pulse of the music, 'based on the overhead projector and manipulation of saucer shaped discs which had the fluids in between them. By the pressure of your thumb on the top one, you could squeeze out the fluids until they made these swirling, wonderful patterns.'[57] At the Winterland, near the beginning of the tour, they split the screen so that on one side McKay projected in the west coast manner and on the other side Boyle and Hills made their light projection. Rather than project to the beat of the band, Boyle recalled that 'we just set the chemical reaction going. But somehow it always seemed to synchronise because there was always something happening on the screen. Or your mind made it synchronise. So I suppose in Europe we always thought that it was more exciting than when you were forcing it – your head was forcing the synchronisation and making it happen.'[58] With this synaesthetic light show, Boyle and Hills were again throwing the performance back to the audience, letting them find their own location between the tactile psychedelic sound of Soft Machine and the accompanying light show. Its relationship to the music reveal the same 'patterns that form continuously and dissolve' that 'are not just patterns of line shape colour texture, but patterns of experience', which Boyle had earlier alluded to in his statement accompanying the abortive series of events at the ICA in 1965.

One aspect of this overlapping of senses was more directly addressed in their events at their 1969 ICA exhibition of surface presentations. This exhibition included a spectacular 360° screening of special high speed slow-motion film of *Earth, Air, Fire and Water*, and the first presentation of *Body Work* which made an attempt to present the surface of the human body in the same way as the surface of earth. However, it also included a *Taste / Sight* event in which a white food, with a different tasting food projected onto it, was offered to the audience to eat; and a *Smell / Taste* event in which a strong food or drink aromatic was placed on a hot plate while a completely different food or drink was offered to the audience. Such a dislocation of the senses was a constant feature of their work: from the earth studies by which land was isolated, replicated and placed on a vertical plane, to the slow-motion film of water or fire. As Boyle explains, 'We only survive because we have a number of filters in place which stop us from feeling the full force of the environment that surrounds us' – filters that Boyle and Hills identify and then re-order and expose through their work.

For the next three years, until its eventual realisation in Rotterdam in 1971 as *Requiem for an Unknown Citizen*,[59] [**82–3**] Boyle and Hills worked around the concept of the 'Multi Human Being' as a means of studying people as social animals and society as a single organism. Boyle and Hills went to randomly selected places where social situations, which had themselves been randomly selected, were filmed at two frames per second and also recorded. The selection was carried out by reclassifying the London Yellow Pages with each entry being allocated a place within the nervous system, the reproductive system, the digestive system and so on. For Boyle this was a 'natural progression from *Bodily Fluids and Functions* to something that indicated an interest in society as a whole – something to teach our brains to be open to everything', and was intended to be a full summation of their earlier events. The resulting event included complete presentations of all three works in the *Son et Lumière* series alongside actions being performed in real time against projections of the films of the depicted events in high speed, and sound recordings made in connection with this charting of the 'multi-cellular animal, London'. The layering of reference (the world, the creatures of the world, the individual person as a sample of humanity and social relations) and representation (live presentation, sound, film and slide projection) draw together aspects of previous events. The cumulative effect of their random selections for *Requiem for an Unknown Citizen*, for their *Son et Lumière* or other events, as well as their gallery presentations, all adds up to the construction of an index not just of the fabric that surrounds us all, but has the power to provide us with a manual on how we might see and start to understand that world for ourselves.

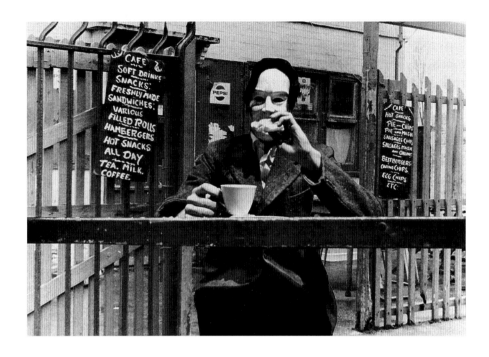

'There's trouble down at our place today, 2 doors down you know. They've got a meter in the hall, the gas is off in my room see. All those buggars have been thieving the money out of the gas meters so they've turned it off. They can't get into my room I've got a yale lock and a mortice on and all. I caretake you see. They've been thieving it now, and I had to pay and I told them I wasn't going to do it no more so I said the easy way was to come and cut off the gas and now I know how they do it an all – you know where they lock it the little thing that tells you the meters, how much you got, well they lift that out, unscrew that put it back see no gas can go even if you put money on you've got to phone the gas board to do it, he told me, he says, I could do it, I could do it with me key like, if he gave me a key, but I haven't got a key. Now he asked me, he says, if you got a key and I says I haven't got a key I was ready to do it but they don't want me so now they've got to phone the gas board. I can put it on for them. It's easy to do it. There's a married couple, a married couple next door and they keep an eye on things. They're alright. I leave my key with them. I leave one of the keys with them. See if they want, see she hasn't got a cooker in there, she's only a little grill see. and I've a big oven, cook anything and she keeps an eye on it, handy, so I let her use the cooker any time she wants to use it.'

82 Café scene from *Requiem for an Unknown Citizen*, De Lantaren Theatre, Rotterdam, 1971. *Requiem* was a study of people as social animals and society as a single organism, the 'multi-cellular animal, London'.

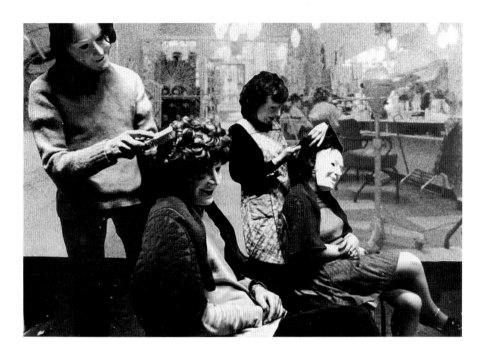

'Take all the petals down there. Um. One shampoo and soapless and give madam a couple of new towels and take the cape off, and make sure she doesn't get wet. Did you go to East Africa this year? Ah yes. I went to er, I went to Mombassa for a fortnight. Oh lovely, for a holiday? Mm yra honeymoon. Oh was it nice? Mm mm fabulous mm. Well these photographs are lovely. Mmm pardon, oh aren't they lovely yeas aren't they yes really lovely. Yes, yes they are. I feel proud of that, yes, it's probably, yes, it's probably only a question of, a question of use though you know. Umm. If I'd have had the tripod with me I'd use it but when you're travelling by air it's umm you know you know you're limited um. Um I suppose you are. How much does it cost yra if you want to go out and shoot say, say if you want to shoot an elephant you probably have to pay I don't know how much, I mean I don't know oh huh about £500 for a licence. For a licence. Well the rarer the animal the more the licence costs. I mean you get a few nice leopard skins, bring you in about £750 each. Yes that's for the skins yes, Lord what a lot of money. Do you think you will go there again. Mm I'd like to terribly expensive though, yeah next time I might go for three whole weeks three, mm yes super. Did you have to change on the flights on the way out?'

83 Hairdresser scene from *Requiem for an Unknown Citizen*, De Lantaren Theatre, Rotterdam, 1971. Masked actors reproduced in real time events shown at high speed on the back projection screen behind them, whilst the recorded conversation was played.

84 Map used for the random selection of sites for the *World Series*, 1968–9. Digitally restored 2003.

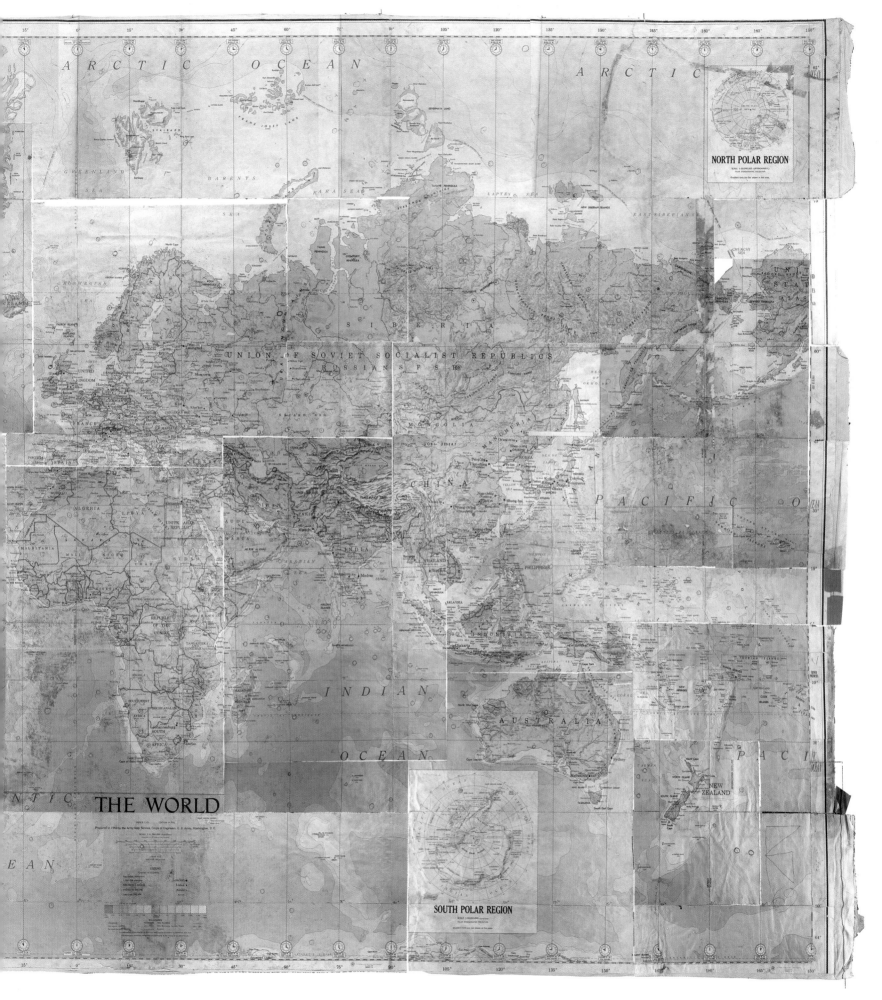

THE WORLD

SOUTH POLAR REGION

NORTH POLAR REGION

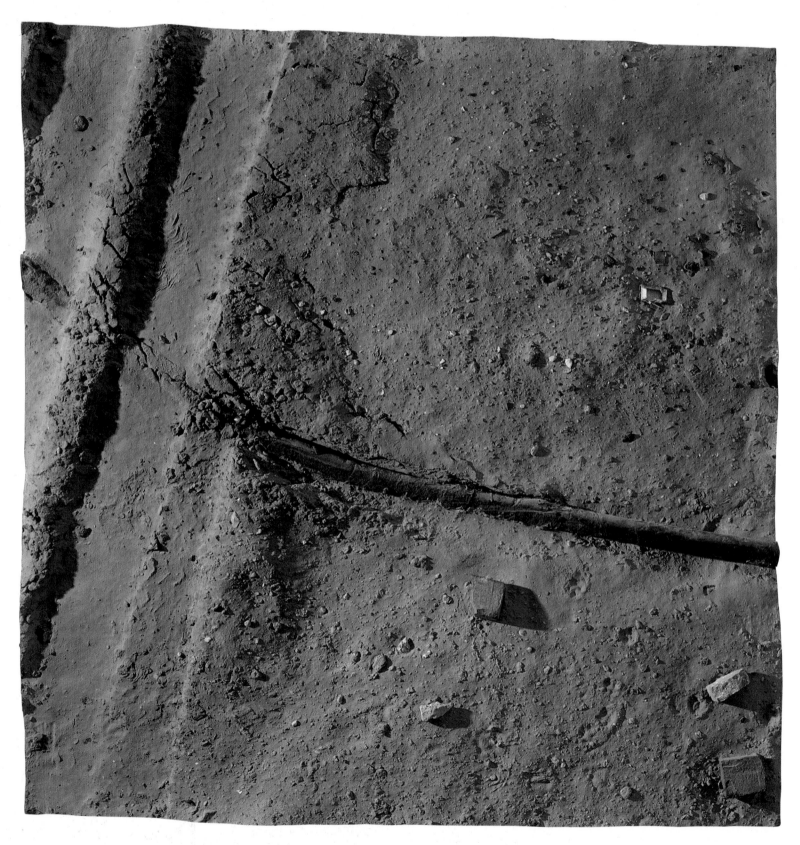

85 *The Hague Study, World Series*, 1970
Mixed media, resin and fibreglass · 183 x 183 · Gemeentemuseum, The Hague

86 *Snow Study, near Bygdin, Ostre Slidre Valley, Norway, World Series,* 1972
Mixed media, resin and fibreglass · 62.5 x 94.5 · Private collection

87 *Concrete Pavement Study, London Series*, 1973
Mixed media, resin and fibreglass · 183 x 183 · Collection Mrs Keller, courtesy Staatsgalerie Stuttgart

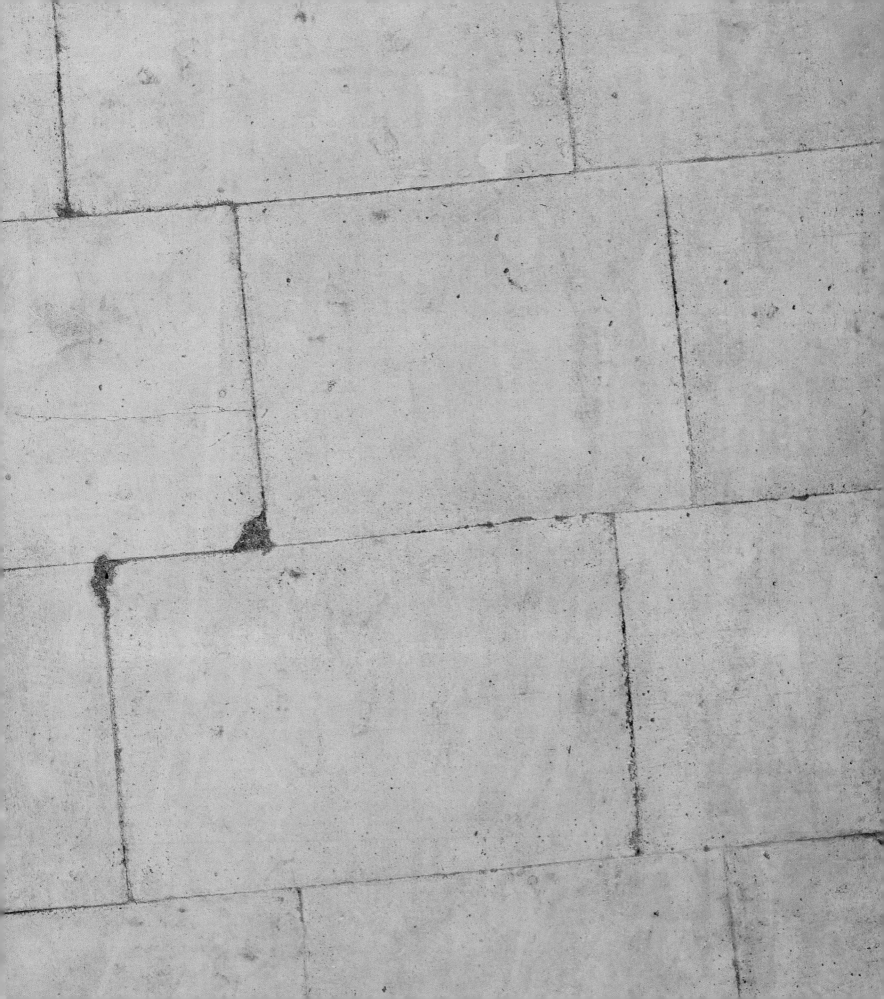

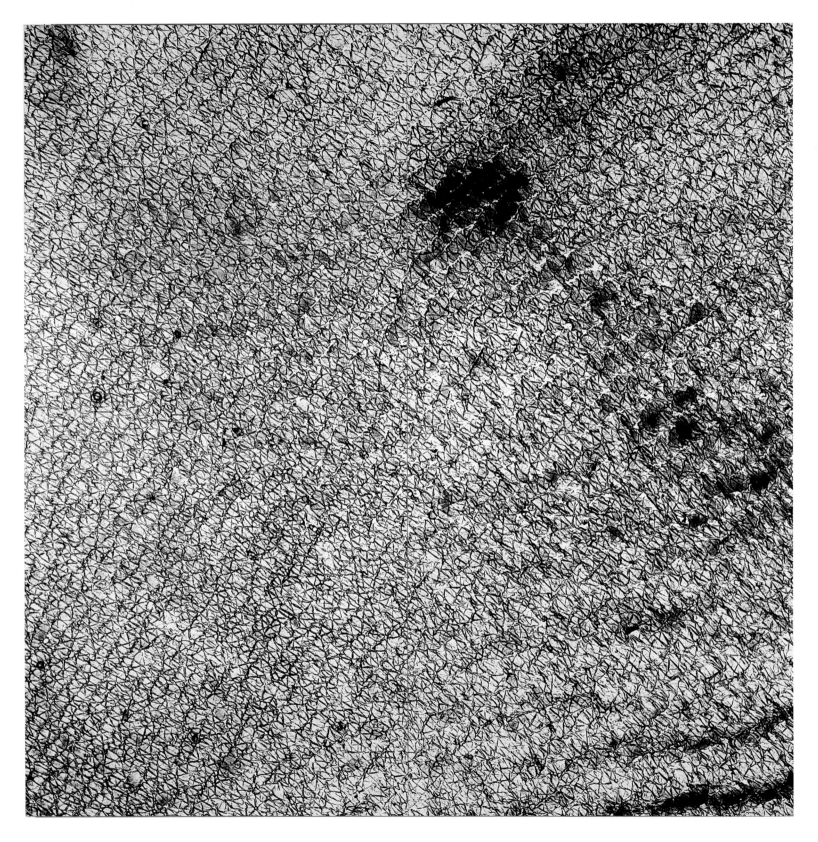

88 *Right Arm Study, Skin Series, No.8,* 1973
Cytogram · 183 x 183 · Scottish National Gallery of Modern Art, Edinburgh

89 *Left Arm Study, Skin Series, No.9*, 1973
Cytogram · 183 x 183 · Boyle Family collection

90 *Location Shot for Density Photograph at Shepherd's Bush Tube Station*
(Multi Human Being Series), 1971–8
Boyle Family collection

91 *Density Photograph at Shepherd's Bush Tube Station*
(Multi Human Being Series), 1971–8
Boyle Family collection

92 *Location Shot for Density Photograph at Street Crossing,*
Shepherd's Bush (Multi Human Being Series), 1971–8
Boyle Family collection

93 *Density Photograph at Street Crossing, Shepherd's Bush*
(Multi Human Being Series), 1971–8
Boyle Family collection

The *Multi Human Being Series* was an attempt to record the movement of people in
social situations. The density photographs indicated by colour differentiation the
degrees of concentration of people who passed by.

90

91

92

93

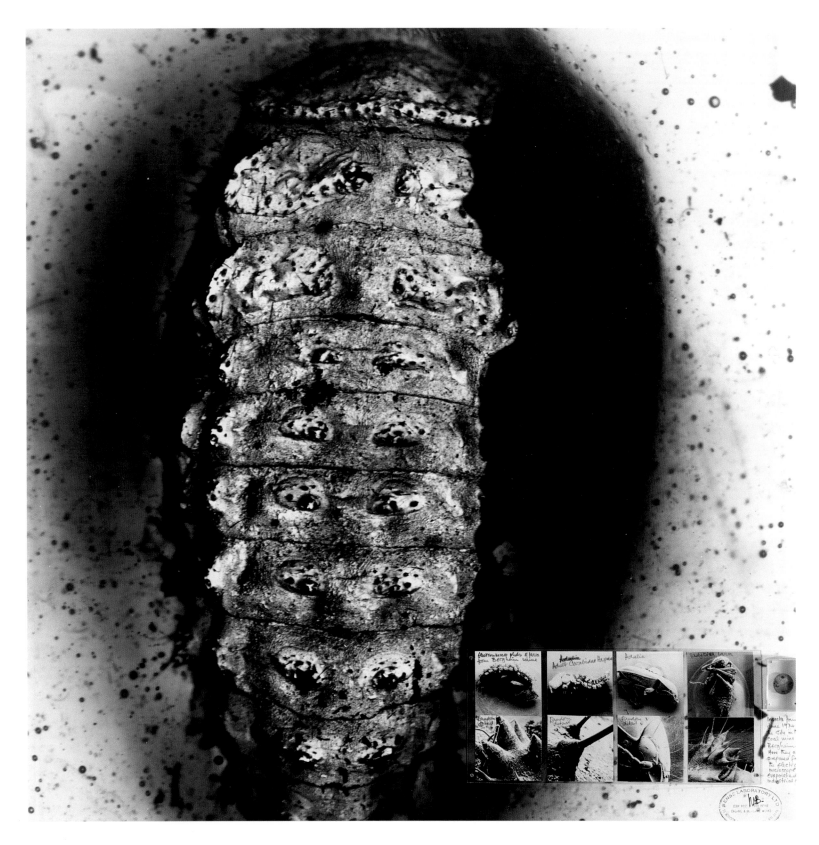

94 *Study of Animal Life: Bergheim Mine Study, World Series, 1974*
Electron microscope photograph, collage, insects · 122 x 122 · Graphische Sammlung Staatsgalerie Stuttgart, Sammlung Dr Rolf H. Krauss

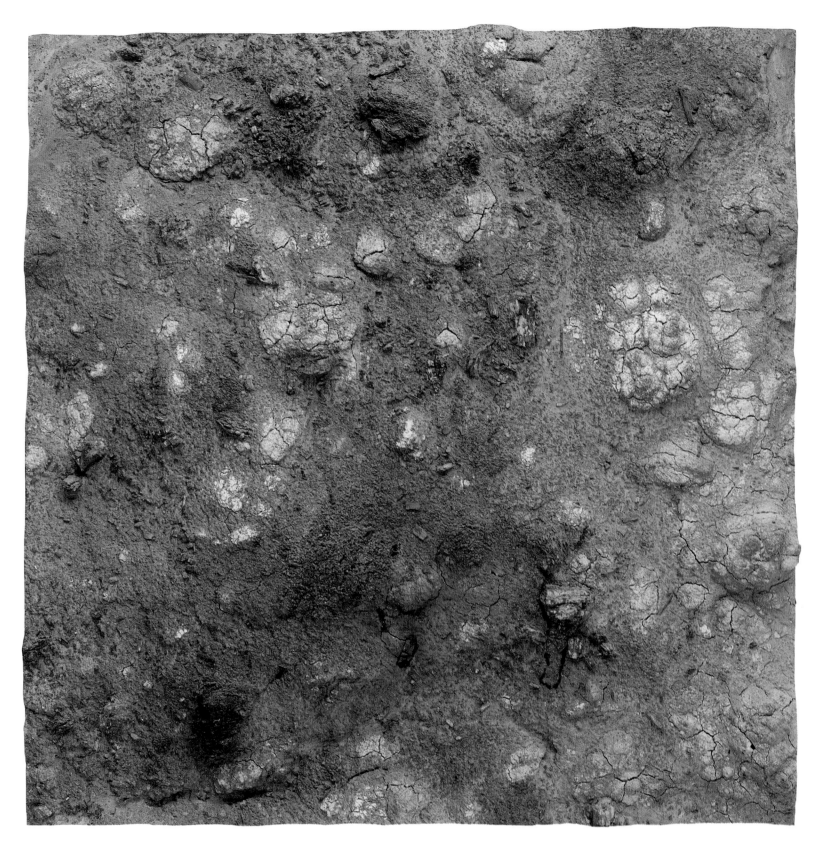

95 *Bergheim Mine Study, World Series*, 1974
Mixed media, resin and fibreglass · 183 x 183 · Collection Mrs Keller, courtesy Staatsgalerie Stuttgart

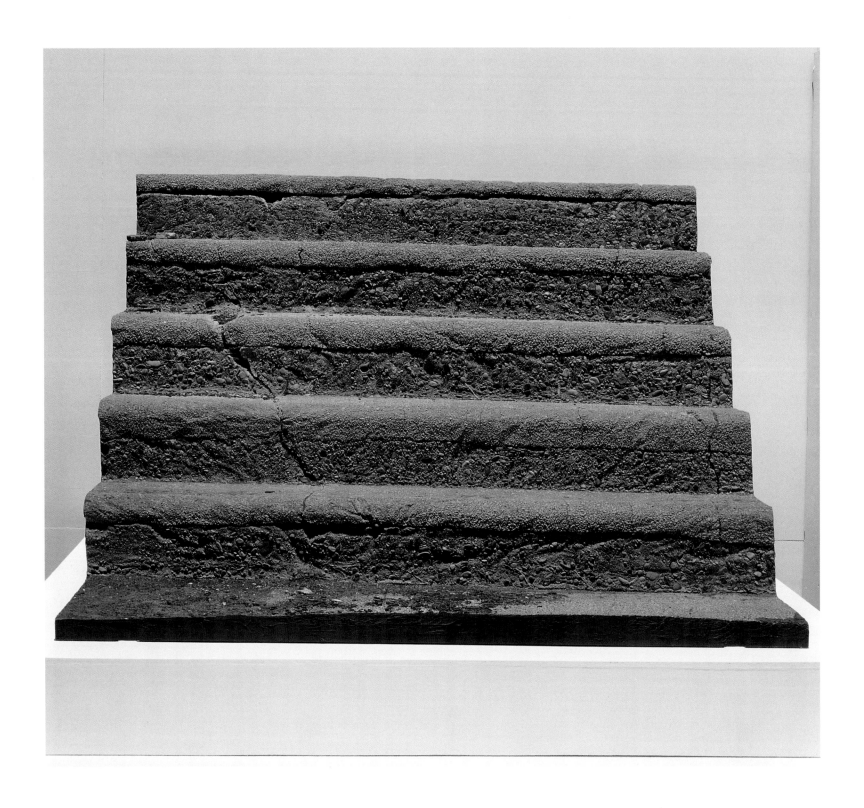

96 *Concrete Steps Study, Liverpool Series*, 1976
Mixed media, resin and fibreglass · 183 x 183 x 30 · Compton Verney House Trust (Peter Moores Foundation)

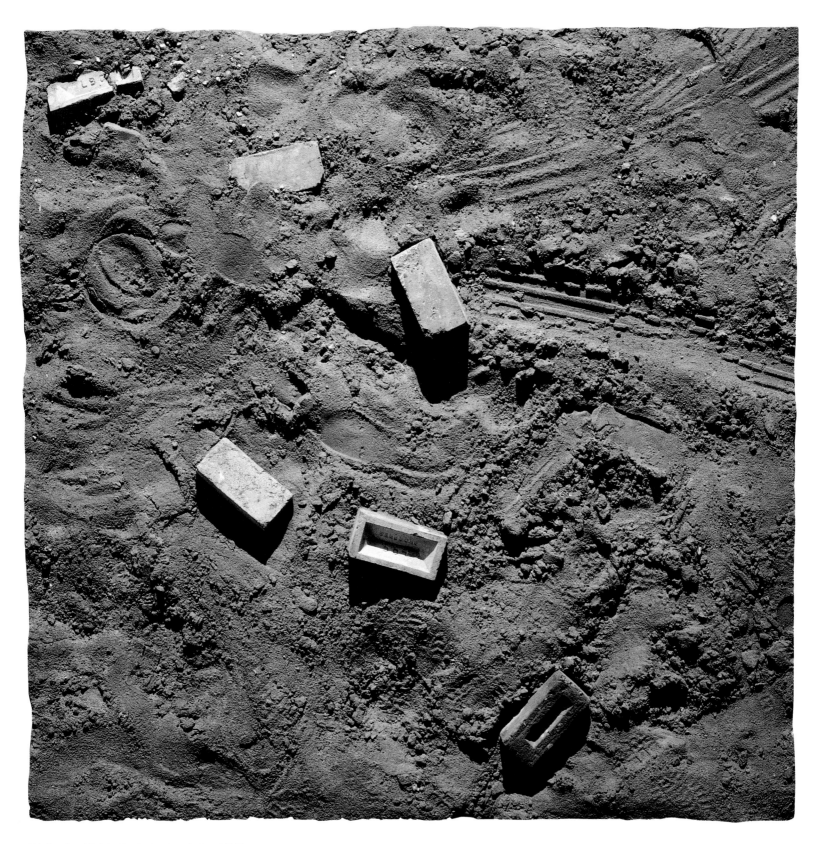

97 *Sand and Bricks Study, London Series*, 1976
Mixed media, resin and fibreglass · 183 x 183 · Henie-Onstad Kunstsenter, Høvikodden, Norway

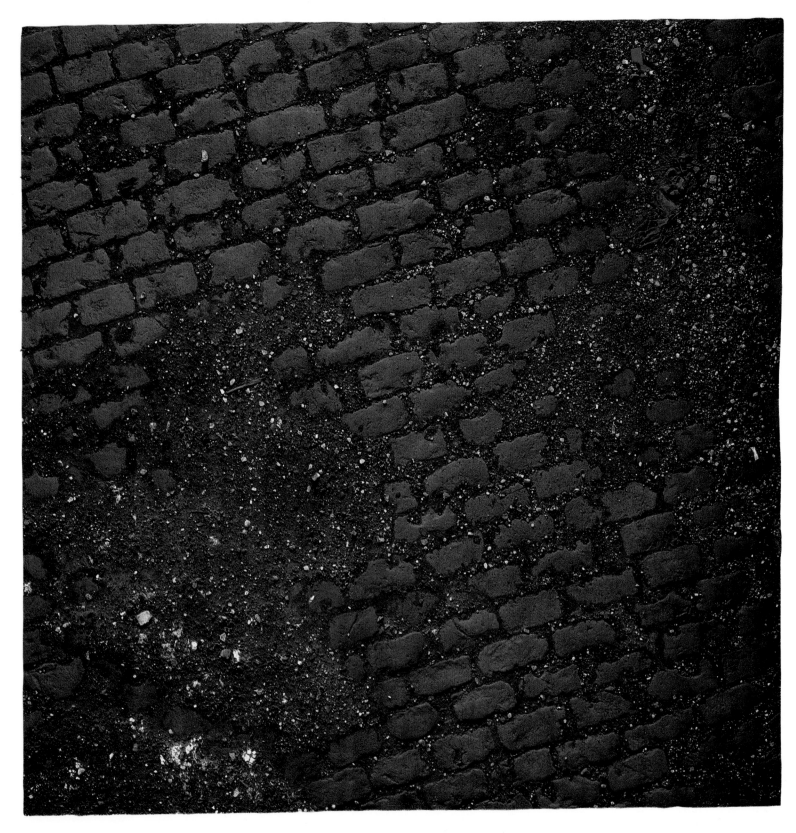

98 *Cobbles Study, Lorrypark Series,* 1976
Mixed media, resin and fibreglass · 183 x 183 · Private collection

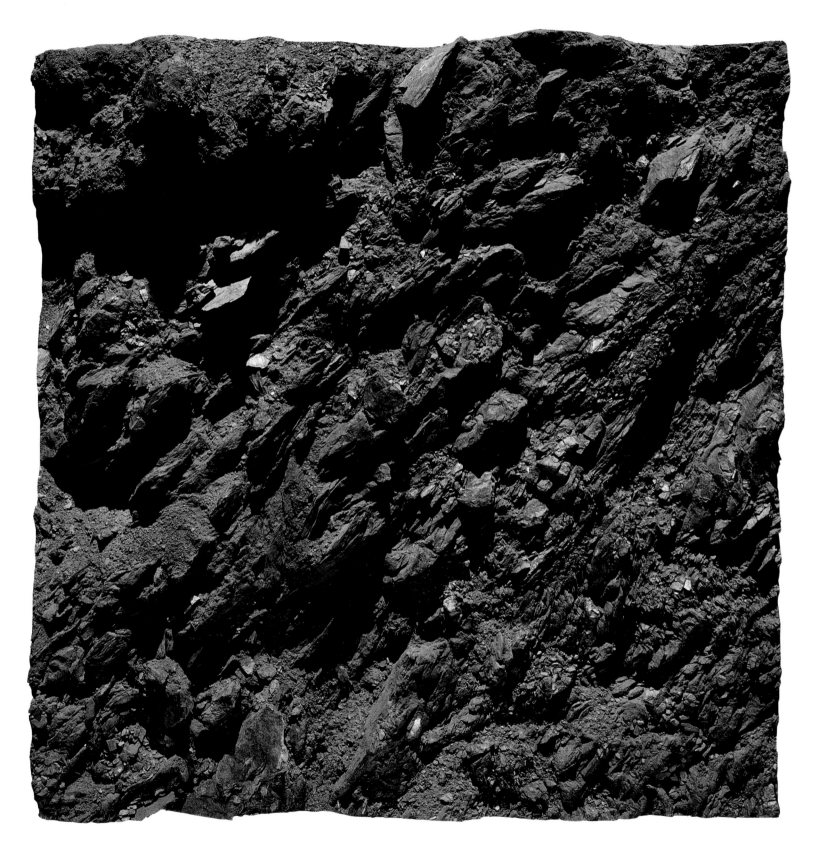

99 *Sardinia, Elemental Study (Brown Scarp), World Series*, 1978
Mixed media, resin and fibreglass · 183 x 183 · Boyle Family collection

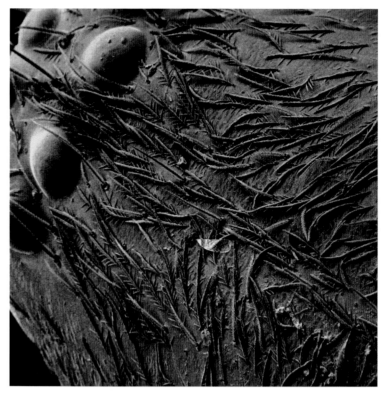
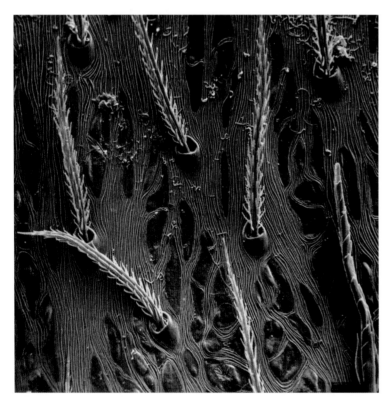
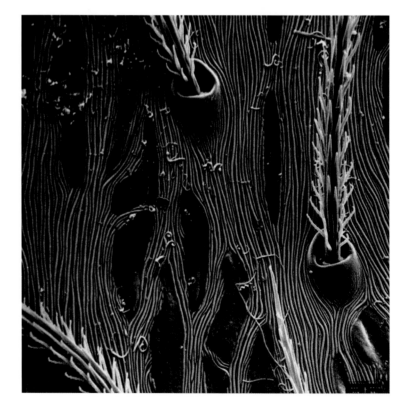

100 *Studies of a Spider (1–4), Swiss Site, World Series, 1978–9*
Electron microscope photographs · 70 x 70 · Kunstmuseum, Lucerne

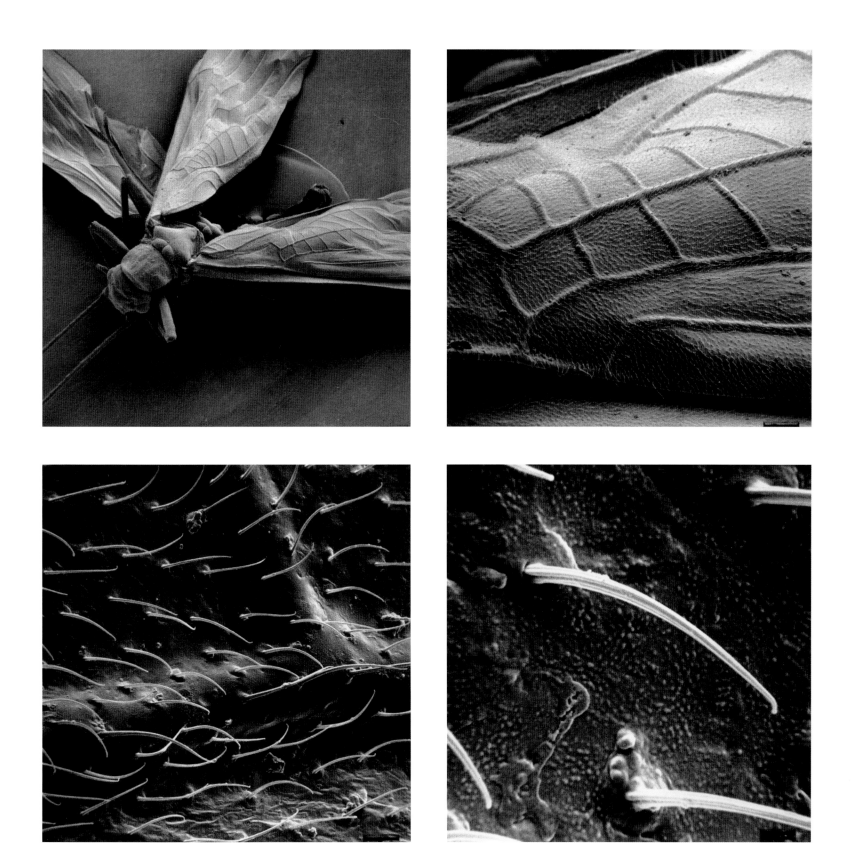

101 *Studies of a Winged Insect (1–4), Swiss Site, World Series*, 1978–9
Electron microscope photographs · 70 x 70 · Kunstmuseum, Lucerne

Old Habits of Looking, New Ways of Seeing The Paintings of Boyle Family

Bill Hare

I have tried to cut out of my work, any hint of originality, style, superimposed design, wit, elegance or significance. If any of these are to be discovered in the show then the credit belongs to the onlooker

MARK BOYLE, 1966

The desire to enter an idyllic 'brave new world' envisioned by Miranda in Shakespeare's *Tempest* has tantalised and enthralled the human memory and imagination since the dawn of civilised society. Such recurring yearnings have manifested themselves in many different religious, philosophical, scientific, political and especially artistic forms. To the classical eras these feelings have been expressed through the Arcadian pastoral. To romantic sensibilities they could only be fully satisfied by regaining the perceptive power of the 'innocent eye'. Now, in our modern technological, consumer age, we have become addicted to the lure of the primitive in all its various guises. Such edenic, utopian longings have undoubtedly been a powerful impulse to artistic creativity through the ages. Poets and artists have continually provided us with reassuring words and images to succour and protect us against our sense of loss and alienation in our hostile historical world. Yet should that really be the mission of art? Should artists be expected to knit cultural comfort blankets for a society that wishes to avoid and escape from the actual realities of its present situation? In truth, should we not try to forget 'the good old days' and focus on 'the bad new ones'?

On the face of it, Boyle Family's minutely accurate descriptions of our world for their on-going, and seemingly endless enterprise, *Journey to the Surface of the Earth*, would appear to resolve these contradictory roles of art between nostalgic reverie and contemporary responsibility. Their work, on the one hand, appears to give us back the lost innocence of uncontaminated vision, and on the other, presents us with a raw slice of the world that is as real and unmanipulated as could be possibly envisaged. When we look at and pour over these enthralling works it seems as if we can become like the entranced Miranda, who suddenly sees the world in a fresh, yet reassuring light. Indeed, for those who find looking at Boyle Family's work consoling and unproblematic, please do not read this essay further. There is no need to raise difficulties where none exist.

Mark Boyle's declaration of intent, quoted at the opening of this essay, seems to have turned the interpretive role, completely over to what E.H. Gombrich called the 'beholder's share'. Thus for those of a more adventurous and enquiring disposition, there are difficulties here which, of course, can also be regarded as challenges that bring their own kinds of satisfaction and reward. One might begin by asking, as one of Mark Boyle's 'onlookers', what are we really looking at? Already at this basic level of enquiry we might not come up with a satisfactory straightforward answer. Right away we begin to perceive that for all their seeming openness, these apparent slices of reality are elusive and enigmatic. They certainly allow us to scrutinise freely their luxuriously austere surfaces and to stand back and admire their extraordinary verisimilitude. However, they also mutely refuse to give a simple answer as to what they might be. Are these 'paintings', as the Boyles call them, really paintings in the normal sense of the term? Or could they just as easily be regarded as collaged relief panels? Are they just as much polychrome, moulded sculpture as painting? Or could they even be seen as monumental, three-dimensional, photographic-like replicas? Even as physical objects, hovering between the sculptural, the mosaic, the photographic and the tableau, they continually evade being readily pigeon-holed into constricting categories.

If, however, we are determined to pursue this line of enquiry, we might try to test the identity of Boyle Family's paintings as cultural artefacts against the academic system of generic classification. For instance, one might suggest that these works are pieces of natural landscape, which are presented to us on the gallery walls as still life. There may be something in this, as both these types of painting – landscape and still life – were traditionally placed at the bottom of the hierarchy of the academic genre system. This was because they lacked decorum and were deemed by the cultural establishment to be 'easy', non-learned subjects which everyone, irrespective of their social status and education, could readily access. This type of classifying approach could also be applied to that other lowly type of painting – genre, which dealt with ordinary, everyday human activity and was suspected of being socially vulgar and politically democratic. Undoubtedly the egalitarian and the demotic, as opposed to the populist, lie at the heart of Boyle Family's belief in the social role of art and its relationship and responsibility to the onlooker.

Another generic possibility of classification might be portraiture. Our English word 'portrait' ultimately derives from the Latin, *protrahere*, meaning to pull or single out one individual from the masses – literally a face in the crowd. Similarly the Boyles, through their random means of selection, extract an arbitary spot from the mass of Earth's surface and present it to us for the same kind of particular scrutiny as a 'warts and all', veristic portrait. In the end, however, any attempt at this kind of defining is futile. Even in the art world, categorisation is commodification under a more respectable name. Artists and their patrons colonise their subjects through the aegis of some act of cultural and material possession; whereas in the art of Boyle Family their subjects select themselves through chance and indifference to any self-seeking, audience-pleasing, aesthetic or ideological motive.

102 *Mount Ziel Study, Central Australian Desert, World Series*, 1979
Mixed media, resin and fibreglass · 183 x 183 · Private collection, London

103 Installation at Indica Gallery, London, July 1966

104 Installation at Gemeentemuseum, The Hague, 1970

105 Installation at Gemeentemuseum, The Hague, 1970,
showing the *Tidal Series*, 1969

106 Installation at Paul Maenz Gallery, Cologne, 1972,
showing the *Rock Series*, 1971

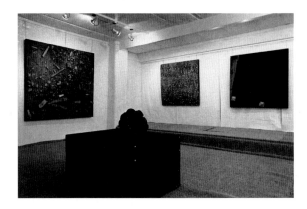

82

Let us now turn to the possibility of placing Boyle Family's painting within the context of modern and contemporary art. Here again we find that categorising is still extremely elusive and ultimately futile. Initially one might wish to link these works with such aspects of twentieth-century art as collage, *art brut*, dadaist ready-made or 'junk art'. Certainly in the 1960s, during the early stages of their careers, Mark Boyle and Joan Hills were very heavily involved with the counterculture art scene of that decade, employing avant-garde, neo-dadaist approaches to their work, which ultimately lead to their epic, world-encompassing series of paintings. Yet always at the core of their art, whatever form it took, was a constant testing and shifting of different strategies to experimental engagement. This was practised through a range of disciplines, from sculptural construction to scientific archaeology, from radical democratic theatre to popular musical entertainment. Thus their work was involved with a whole variety of challenging and subversive acts, including performance, land art, collage, conceptualism, relief sculpture and documentary serialism. Boyle Family's work could never be contained or categorised by any one of these multi-activities. Their art is as open and receptive as any, and the Boyles' identification with archaeology is crucially significant here. Archaeologists must work with the evidence of the past as they find it; everything is potentially of equal importance and use in their pursuit of knowledge. Similarly, the Boyles engage with the landscape of our contemporary world, without any motivating appraisal on the one hand, and with an encyclopaedic curiosity on the other.

If any attempt to categorise the paintings of Boyle Family is fraught with difficulties and contradictions and is ultimately doomed to failure, then by contrast, the viewing of their content does appear to be straightforward and open in a 'Miranda-like' fashion. The labels and captions attached to their paintings would seem to confirm this, with clear statements as to subject, locale, date, size, etc. To all intents and purposes it would appear that we have secure pieces of verifiable realism hung on the wall for our critical examination and philosophical contemplation.

Why then do we, the onlookers, experience so much profound pleasure and sentiment from such a seemingly obvious state of affairs? Surely we can all see such things literally at the drop of a hat, anytime. Therefore, it cannot just be the subjects themselves that are so fascinating, but the actual context in which they are presented and viewed by us. Although they may appear to be 'pure' reality, we inevitably encounter them within a historically and culturally conditioned situation and tradition. Thus the frisson which these works create in us may be something similar to looking at any other painting or sculpture with a high degree of mimetic imput: such as, for example, a

seventeenth-century Dutch still life by Willem Kalf or a Duane Hanson superrealist figure. Boyle Family's art, however, has a much more intense and fundamental effect on our heightened awareness than any piece of mere high illusionism. This is very much to do with the way the Boyles present 'the brutality of fact' to the onlooker; in particular, their reorientation of the normal horizontal relationship we have with the world to a vertical one. Some commentators on Boyle Family works have, in fact, singled out this feature – transferring the horizontal surface of Earth onto the verticality of the gallery wall, as being one of the significant ways in which their paintings distinguish themselves as works of art rather than pieces of reality. Without challenging their status as artworks, one might question, however, whether this re-presentation of viewpoint invalidates in any way, the vital connection between these paintings and our perceptual experiences of the real world. Of course, standing on two legs as fully paid-up members of the *Homo Erectus* species, we do look towards an horizon which is never found in a Boyle Family painting. Yet were we always so erect? The Sphinx's riddle to Oedipus reminds us that we all made our initial, tangible contact with Earth's surface on all fours. Thus it could be argued that one of the reasons why we immediately and instinctively have such an intense visual and tactile bond with these almost mesmeric surfaces is that they put us back in touch with our very early evolutionary, pre-adult, pre-erectus self. Then we were all receptive sentient beings, clawing and crawling around with our eyes and noses a few inches off the ground.

This pre-Oedipal stage in the development of our optical/tactile relationship with the world is as crucially important as the later symbolic one in personality evolution when we begin the process of acquiring verbal and textual language. Could it be that, psychologically speaking, our attitude to Boyle Family's work is relocated in this early, but very fertile and potential, pre-linguistic period of our human consciousness? Could this be a possible reason as to why their paintings, while seeming to be so open and accessible, are also so resistant to semantic interrogation and explanation? Such uniquely autonomous work not only challenges each individual onlooker's rationale, but the power and authority of the *logos* itself.

Boyle Family have always been committed to subverting conventional attitudes and practices and their work needs to be seen within the history of modern and contemporary art. From the outset, modern artists wished to overthrow the traditional forms of representations of appearances as witnessed by the development of innovatory techniques from the Impressionists through to the Cubists and their followers. The second focus of attack by the avant-garde was concentrated on breaking the seemingly inviolable link

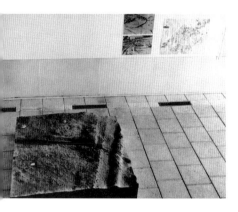
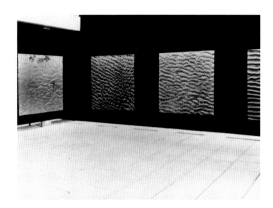
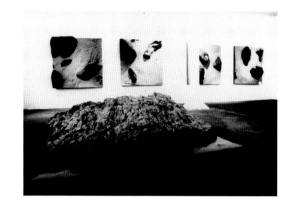

between imagery and language. This particular aspect of radical modern art led to abstraction, but was also associated with Dada and Surrealism, especially in the subversive work of Marcel Duchamp and René Magritte. Thirdly, and maybe finally, not only has that possible hiatus between the visual and the textual been achieved, but with the work of Boyle Family (as with Jasper Johns's *Flag*, for example) the visual can and does resist, the colonising and mythologising process of iconographical language and the politics of representation. Thus, when the onlooker gazes at the non-semantic worlds that the Boyles present to our linguistically conditioned eyes, their nature directly confronts our culture, but this time to our dumb amazement without the intervention of symbolic mediation acting as either a bridge or a barrier.

There is a certain irony that these mimetic works by Boyle Family should be so independent and resistant to the mythologising power of symbolic and linguistic authority. According to modernist criticism and theory as espoused, for instance, by Clement Greenberg and his followers, such autonomy could only be achieved through non-figurative abstraction. Only abstract art was deemed pure and uncontaminated by its power to withstand and transcend the very materiality and the historical conditions which brought it into being. In striking contrast, Boyle Family's ultra-descriptive painting achieves its own kind of independence, not by denying the realities of the world of which it is a part, but by embracing them. Instead of relying on the language of symbol or metaphor, which always leads us away to some significant 'other', here we are allowed to scrutinise and delight in the random, metonymic bits and pieces of the world that appear to describe and represent nothing but themselves.

If these works are really so autonomous and unique, how are they also so open and accessible at the same time? This is another intriguing aspect to the contradictory nature of Boyle Family's paintings. They appeal to us because they are, paradoxically, both so realistic, and yet so perfect. Their perfection, however, is the antithesis of normal aesthetic associations connected with that critical and philosophical concept. For Boyle Family, beauty and perfection lie in the supreme individuality of the thing itself, not in some abstract system of aesthetic order. Thus they equally eschew the selective idealism of classicism and the self-referential purity of modernism. Boyle Family's empirical art reifies the appearance of the world to the onlooker, not as a culturally constructed image, but as a perfectly authentic fact.

This is not to imply that the Boyles literally bring the real, physical world to our attention. What they create for us is access to an exceptionally excessive description of the minutiae of material reality, which normally passes beneath our highly conditioned and selective notice. This optical engagement with the previously insignificant can be so unsettling, and even disturbing, that sometimes it feels as if we have inexplicably come across an uncanny parallel universe. What we encounter here is something akin to déjà vu – an intensity of vision and certainty of being which, if it were not so rooted in the material world, might be taken for being a metaphysical insight and revelation. Yet it is physical exactitude, not aesthetic idealism or spiritual enlightenment, which is the foundation for the sense of perfection in these works. This again brings us back to another paradoxical dimension to Boyle Family's work, where beauty of perfection is not based on some Pythagorean system of mathematical order and control, but on an open and receptive creative process that incorporates the risky, but crucial role of chance. Each Boyle painting is more than an image. It is a unique event.

Chance and accident are frequently conflated, when in fact they are antithetical to each other. Accident is the ghost in the machine, the unpredictable threat to reason and control. It constantly refutes and destroys the security and intellectual optimism we desire to create for ourselves through the power of our rational ideas and actions. Chance, by contrast, is not an anarchist, but a terrorist. It does not simply wish to destroy, but to create an alternative to the logical, orthodox order of things. Instead of a man-made selective system operating to predetermined ends, with chance, selection and intent are replaced by the totality of natural possibilities. With this immutable faith in the redemptive power of chance and its essential role in the all inclusive creative process of their art, then the accidental is completely eliminated and each work attains a perfect 'rightness' about it, which no amount of conscious intent could achieve. Thus we onlookers become instantly enthralled by these aleatoric encounters manifested in Boyle Family's paintings which, along with their excessive descriptive displays of detailed reality, arrest our normal, hyperactive optical habits and transform the passing casual glance into an intense, concentrated gaze.

Our entranced optical and tactile engagement with a Boyle Family painting is infinitely more visceral than normally experienced in front of a typical example of figurative art. In fact the sensation engendered is more akin to looking at the well-wrought surface of an abstract expressionist work. In a conventional imitative picture the artist sets out to recreate, through the devices of pictorial illusionism, the physical conditions we usually encounter in our familiar environments. The most obvious aspect of this process is the graphic re-creation of three-dimensional objects in a continuum of receding space through the employment of such formalities as perspective and

83

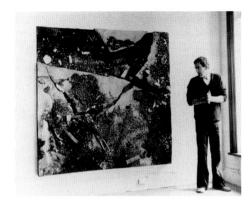

84

chiaroscuro. This illusionistic role of art aping reality was concisely summed up by the fifteenth-century Italian Renaissance theorist, Alberti, when he described painting as a 'window on to the world'. This trope, common to all post-Renaissance Western art, began to be challenged and undermined by the emergence of modern painting in the later nineteenth century. From Édouard Manet onwards, the shift of emphasis in painting began to focus not on spatial depth, but tactile surface. With each new phase of modernist painting more and more illusionistic depth was squeezed out of Alberti's window, until by the mid-twentieth century, progressive abstract painting had little space left, which could possibly contain a three-dimensional figure. 'Flatness' had triumphed along with American Abstract Expressionism. Boyle Family's paintings are of course not 'flat', yet despite being figurative, they do share the same (non) spatial characteristics as abstraction. In their work there is no illusion of depth. Unlike a conventional figurative picture, where the pictorial image recedes from your eyes as you approach its surface, a Boyle Family painting, like the surface of a true abstract work, seems to come forward to greet you the more intimate your proximity becomes to it.

Such close optical contact with the surface of a Boyle Family painting can create an hypnotic hold over the onlooker, who becomes increasingly fascinated and intrigued as to how it has been made. The surface of these paintings are not there, as in other pictures – figurative or abstract, to display the skilful and expressive presence of the artist. There is no bravura brushwork, angst-ridden distortion or cool manipulation of decorative and compositional design. In fact what we have here is modern art, which does not 'look' modern. The Boyles create works that are so 'frighteningly exact', as one writer has described them, that we, as onlookers, are initially compelled to scrutinise their surfaces in a vain attempt to locate the point where fiction and faction meet. This seems to be a perfectly normal reaction on seeing Boyle Family's paintings for the first time. This, however, should be quickly succeeded by the onlooker being taken on a sensuous journey of discovery towards the philosophical heartland of Boyle Family's existentialist art practice. From the beginning of their careers, Mark Boyle and Joan Hills and later their children, Georgia and Sebastian, have consistently and relentlessly set out to challenge and break down the artistic, aesthetic, social, political and psychological barriers of established orthodoxy and control, which separates artists from the authentic experience of their subject in its entirety and totality. Thus, with the art of Boyle Family, there is a connectedness between form and formlessness, between the smallest detail on the surface of their paintings and the sublime all-inclusive possibilities of their boundless subject.

The basis of Boyle Family's philosophical belief and artistic commitment is scientific empiricism; and such an attitude is out of step with the dominant ideologies of our post-modern contemporary world. Since Nietzsche's pronouncement on the 'death of God' at the end of the nineteenth century, modern philosophy has been obliged to formulate new paradigms in which the world is forever recreated by different forms of cultural representations. The previous Enlightenment belief that the appearance of the world shaped its representation has now been radically superseded by the intertextuality of post-modernism, where the former distinction between what is real and what is represented is an outmoded anachronism. Reality has become formulated and experienced through the all-pervasive presence of interconnecting sign systems of communication. Needless to say, Boyle Family do not subscribe to this current orthodoxy and emphatically oppose such semantic hegemony. Boyle Family's resistance to the contemporary politics of representation is in the area of visual and textual interpretation. Their art seeks to occupy that space between nature and culture before the visual is turned into a veil of images and secondary semantic meanings.

What distinguishes and marks out Boyle Family's art for particular critical notice is that it is prepared to confront this tyranny of textuality head-on. The ultimate triumphalism of post-modern theory is to conflate reality and fiction into the simulacrum. As with the 1956 film, *Invasion of the Body Snatchers*, the replica completely colonises and destroys without trace, that which has been replicated. We now have endless reproductions where no original exists. In our multimedia, electronically generated world, this replication process seems to have become so insidious that the medium has not only become the message, but the very subject / content itself – television aping life and life becoming television, à la *Big Brother*. Without any sense of there being an 'original' this quickly sets the assumption that there is 'nothing out there'; and a contemporary philosopher can provocatively claim that the Gulf War, for instance, did not happen, but was merely a set of images on our television screens.

Boyle Family's work also deals in the process of replication and communicates with the onlooker through the visual language of mimetic resemblance. Yet no one is led to believe that these paintings are simulacra of the world itself. These are works of art and their content and appearance have to be considered within their relationship to their source and the context of their presentation – cut off, set apart and displayed on the gallery wall. Their presence in such a distinctively cultural space emphasises their difference and separation from their original abode. What we have is not simply simulated replication, but physical transformation. Thus it would be deceptively

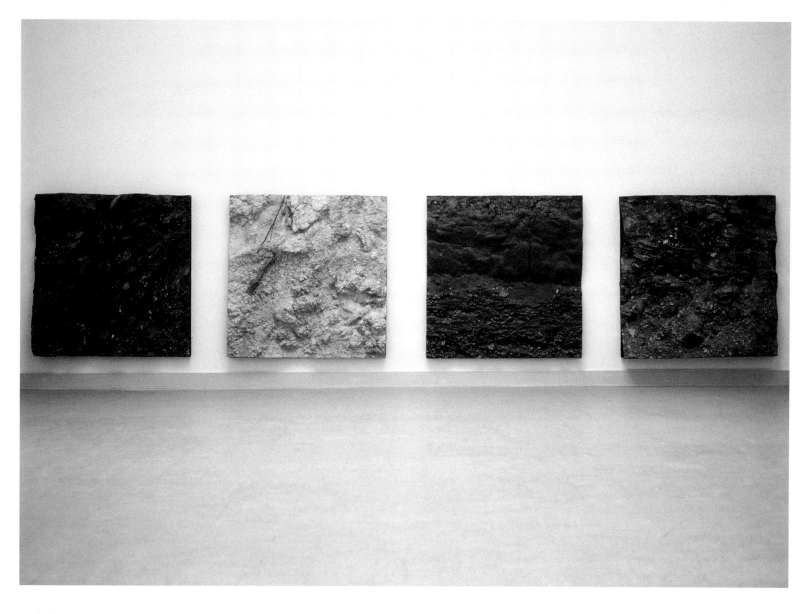

misleading to regard Boyle Family's work as straightforward fragments of reality. These paintings are not the 'real thing', but are independent entities in their own right. Boyle Family's autonomous works stand neither for their creators nor their audience, but for themselves. Through the direct, unmediated power of their appearance, uncontaminated by any conventional image-making process, these representative paintings present to our notice those aspects of reality that have never been previously granted any recognition and acknowledgement in our civilised culture.

This again brings us back to the politics and languages of representation. All language systems whether oral, textual or visual, operate on the basis of differences and similarities. For example, the arbitrary sound, or written appearance, of the word 'dog' tells us that it is different from the word 'cat'. Furthermore, if a word has more than one meaning, the different contexts in which it is used will tell us, unless it is a pun, what meaning to apply. The representational visual arts on the other hand, have a markedly different method of communication based, not on difference, but on reference and

resemblance. Thus we recognise a dog in a painting because it appears to look like one, for example, its image has enough of the same visual features as a dog in the real world to allow us to refer it to that particular animal. Yet, what if we are encouraged to doubt our security in the appearance of the real world? What if we are now told that a picture of a dog only looks like a dog because it resembles another image of a dog? What if finally we are told that our post-modern, hyper-real environment is merely a hall of mirrors, a complex interconnecting system of reflecting signage generated by the all-pervasive presence of the mass media? Is a Boyle Family painting then just another piece of replication in a world of continuous replicating imagery? Or do these paintings resist and challenge such a view of our present state of affairs?

There are, of course, no absolutes in the act of seeing. Despite all the Ruskinian rhetoric, the 'innocent eye' of pure vision is wishful thinking. Seeing is never straightforward, but a highly complex neurological activity with around thirty areas of the brain programmed to deal with the innu-

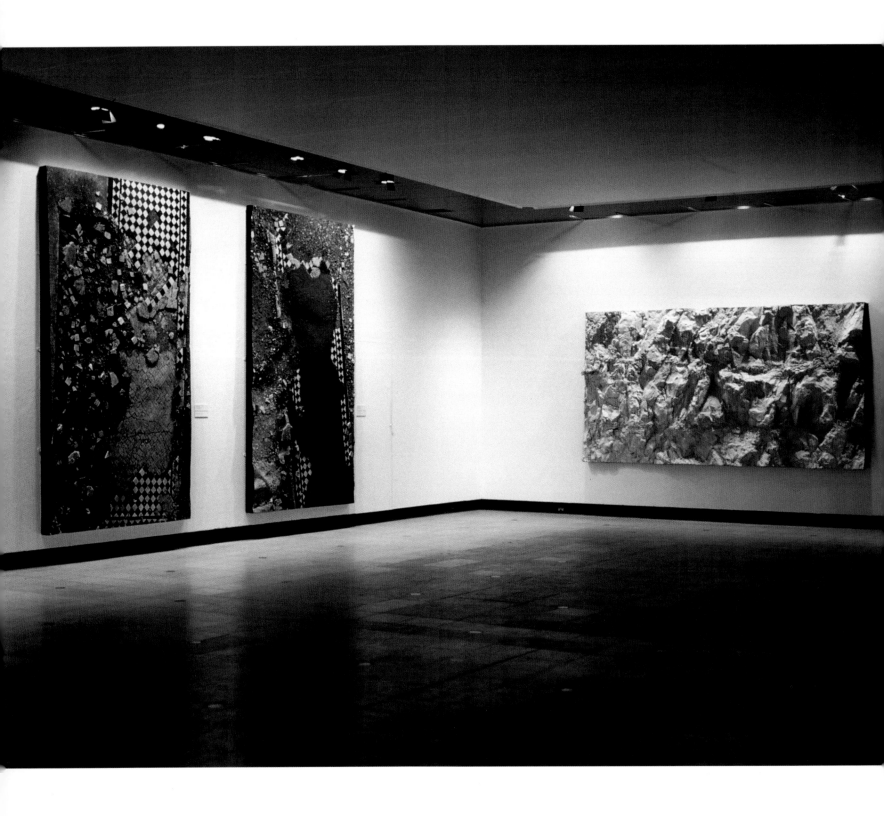

110 Installation at Hayward Gallery, London, 1986

merable ways we optically respond to the visual world. Broadly speaking, it is possible to divide the process of looking into conscious and subconscious, or subliminal, ways of seeing. While the latter method merely registers the vast amount of visual information that is familiar and expected, the former type of observing is stimulated to focus on appearances which seem to be distinctive, significant and exceptional. Most image-makers in our post-modern world usually try to capture our attention by resorting to obvious arresting devices through some kind of mendacious manipulation. Appearances are then turned into spectacular images. Their attitude and approach is the complete opposite of this circus of insidious visual fakery. They do not seek out unusual and bizarre subjects which are the stuff of the entertainment business, nor do they attempt to transform the appearance of things by formal rearrangement which is the hallmark of most modern and post-modern art. On the contrary, any transformation that does take place in front of a Boyle Family painting does not occur in the subject itself, but in the attention and attitude of the onlooker. The apparently insignificant subjects with which we are confronted in these works are the very ones which we would barely register through our subliminal habit of looking. Now, however, we are made to see for the first time this everyday world, which we merely took for granted. Boyle Family's seemingly revelatory art allows us to engage directly with the very fabric of the familiar and makes us suddenly and acutely aware that the ordinary is in fact quite extraordinary. As Francis Bacon, an ardent admirer of Boyle Family's work stated, 'If only people were free enough to let everything in, something extraordinary might come of it.'

How this mundane miracle occurs is open to speculation. Amongst other things, this profound change in attitude forces the viewer to make comparisons between what is found in Boyle Family's work and other means of depicting the appearance of the world. Thus, a final comparison should be made with the most ubiquitous image-maker in our contemporary world – photography, which also brings the familiar in all its variety to our jaded awareness. Many would contend that it is the photographic image to which the art of the Boyles is most closely linked. There are undoubtedly some points of similarity with certain kinds of photography – through such features as, documentary empiricism, high-detailed recorded factuality and a contingent engagement with the world. On the other hand, however, there is a crucial difference between any photograph and a Boyle Family painting. This has nothing to do with obvious disparities in scale or surface, for example. The fundamental contrast again lies with the simulated and imaginary sense of space created in the image-making process. Photographs, like other kinds of picturing, present a view of the world as a continuum of space. Yet this has further implications in a photograph compared with a painting. When a photographic image is snapped it freezes the spatial flux of reality and transforms a point in space into a moment in time. Photographs by the particular spatial / temporal relationship they have with the world are forever locked into the split second of their immaculate conception. At the very moment of their miraculous, mechanical creation they become instant history and immediate nostalgia. Boyle Family, by contrast, create an overwhelming sense of concentrated corporeality where time and space become one. Thus by expunging any pictorial illusion of both time and space, and eschewing narrative descriptions of reality, Boyle Family's paintings always remain in the eternal 'now' of their own presence and materiality.

Despite the layers of semiotic encrustation accumulated through the civilising process, we humans are still basically visual creatures and the way we optically engage with the world links back to our distant pre-history. Then we were an endangered hunting species with our eyes acting as our life-line to survival. Human brain and eye had to work in self-supporting co-ordination in order to discern the nature of the surrounding environment. There was a constant checking between visual information and stored memory in the brain. Thus the sensation of revelation goes back to when Man's sight would pierce the camouflaged veil of appearances in the natural world and in a flash of recognition discern between friend and foe, between prey and peril. Ironically, we now call our revelations blinding insights in order to distance them from their primordial origins and elevate them on to a higher, otherworldly plane of mental and spiritual insight. The art of Boyle Family radically goes in the other direction. With their consistently all-inclusive, non-hierarchical, anti-aesthetic approach to art, their revolutionary work directs us to reconnect with the visual and physical world in order that we can see it for what it is. Reflecting intently on Boyle Family's uncompromising realistic paintings, the onlooker begins to realise that Miranda's 'brave new world' is in fact our courageous old one, which has always been here. We are all, including these paintings, part of this ever-changing world.

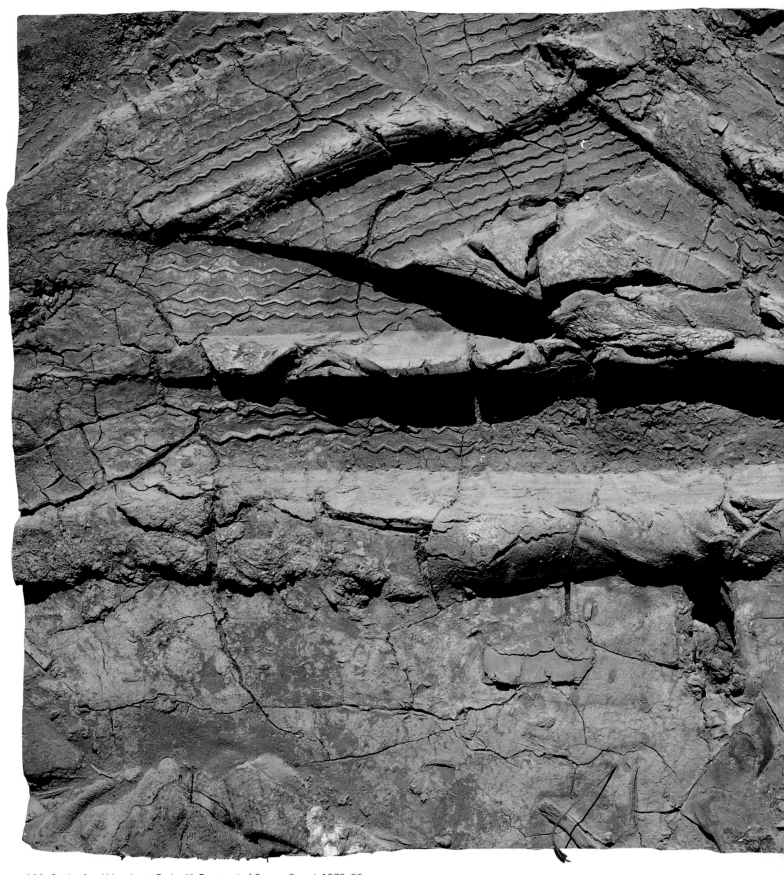

111 *Study of an Urban Lorry Park with Fragment of Orange Carpet*, 1979–86
Mixed media, resin and fibreglass · 183 x 366 · Private collection

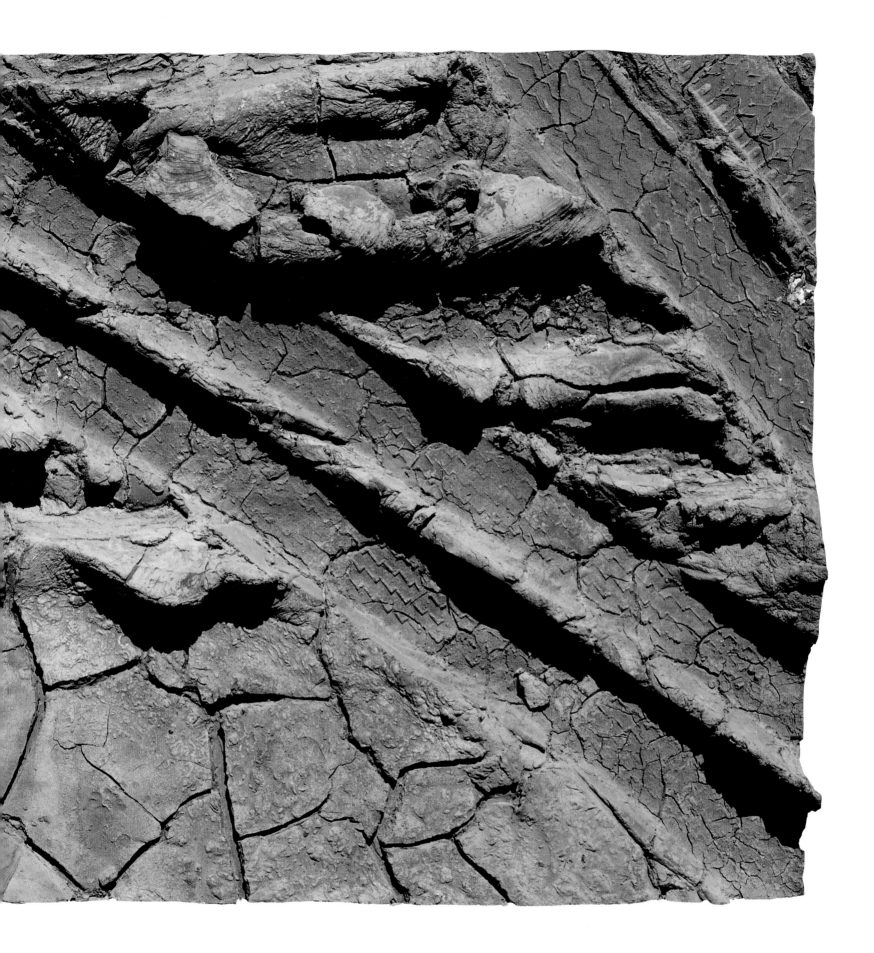

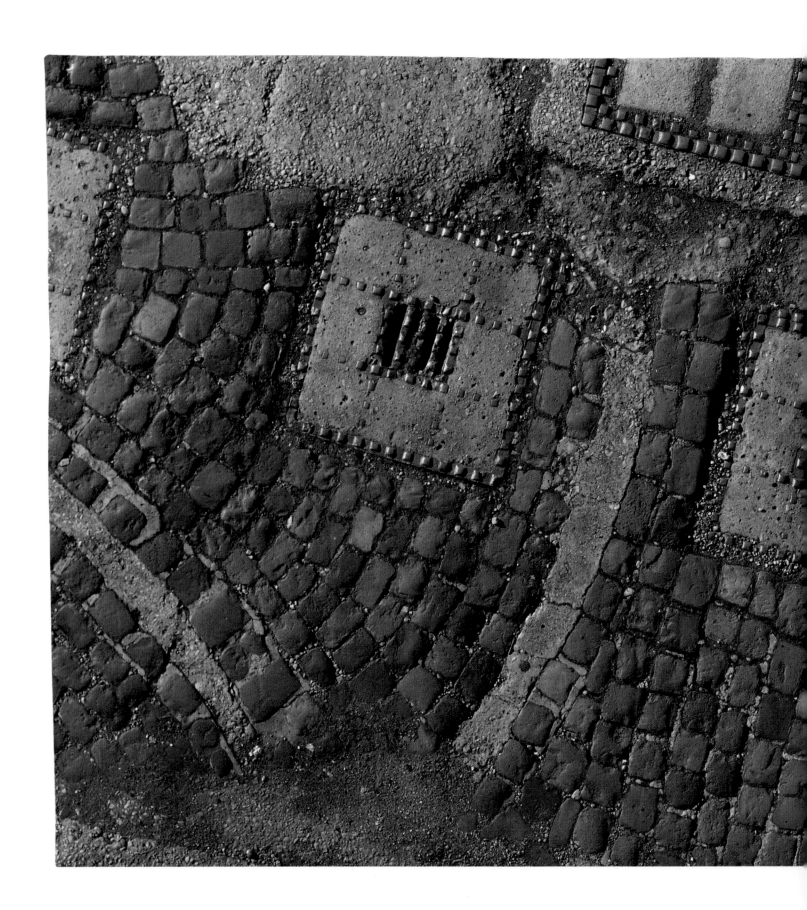

112 *Cobble Study with Drains,* 1979–80
Mixed media, resin and fibreglass · 183 x 366 · Sammlung Ludwig, Ludwig Forum für Internationale Kunst, Aachen

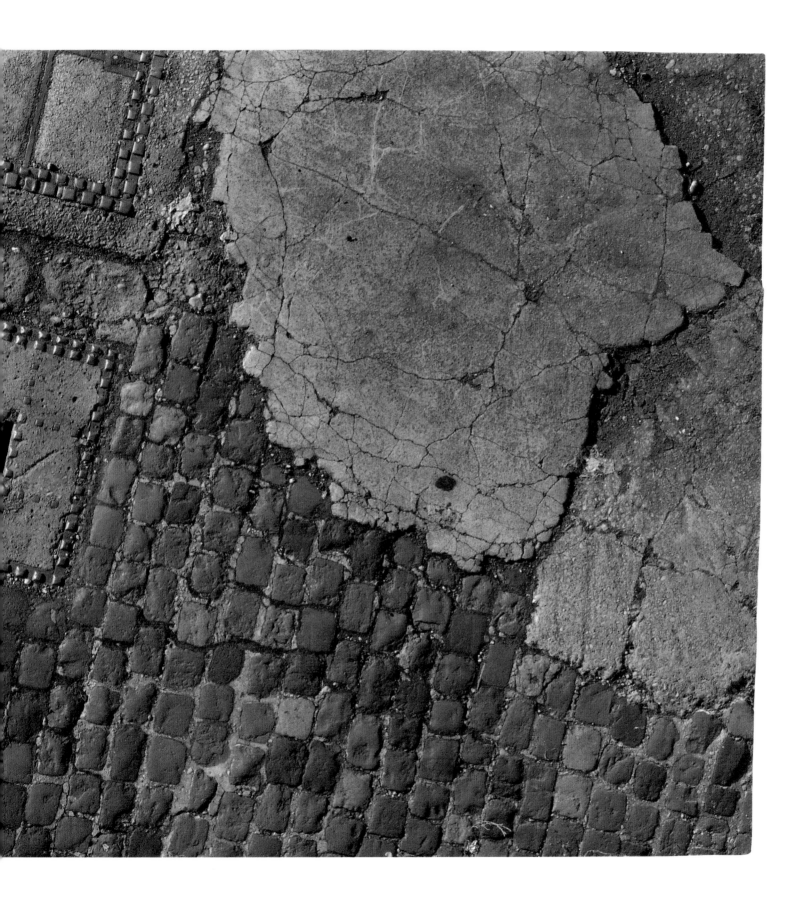

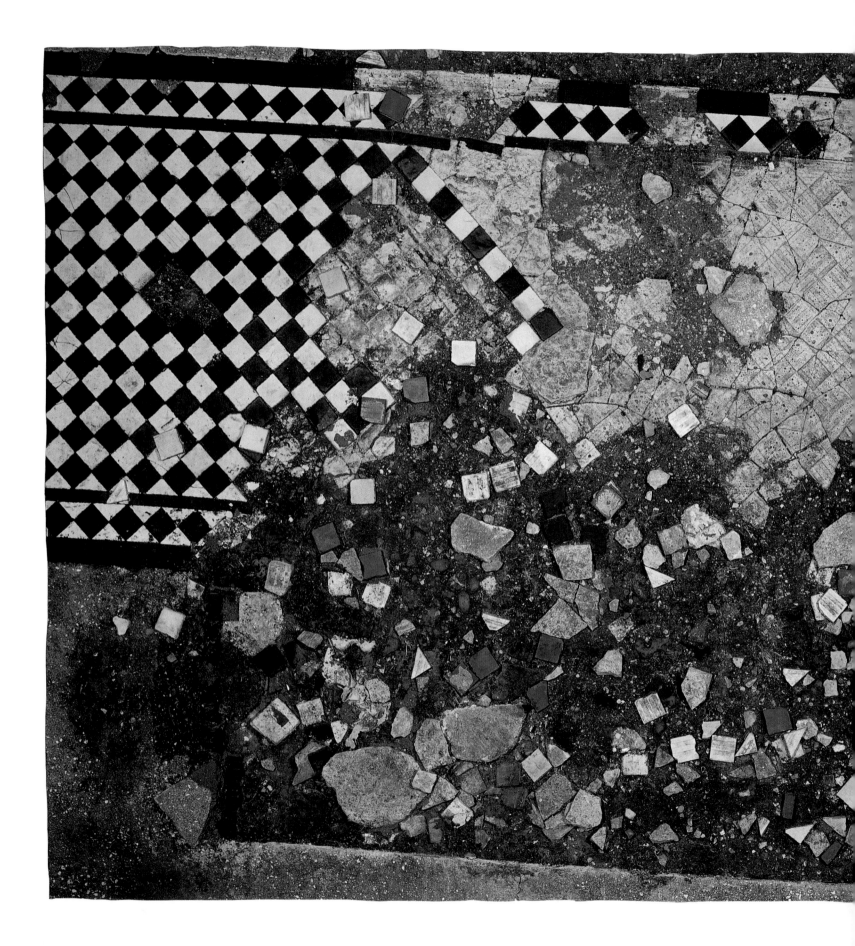

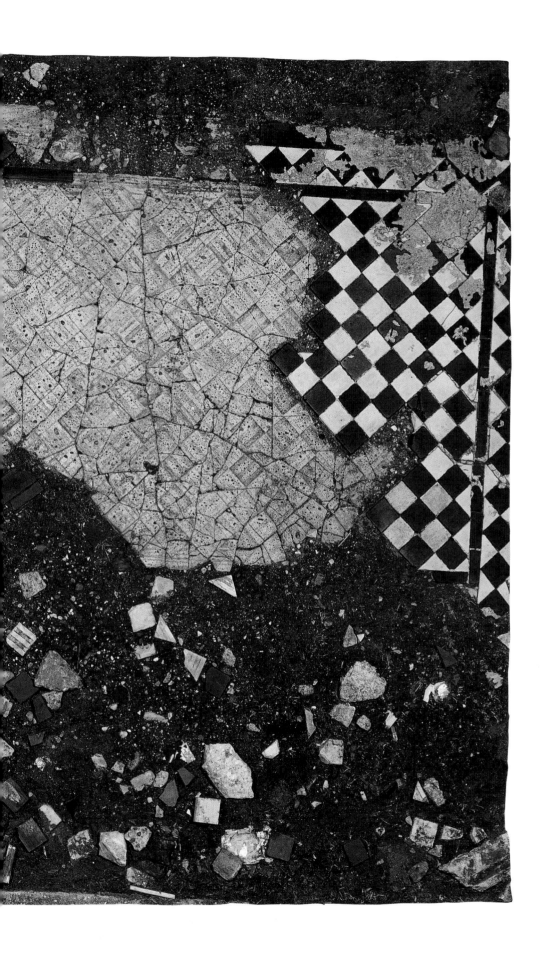

113 *Study from the Broken Path Series with Border Edging*, 1986
Mixed media, resin and fibreglass · 305 x 183 · Scottish National Gallery of Modern Art, Edinburgh

114 *Study of a Potato Field*, 1987
Mixed media, resin and fibreglass · 183 x 366 · Hess Collection; Bern, Napa (California)

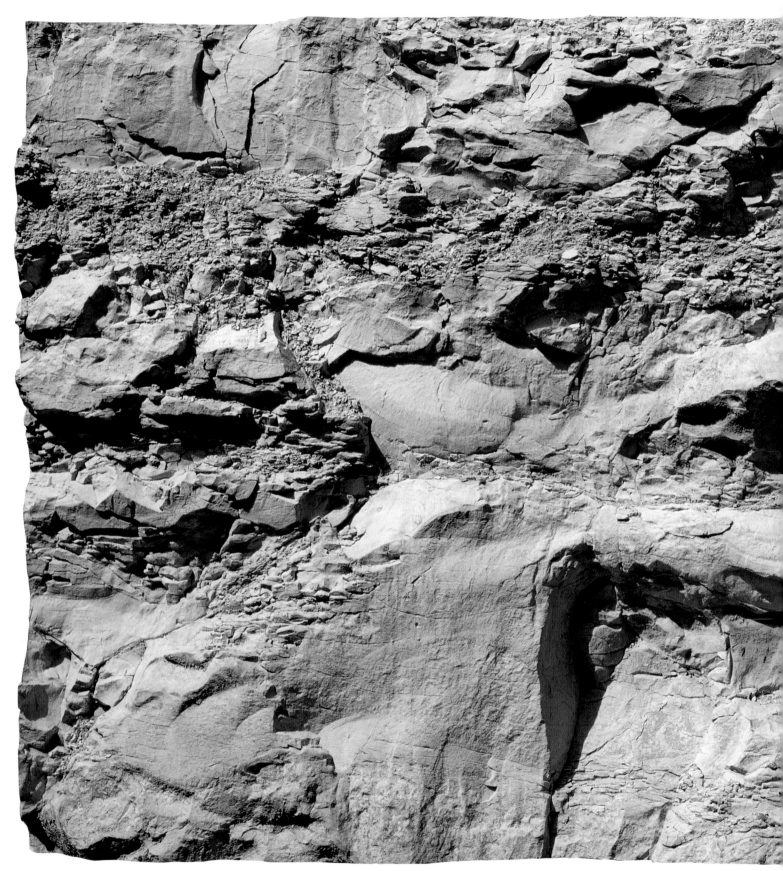

115 *Chalk Cliff Study*, 1987

Mixed media, resin and fibreglass · 183 x 366 · Private collection

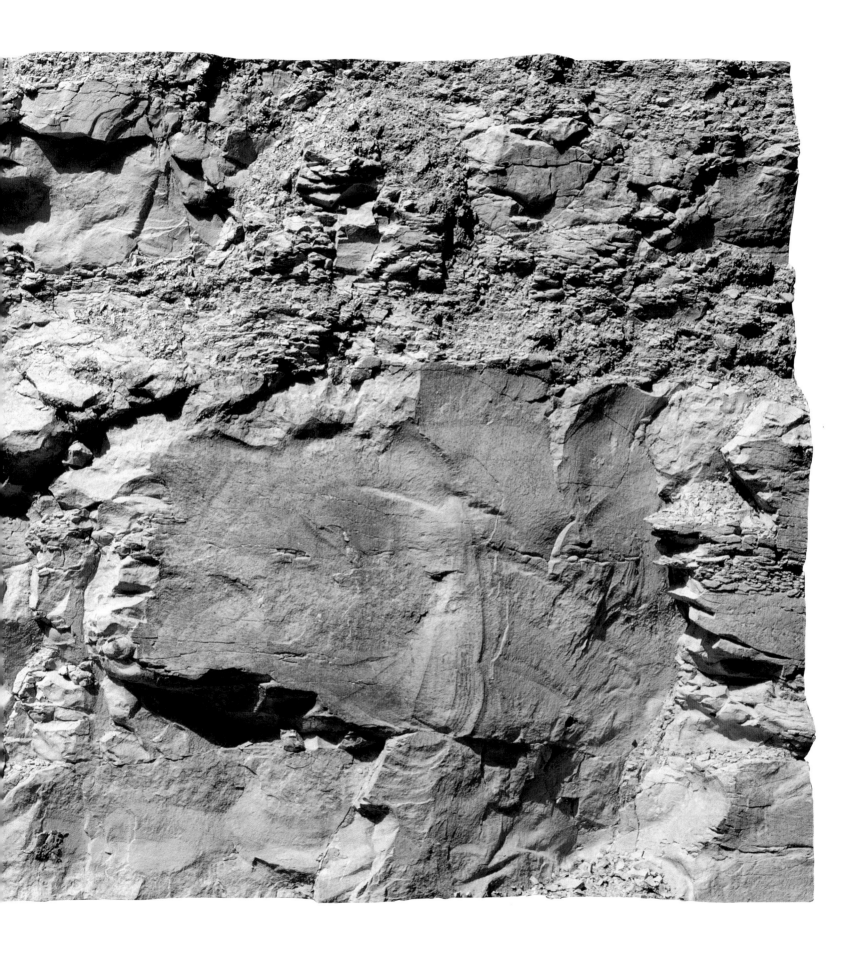

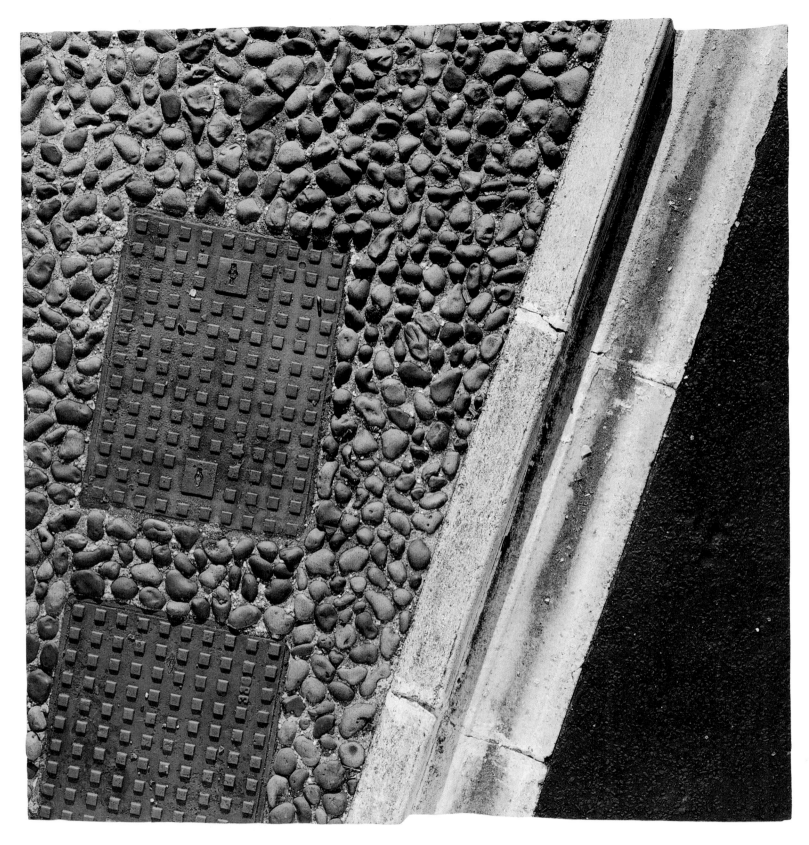

116 *Study from the New Town Series with Concrete Gutter and Embedded Stones*, 1988
Mixed media, resin and fibreglass · 183 x 183 · Private collection

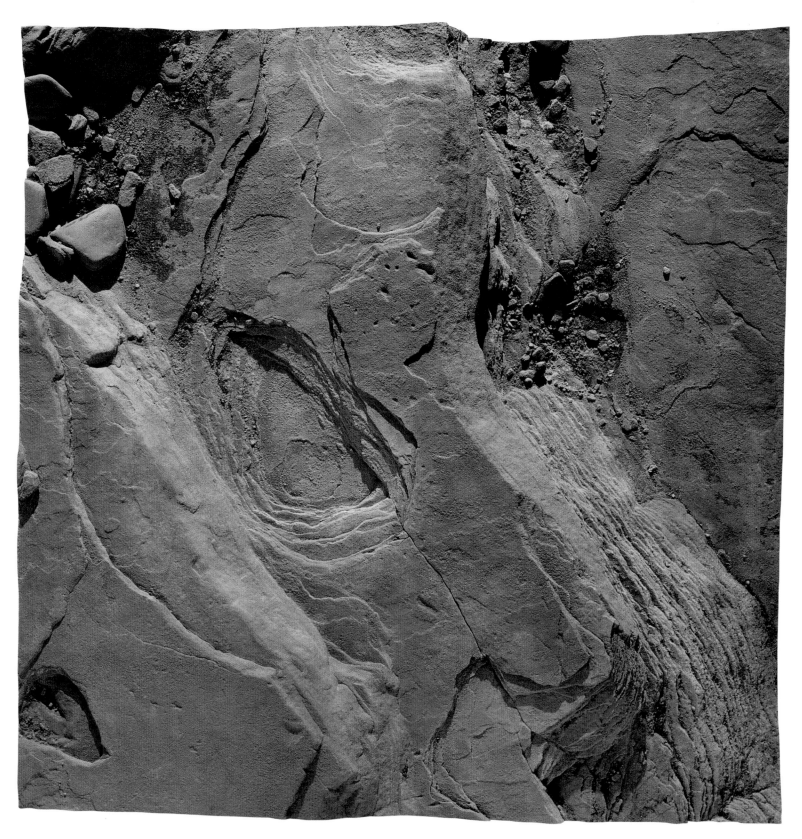

117 *Highland Shore Study*, 1988
Mixed media, resin and fibreglass · 183 x 183 · Private collection

118 *Kerb Study with Tarmac, Cobbles and White Line, New York*, 1990
Mixed media, resin and fibreglass · 305 x 183 · Boyle Family collection

119 *Study of a Demolition Site with Slabs of Reinforced Concrete, Rusty Oil Drum and Twisted Girder, Docklands Series, London,* 1990–1
Mixed media, resin and fibreglass · 183 x 366 · Hess Collection; Bern, Napa (California)

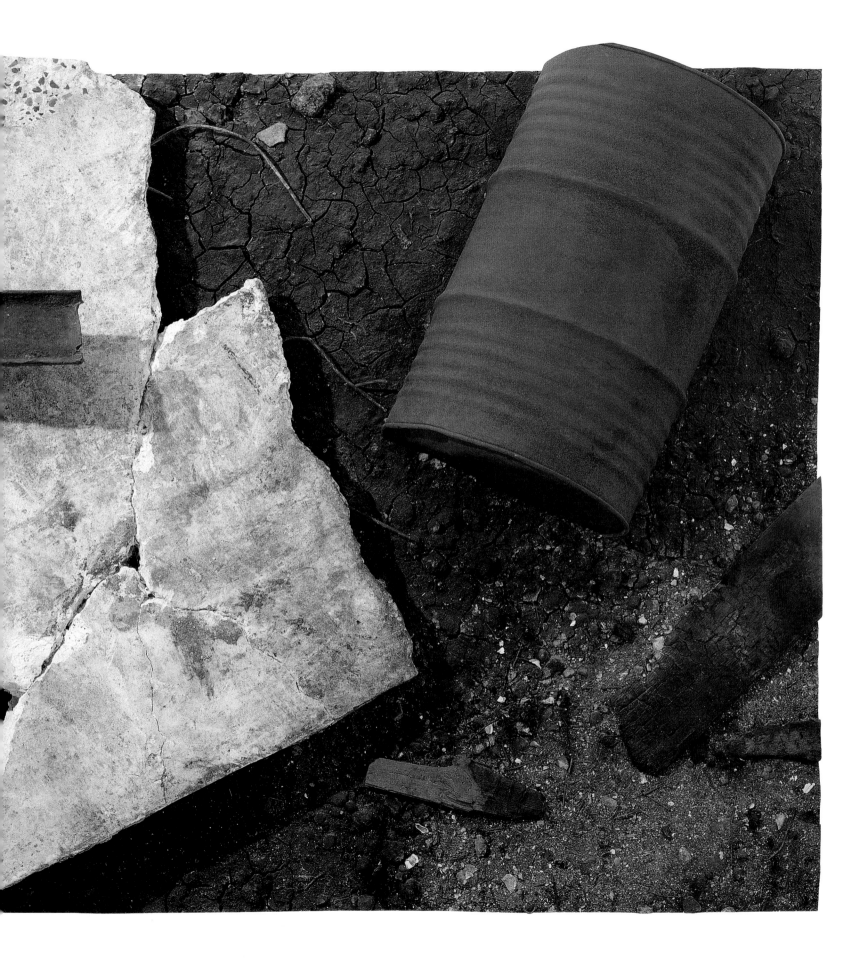

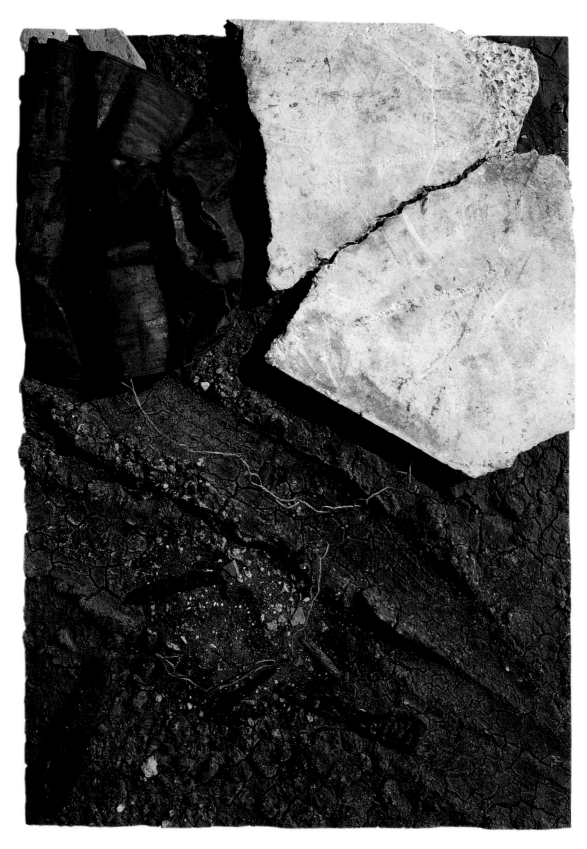

120 *Study of a Demolition Site with Black Oil Drum, Reinforced Concrete and Wire, Docklands Series, London*, 1990–1
Mixed media, resin and fibreglass · 213 x 152 · Boyle Family collection

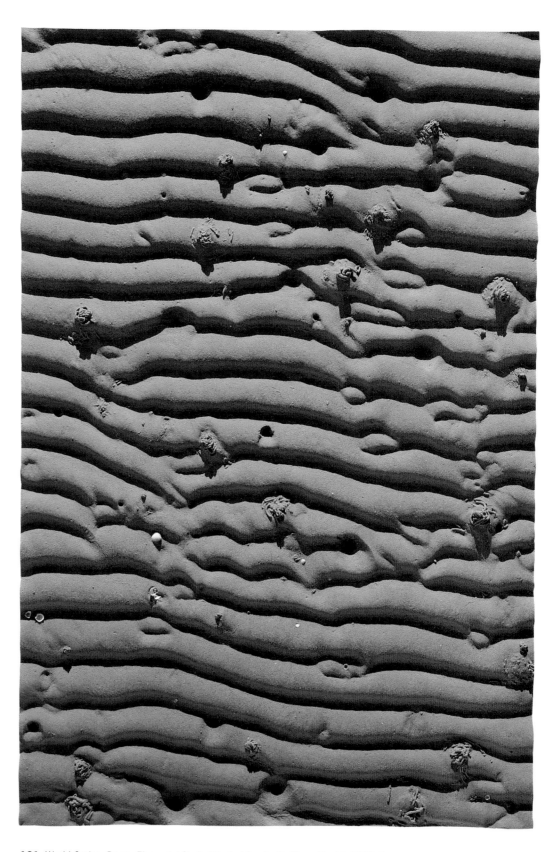

121 *World Series, Barra. Elemental Study (Rippled Sand with Worm Casts)*, 1992–3
Mixed media, resin and fibreglass · 183 x 122 · Boyle Family collection

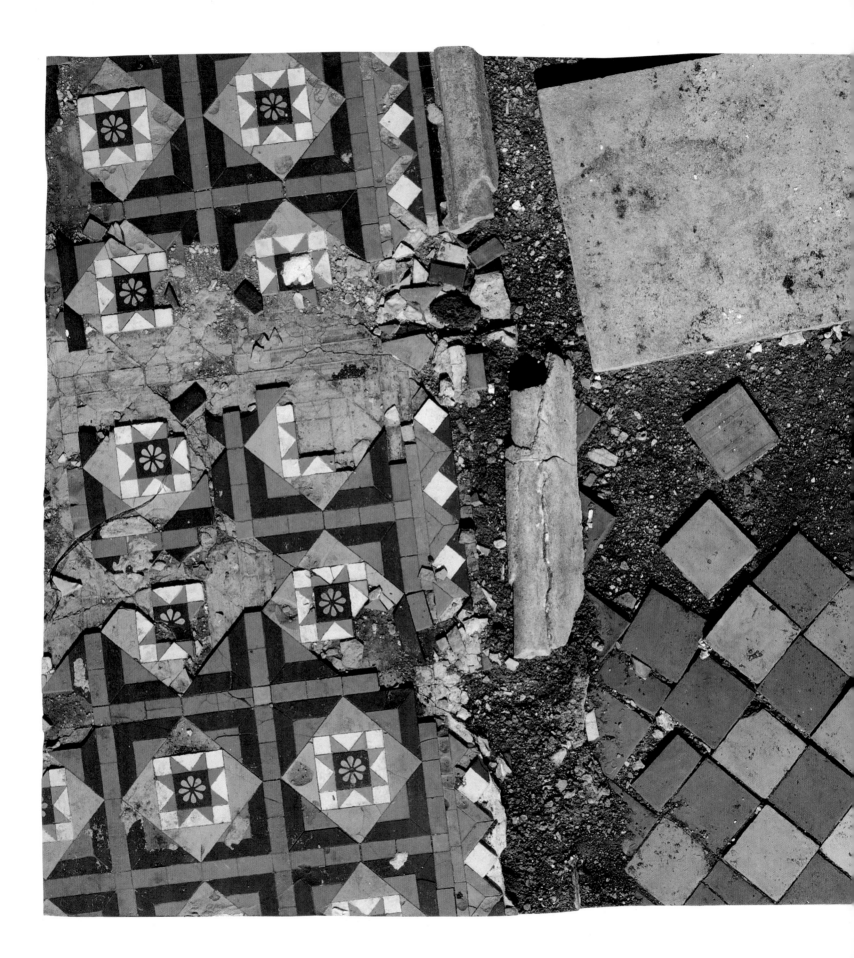

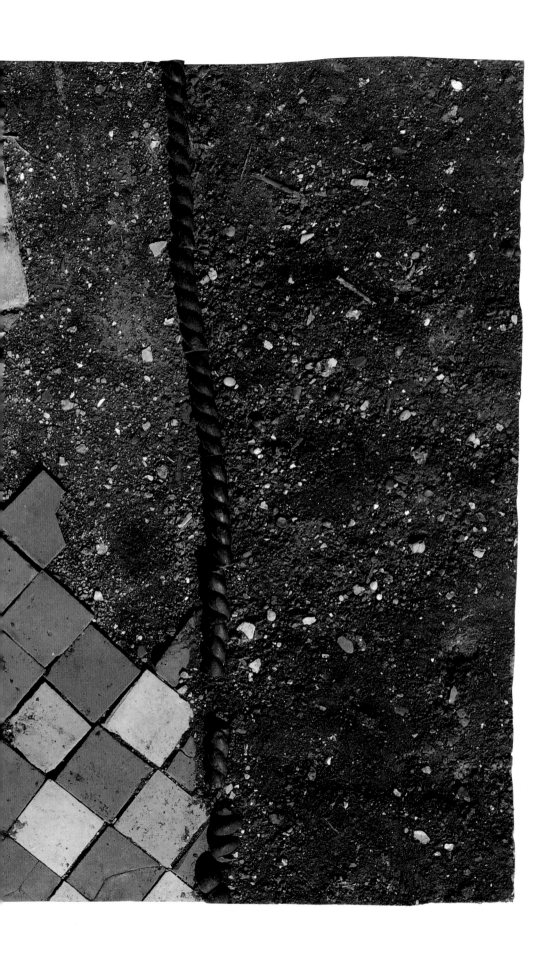

122 *Victorian Tiled Path Study*, 1994
Mixed media, resin and fibreglass · 305 x 183 · Boyle Family collection

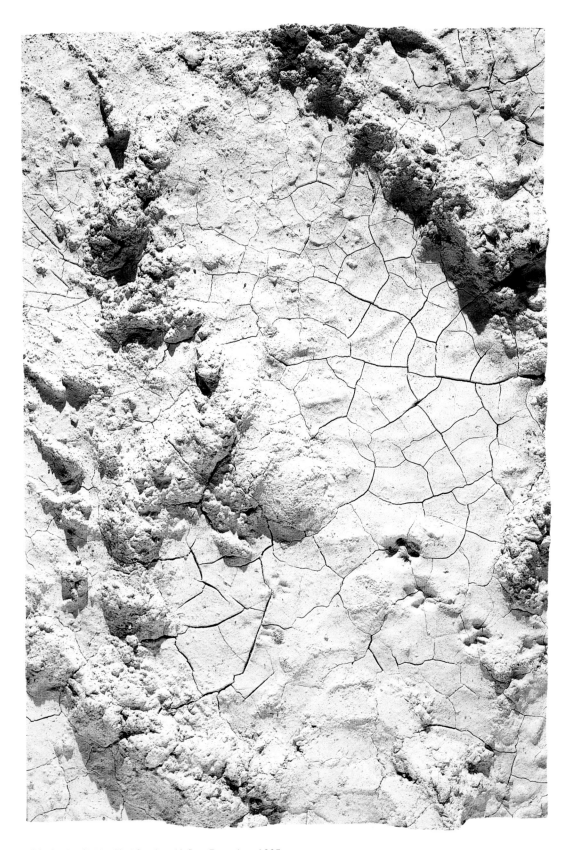

123 *Study of White Mud Cracks with Dog Footprints*, 1995
Mixed media, resin and fibreglass · 183 x 122 · Boyle Family collection

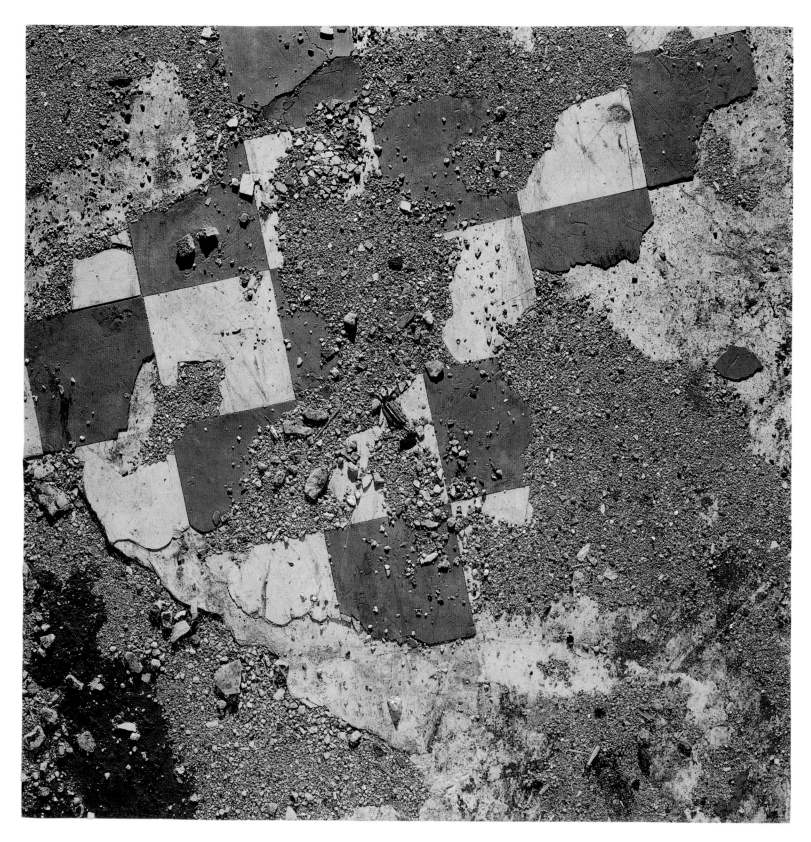

124 *Study of Red and Cream Compo Tiles, Leytonstone, London,* 1998
Mixed media, resin and fibreglass · 183 x 183 · Private collection

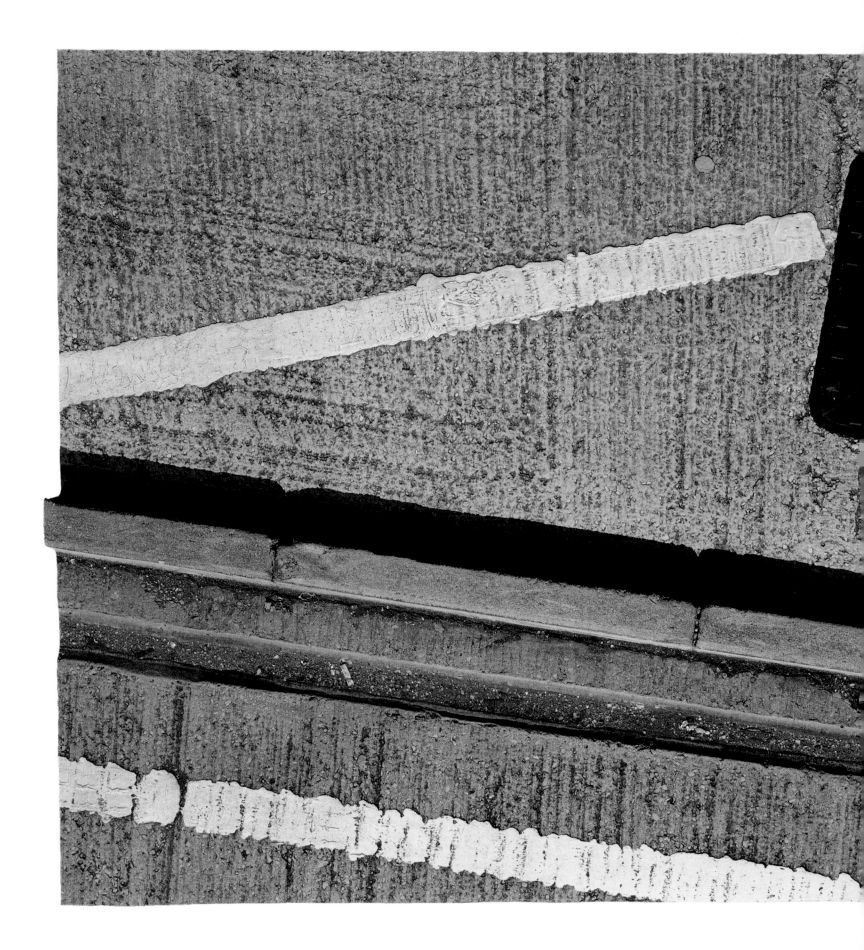

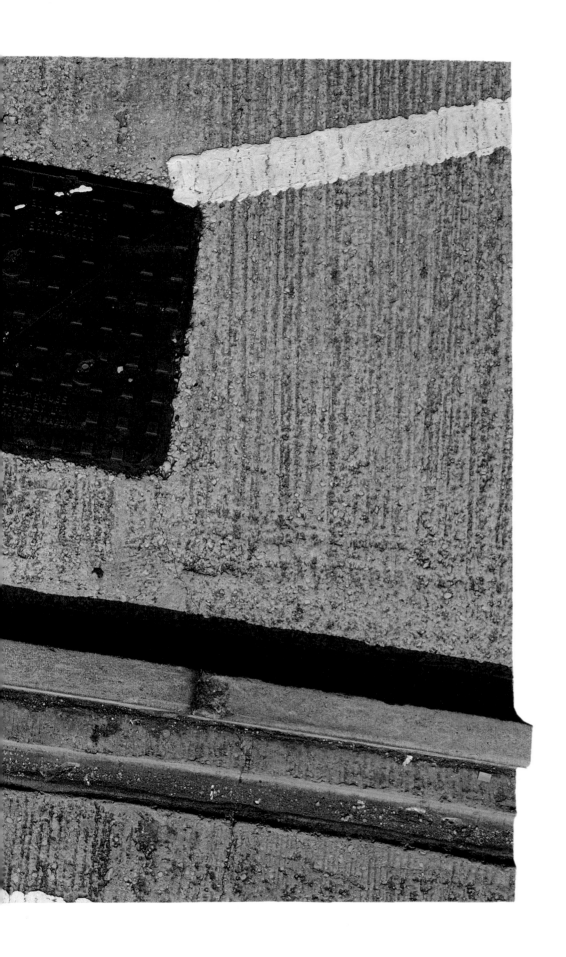

125 *Industrial Parking Lot Study with Yellow and White Parking Lines*, 1999
Mixed media, resin and fibreglass · 305 x 183 · Boyle Family collection

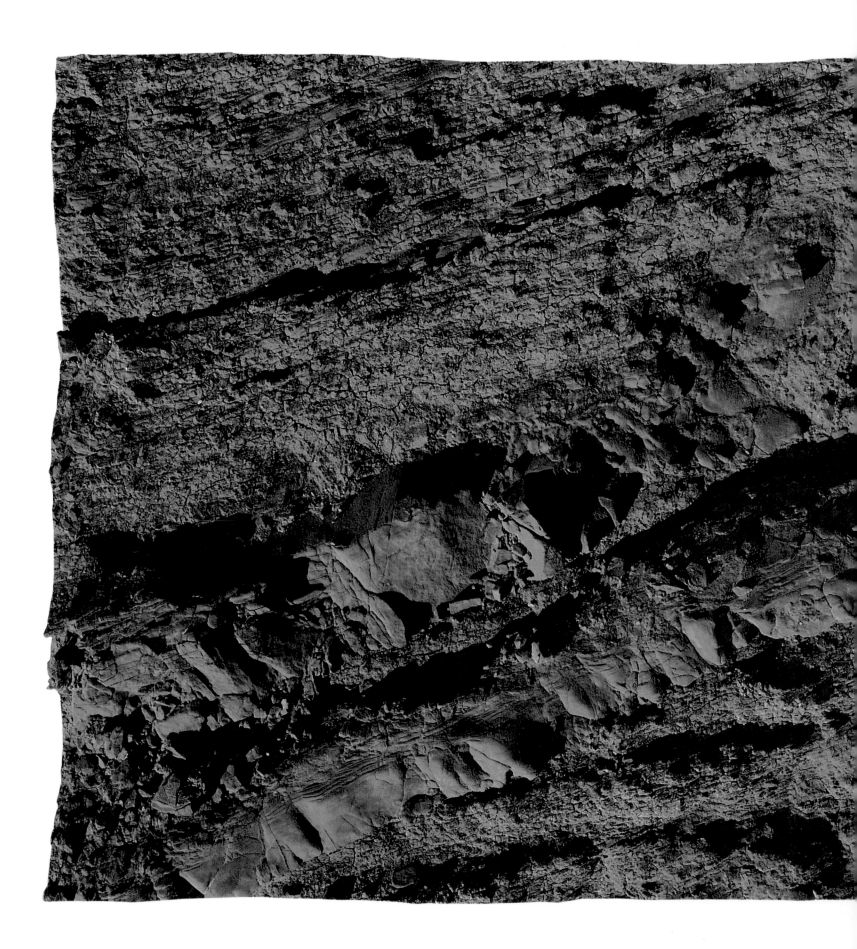

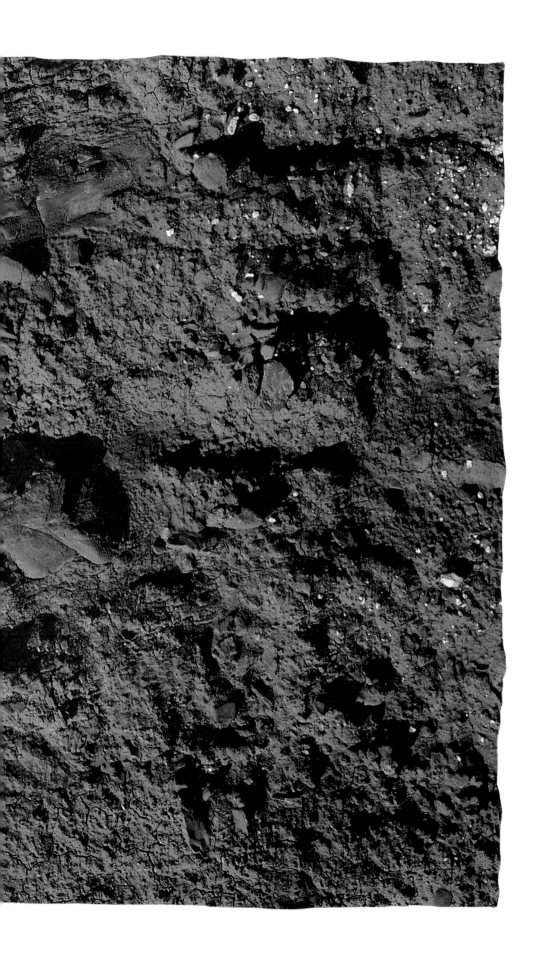

126 *Landslip Study with Mud and Rock (1)*, 2001–2
Mixed media, resin and fibreglass · 305 x 183 · Boyle Family collection (commissioned by Sir Peter Moores)

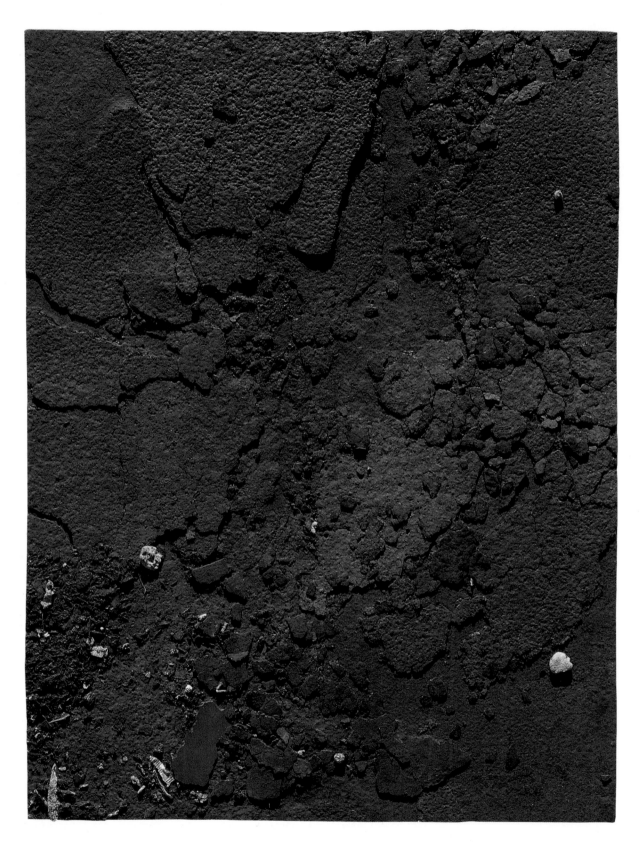

127 *Study of Rusting Metal Plate*, 2001–2
Mixed media, resin and fibreglass · 89 x 68.6 · Boyle Family collection (commissioned by Sir Peter Moores)

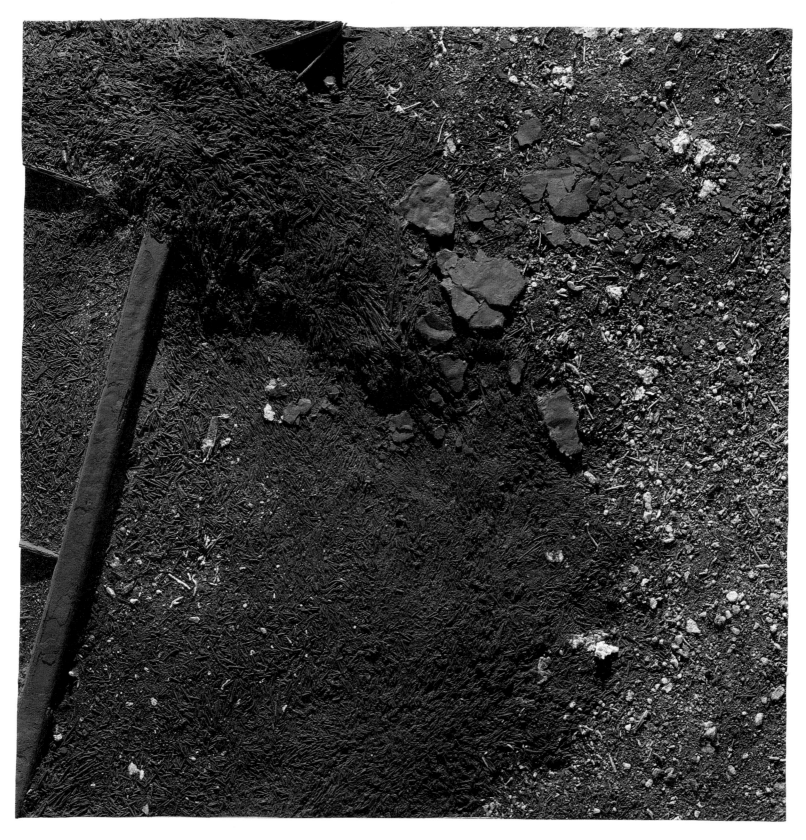

128 *Study of Rusting Wire Cable etc and Spent Welding Rods,* 2001–2
Mixed media, resin and fibreglass · 183 x 183 · Boyle Family collection (commissioned by Sir Peter Moores)

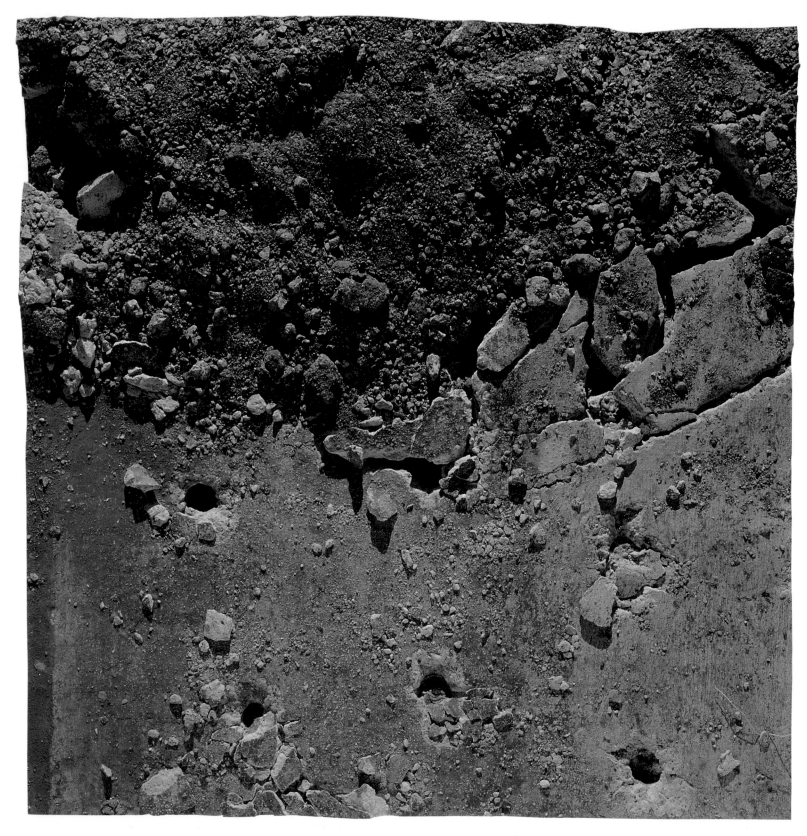

129 *Study of Broken Up Concrete and Earth*, 2002–3
Mixed media, resin and fibreglass · 198 x 198 · Boyle Family collection

Notes to the essays

Presenting Reality pages 9–19

1 'Quotations from Mark Boyle' in *Studio International*, no.177, June 1969, p.278.

2 Mark Boyle, 'Background to a Series of Events at the ICA' in *ICA Bulletin*, no.146, May 1965, p.6.

3 The shop in Notting Hill was for sale and Boyle had borrowed the keys from the estate agent to view it over the weekend, staging the event on Sunday.

4 *Event for Judge, Jury and Prisoner at the Bar*. This concerned the prosecution of a woman who had appeared nude in Boyle and Hills's event, *In Memory of Big Ed*, held in Edinburgh during September 1963. The trial never came to court. See Andrew Wilson's essay, footnote 7.

5 This and all other unfootnoted quotes are taken from interviews with Boyle Family in March 2003.

6 The collector subsequently stored them in an attic room, where they were destroyed by leaking water. No paintings by Boyle or Hills have ever been exhibited or illustrated.

7 Hayward Gallery, London, *Boyle Family: Beyond Image*, 1986, p.11.

8 There was a major Schwitters retrospective at the Marlborough Gallery, London in March 1963.

9 *The Scotsman*, 28 August 1963, p.10. The 31 August issue carried photographs of Boyle and one of the works under the heading 'Glasgow Man Exhibits above the Traverse Theatre'.

10 *Glasgow Herald*, 23 August 1963, p.10.

11 Because they were unable to show at the Traverse Art Gallery, Demarco managed to get temporary accommodation at the Bank of Scotland building at 97–9 George Street, Edinburgh. The other artists in the exhibition were Xavier Corbero, William Featherstone, Esther Gentle, Olivier Herdies, Allen Leepa and Abraham Rattner.

12 Undated letter, Traverse Theatre Club archives, National Library of Scotland (Acc.4850, box 18). Boyle's reluctance to discuss his biography resulted in an erroneous birth date being listed in the catalogue.

13 David Irwin, 'Current and Forthcoming Exhibitions: Edinburgh Festival' in *Burlington Magazine*, no.106, October 1964, p.474.

14 They had first used resins in 1963, filling drawers with transparent resin in which they placed small objects.

15 Mark Boyle, untitled statement in *Control Magazine*, no.1, 1965, unpaginated.

16 'Two Statements by Mark Boyle' in *Studio International*, no.172, October 1966, p.196, quoting from Boyle's statement published on the occasion of the Indica Gallery exhibition.

17 Those who threw darts included Richard Hamilton, Dorothy Morland, Liliane Lijn, Carl Davis, Julie Lawson and Mike Figgis. A second version of the map was made by Hansjörg Mayer and his students at Watford School of Art in 1970, for publication in the catalogue *Journey to the Surface of the Earth: Mark Boyle's Atlas and Manual*, published in 1970. Small arrows, highlighting each dart hole, were added for the purposes of the publication.

18 Ibid., 'Manual for the Journey', unpaginated.

19 Ibid., appendix 2, unpaginated, quoting an interview in the *Daily Telegraph*, 1969.

20 Ibid., appendix 7, unpaginated.

21 *Mark Boyle und Joan Hills' Reise um die Welt 3: Schweizer Serie / Mark Boyle and Joan Hills' Journey to the Surface of the Earth 3: The Swiss Site*, Kunstmuseum, Lucerne, 1980, p.10.

Towards an Index for Everything pages 45–61

1 Mark Boyle, untitled statement in *Control Magazine*, no.1, 1965, unpaginated. This statement was also printed in 'Two Statements by Mark Boyle', *Studio International*, no.882, October 1966, p.196, which states that it 'was written in 1965, and was intended for the catalogue of an exhibition called *Ventures*, which was to take place at the Marlborough New London Gallery, and was subsequently cancelled'.

2 Alexander Trocchi, 'The destruction of the object' [1962], 1 page ms. note, Trocchi Estate.

3 The announcement handbill for the conference lists 100 participants from around the world, including Lindsay Anderson, Lionel Bart, Peter Brook, Richard Burton, Ken Dewey, Marguerite Duras, David Frost, Jack Gelber, Peter Hall, Eugène Ionesco, Joan Littlewood, John Mortimer, Harold Pinter, Joan Plowright, Alain Robbe-Grillet, Peter Schaffer, Wole Soyinka, Peter Ustinov and Arnold Wesker, most of whom attended. See Jim Haynes, *Thanks for Coming!*, Faber and Faber, London, 1984, unpaginated.

4 Kenneth Dewey, 'Act of San Francisco at Edinburgh', *New Writers Four*, Calder & Boyars, London, 1967, p.68.

5 Dewey had invited Boyle and Hills to collaborate after having seen their solo exhibition of assemblages at the Traverse Art Gallery, which coincided with the Edinburgh Festival.

6 Allan Kaprow, *Assemblage, Environments & Happenings*, Harry N. Abrams Inc., New York, 1966, p.281.

7 The startling appearance of the naked art school model (Anne Kesselaar) was specifically aimed at the law that did not allow for naked actors to move on stage – so she had remained still while being moved across the balcony on a trolley. It was this moment that caused uproar in the press and the threat of legal action on Dewey and Boyle. The model was prosecuted and Boyle and Dewey were told that if a conviction was obtained against her then they would also be prosecuted. In the event, the magistrate came out with a judgement in her favour, accusing the press of hypocrisy. Boyle treated the threat of a court case as the basis for *Event for Judge, Jury and Prisoner at the Bar* in which the main protagonist, the prisoner at the Bar, swears to 'tell the truth, the whole truth and nothing but the truth', before making 'a serious and profound attempt to tell the whole truth' – just as in the same way Boyle and Hills saw 'everything' as the material for their work. This event was never performed.

8 For differing accounts of *In Memory of Big Ed* see Charles Marowitz, 'Happenings at Edinburgh' and Ken Dewey 'Act of San Francisco at Edinburgh' both in *New Writers Four*, 1967, pp.57–74. Mark Boyle's memory of the event is printed in J.L. Locher, *Mark Boyle's Journey to the Surface of the Earth*, Edition Hansjörg Mayer, London, 1978, pp.97–104. Ken Dewey's score is reproduced in Allan Kaprow, 1966 (see note 6), pp.281–4. The conference ended with the delegates and audience leaving the hall via Kaprow's environment / Happening, *Exit Play*, described by Marowitz, ibid., p.61, as a 'ritualistic walk along a barriered path jammed with auto tyres'.

118

9 Charles Marowitz, ibid., p.60.

10 When they had been living in Harrogate in 1959 Boyle and Hills had constructed 'anxiety objects' such as a chair with no visible means of support, which they had exhibited in their home for friends.

11 Antonin Artaud, *Collected Works*, vol.2, Calder & Boyars, London, 1971, p.26.

12 Mark Boyle remembers *Bags* as originally having no title.

13 From a conversation with the author. This comes from a series of conversations with Mark Boyle, Joan Hills and Sebastian Boyle, 8 March and 5 April 2003. Any future unreferenced quotations come from these conversations.

14 Jasia Reichardt, 'On Chance and Mark Boyle', *Studio International*, no.882, October 1966, p.165.

15 This is reproduced in Mark Boyle, *Journey to the Surface of the Earth Mark Boyle's Atlas and Manual*, Haags Gemeentemuseum / Edition Hansjörg Mayer, London, 1970, 'Appendix 15, Human, Social', unpaginated.

16 Both Metzger and Willats were in the audience both have attested to its imaginative power and resolution in coversations with the author.

17 Contemporary review in *Encore* magazine, reprinted in Mark Boyle, 1970 (see note 15), 'Appendix 16, Human, Social', unpaginated.

18 Apart from Boyle and Hills, the festival included the second presentation of Carolee Schneeman's *Meat Joy*, Lebel's *Pour conjurer l'esprit de catastrophe*, as well as work by Ferro and Daniel Pommereulle. It had been intended to take place on 8 and 9 June, but in the event the second evening was abruptly cancelled by the building's caretaker. The handbill for the event titles it as *A Happening Collage from the Paris Exhibition of Free Expression, A Sociodramatic Event*. The Paris exhibition of Free Expression had taken place on 29 May, with many of the same participants.

19 Jean-Jacques Lebel cited in 'It happened', the *Guardian*, 10 June 1964.

20 Jean-Jacques Lebel, 'Theory and Practice' *New Writers Four*, 1967, p.20.

21 This coincided with the theatre production of Joan Littlewood's *Oh What a Lovely War*.

22 Mark Boyle, 'Background to a series of events at the ICA', *ICA Bulletin*, no.146, May 1965, p.6.

23 For this event Stephen Willats contributed a cybernetic flow diagram to indicate the routes the audience might follow, printed versions of which were given to every member of the audience as they arrived. Willats's diagram divided the event into four periods: the first was the entry procedure, the second was the committee stage in which the audience, having decided which areas they were to work in, discussed how they were to follow the event through; the third period was the event itself. For this the space was divided into six areas: area one, trampoline; area two, play ballet, opera singer, charades, piano, orchestra, orators, painting by numbers, balloons; area three, film making; area four, projection; area five, direction and programming, sound, press communiqué; area six, projection on buildings. The fourth period, 'Artwork', entailed the writing of notes on the event. Willats also discussed the structure of the following two events in the ICA series with Boyle and Hills. Although Willats's audience flow structure for *Oh What a Lovely Whore* is echoed in contemporary reports of the event it was not strictly adhered to and its description of the event was more organised and planned than Boyle and Hills intended the event to be and certainly did not reflect how the event turned out. Although all the activities listed were arranged, there was no suggestion that any of these had to be done. The crowd was free to do whatever it wanted to do. Information from a conversation with Stephen Willats, 6 May 2003; the documentation on the event is held in his archive.

24 'Happenings …', *ICA Bulletin*, no.147, June 1965, p.14, carries the polite note that 'Owing to the overwhelming success of the Event which took place at the ICA on May 11th it has been decided to postpone the next one until larger and more suitable premises are found. We hope to be able to announce one for July.' The series was in actual fact cancelled. The two *Dig* events the following year offered a form of continuation for this aborted series.

25 Hills worked with the Mithras film company (1963–4) when they were working at Transport House preparing films for the 1963 general election. The group then moved to Wardour Street as David Naden Associates and Hills left the company in 1967. The film component of their events was a direct result of Hills's work.

26 Cited in Mark Boyle, 1970 (see note 15), 'Appendix 19 Human, Social', unpaginated.

27 This was part of a fundraising event for the ICA organised by Boyle which included performances by John Latham and Jeff Nuttall, Cornelius Cardew and a light projection by Gustav Metzger – *Notes on the Chemical Revolution in Art* – a rear projection using three adapted stage projectors.

28 A report of *Dig* was published in the *ICA Bulletin*, June 1966, p.18. It reports that 'Each person was invited to select 5 items for exhibition and they proffered everything from Venus to the kitchen sink. Cardew unearthed and nominated the concrete floor of the factory. Gustav Metzger uncovered a cache of plaster moulds, with improvised ligatures lying untouched since fire brought production here to an end over six months ago. Documentation found with the moulds disclosed that the factory did a secondary line in various filtration processes.'

29 Statement by Boyle written for a 1966 issue of *Find* magazine, reprinted in Mark Boyle, *Journey to the Surface of the Earth, an exhibition to launch project 'Earthprobe'…*, ICA, London, 1969, unpaginated.

30 Boyle knew what was on the site but none of the invited group did – he had first come across the site while looking for locations for *Exit Music*. A second *Dig*, the following day at a site selected at random, which turned out to be an allotment garden in Watford. The collections gathered from the two *Dig*s were then exhibited together. Given the cancellation of the series of events at the ICA the previous year, many people who turned up at the ICA for *Dig* thought that Boyle was having a 'dig' at the ICA, assumed the event was a lecture, and so arrived suitably (or unsuitably, as it turned out) dressed.

31 In conversation with Barry Miles, 10 April 2003, there was some uncertainty as to whether this move took place before or immediately after the Boyle presentation. However, as the presentation occupied both the ground and basement floors of the gallery, this does suggest that the move took place just before the presentation.

32 Gustav Metzger, untitled statement in *Art & Artists*, August 1966, p.22.

33 Gustav Metzger, 'Auto-Destructive Art', London, June 1965, published in *Art & Artists*, August 1966, p.1. Metzger states that Auto-Destructive Art does not limit itself 'to theory of art and the production of artworks. It includes social action.'

34 Gustav Metzger, 'Excerpts from selected papers presented at the 1966 "Destruction In Art Symposium"', *Studio International*, December 1966, p.282.

35 It is not certain when or where the first in the series, *Son et Lumière for Earth, Air, Fire and Water*, was first performed. Given the conceptual evolution of the series from *Earth, Air, Fire and Water*, to *Insects, Reptiles and Water Creatures* and then to *Bodily Fluids and Functions* (for example, from the world we see, to the creatures in the world and then to us) it is inconceivable that *Earth, Air, Fire and Water* was not presented first. It is assumed that it was first presented at the Cochrane Theatre or at the ICA in July or August 1966, either under the given name or as a work in progress, however, no records to support this can be located. It is known, for instance, that through 1966 Boyle was presenting a number of light projection events at the ICA and elsewhere – some more impromptu than others – which may have essentially constituted *Earth, Air, Fire and Water*. *IT*, no.3, 14–27 November 1966, carries a listing for an event at the ICA on 29 November, as: 'Mark Boyle shows his work with help from Joan and Cameron Hills – psychedelic-type projections, burning slides.'

36 Mark Boyle's programme note for *Sound/Light for Insects and Water Creatures*, opening programme for DIAS at the Cochrane Theatre, London, 1 September 1966. Reprinted in Mark Boyle, 1970 (see note 15), 'Appendix 8, Animal', unpaginated. In Mark Boyle, 1969

(see note 29), the other two works in the series are titled as *Son et Lumière for Earth, Air, Fire and Water* and *Sound/Light for Bodily Fluids and Functions*. Boyle and Hills's use of the *Son et Lumière* at the ICA probably stems from the section of *Oh What a Lovely Whore* event, which involved light projection onto the buildings around the ICA in Dover Street. Today they prefer to refer to this series of three events without using the prefix *Son et Lumière* or *Sound/Light*.

37 For Metzger, Auto-Destructive Art actually involved destruction and creation in equal measure. That his third manifesto of Auto-Destructive Art, 23 June 1961, was titled *Auto-Destructive Art Machine Art Auto-Creative Art* makes this distinction clear.

38 Reprinted in Mark Boyle, 1970 (see note 15), 'Appendix 8, Animal', unpaginated.

39 J.L. Locher, 1978 (see note 8), p.68, material taken from a letter from Mark Boyle to Locher, October 1977.

40 Mark Boyle, 1969 (see note 29), unpaginated.

41 Jasia Reichardt, 1966 (see note 14), pp.164–5 (excerpts from this text were reprinted in the catalogues for the exhibitions in Liverpool and Bristol).

42 In 1968, *Bodily Fluids and Functions* was presented at the Roundhouse on a huge circular screen. For this performance the copulating couple were wired up to ECG and EEG and the resulting oscilloscope images were projected onto the large screen behind the couple – the record of their heartbeats and brainwaves being revealed alongside images of swimming sperm. The work had also evolved in that this performance included a collaboration with Graziella Martinez: 'The original intention was for the girl to go to sleep afterwards with a strong soporific and to be wakened as soon as the ECG showed that she was dreaming. She would then tell her dream, and the dancer, Graziella Martinez, would attempt to dance it. This experiment failed, because the girl was not put to sleep by the pill. In the end, Martinez and her partner, the artist, Graham Stevens, had to dance variations on the theme of a dream one of them had had.' J.L. Locher, 1978 (see note 8), p.73.

43 Mark Boyle, 1970 (see note 15), 'Appendix 9, Human, Physical', unpaginated.

44 From *IT*, no.3, 14–27 November 1966, Miles had initiated the forlorn campaign to turn London into a twenty-four-hour city.

45 John Hopkins, 'The Pink Floyd versus psychedelphia', *IT*, 13–16 March 1967, p.4.

46 Barry Miles, *In the Sixties*, Jonathan Cape, London, 2002, p.152.

47 Ibid. p.185.

48 Peter Fryer, 'A Map of the Underground', *Encounter*, October 1967, pp.17–18.

49 There is little contemporary documentation concerning the events at UFO in its early weeks (the first published mention of Boyle and Hills making light projections at UFO is the advertisements and poster for the evening of 17 February, 1967). However, Mike Ratledge of Soft Machine claims that Boyle and Hills projected at UFO from the first evening, and certainly other evidence supports this. Communication with Mike Ratledge, 21 May, 2003: 'I seem to remember that our first appearance at UFO (23 December, 1966) was accompanied by the Boyle light show and that we started collaborating soon afterwards.'

50 Boyle and Hills were not alone in this. For instance, Gustav Metzger, in October 1965, had pioneered a technique of projecting liquid crystals, had provided projections at the Roundhouse for the Cream on 30 December 1966, and the Who and the Move on 31 December.

51 For accounts of this event see Barry Miles, 2002 (see note 46), pp.181–4; Jonathon Green, *Days in the Life, voices from the English underground, 1961–1971*, William Heinemann, London, 1988, pp.161–5; Jonathon Green, *All Dressed Up, the Sixties and the counterculture*, Pimlico, London, 1999, pp.219–21.

52 A useful chronology for Soft Machine's performances can be accessed at www.angelfire.com/music/PFArchives/Tourdate/Smdates.htm.

53 'Light Show', *IT*, no.14, 2 June 1967, pp.8–9 and p.15.

54 Ronald Bryden, 'Epitaph on a young seedbed' reprinted Jim Haynes, 1984 (see note 3), p.214.

55 This experience contributed to Boyle and Hills's decision to cease public light projection events at the end of 1968. They ultimately took this decision when, shortly after returning from the tour of America with Soft Machine, they found themselves fulfilling a gruelling daily schedule whereby Hills did a film and light scenario for John Arden's musical on Nelson, *The Hero Rises Up*, at the Roundhouse, while Boyle was doing a light show at the ICA in conjunction with the Apollinaire centenary celebrations and then they would come together to provide a ten-minute light overture for *The Beard* at the Royal Court. The schedule alongside the pressure to provide strictly scripted and timed light shows for the theatre encouraged them to stop this activity.

56 Boyle and Hills returned in March for their son Sebastian's birthday and to provide a light show for the ICA's house-warming party at its new building at Nash House on the Mall on 22 March with Graziella Martinez and Ginger Johnson's African Drummers. (Sensual Laboratory and Soft Machine had earlier mounted the ICA Move Out Party from Dover Street on 8 December 1967.) At the end of March, Hills remained in London, but Boyle flew back to America to continue the tour until the end of April. Soft Machine returned to America for a second tour, 30 July – 14 September, without Sensual Laboratory.

57 Mark Bloch 'takes a journey beneath the surface with Britain's Mark Boyle' (interview): 'When the dust settles …' *High Performance*, no.15, Fall 1981, p.76.

58 Ibid.

59 The score for *Requiem for an Unknown Citizen* is reprinted in Mark Boyle, 1970 (see note 15), alongside a discussion of its development, 'Appendix 20, Human Social', unpaginated. It is also discussed at some length in J.L. Locher, 1978 (see note 8), pp.79–88 and pp.146–53.

Chronology

Major exhibitions and events by Mark Boyle, Joan Hills and Boyle Family are shown in **bold** type.

1931

Joan Hills (née Little) born, Edinburgh.

1934

Mark Boyle born, Glasgow.

1948–9

Hills continued her painting from school days to student years, but studied building, construction and structural mechanics at Heriot Watt College in Chambers Street, Edinburgh.

1950

Hills enrolled on architecture course at Edinburgh College of Art.

1951

Hills married, taking her husband's name, and left Edinburgh College of Art; moved to Suffolk where her husband worked.

1952

Mark Boyle enrolled at the University of Glasgow, studying law. Developed an interest in poetry.

Cameron Hills born.

1953

Boyle left university and joined the army. Initially with the Scots Guards; later he moved to Northern Command Headquarters, outside Harrogate, where he organised supplies for the Ordnance Corps. He continued writing poetry.

1956

Joan Hills separated from her husband. Moved back to Edinburgh and then on to Harrogate, with her son, Cameron.

1957

April: while in the army, Boyle met Hills in Harrogate. They moved in together in the summer. Boyle left the army and started painting.

1959

Boyle and Hills sold their first paintings to a local collector in Harrogate.

1960

In the spring, Boyle and Hills lived in Paris for three months, then settled in London, staying in Regent Park Terrace, and towards the end of the year moved to Hanson Street, near the Post Office Tower.

Boyle and Hills began working at Jasper's Restaurant behind the Royal Court Theatre, London.

1961

Boyle and Hills made their first assemblages, fixing paint tins, brushes, lids and paint onto home-made wooden palettes.

Moved to 114 Queensgate, west London.

1962

March: Sebastian Boyle born.

First projection experiments.

1963

Woodstock Gallery, London
Erections, Constructions & Assemblages by Mark Boyle (29 July – 17 August)

Traverse Art Gallery, Edinburgh
Erections, Constructions & Assemblages by Mark Boyle (20 August – early September)

August: Boyle gave a poetry reading with Spike Hawkins and Ted Milton behind Jim Haynes's bookshop in Edinburgh.

In Memory of Big Ed
7 September event at the McEwan Hall, Edinburgh on the last day of the International Drama Conference as part of the Edinburgh Festival. Boyle and Hills collaboration with Ken Dewey, Charles Lewson and Charles Marowitz.

Judge, Jury and Prisoner at the Bar
Event conceived in response to the threat of Boyle being prosecuted for obscenity following the appearance of a nude model in *In Memory of Big Ed* (never performed).

Citizen's Theatre, Glasgow
Erections, Constructions & Assemblages by Mark Boyle, Traverse Art Gallery, toured by Scottish Arts Council (September).

Ledlanet Nights: Painting, Sculpture and Things by Living Scottish Artists, group exhibition at John Calder's mansion near Edinburgh. Other exhibitors included William Gear, Ian Hamilton Finlay and Alexander Trocchi (20 September – 1 October).

October: Georgia Boyle born.

Wanting to incorporate film into their events, Hills worked part-time with film editor Julia Wolf and then with the Mithras film company, 1963–4. Mithras subsequently became David Naden Associates, where Hills continued to work part-time until 1967.

Three poems by Boyle were published in *Paris Review*, no.39, winter / spring 1963 issue.

1964

Contrasts, a mixed exhibition including Moore, Hepworth and others, at McRoberts & Tunnard Gallery, London.

Exit Music
Event at Strand Electric Theatre, London. A collaboration with Ken Dewey and Charles Marowitz.

Bags
Event performed as part of the International Festival of Happenings, organised by Jean-Jacques Lebel, at Denison Hall, London (8 June).

Exhibition of International Contemporary Art, Traverse Art Gallery, held at 97–9 George Street, Edinburgh (16 August – 5 September).

Traverse Art Gallery, Edinburgh
Mark Boyle Assemblages, exhibition of twenty constructions in boxes (October).

First random earth studies, on a demolition site at Norland Road, Shepherd's Bush, London.

First presentation of physical and chemical reactions through light projectors.

Suddenly Last Supper
Event coinciding with the eviction of Boyle Family from their flat at 114 Queensgate, London.

Moved to 7a Lansdowne House, Lansdowne Road, near Holland Park Underground station.

Street
Event in Pottery Lane, Notting Hill, London.

1965

Began using resins in earth studies, with *Shepherd's Bush Series*, including street studies, sites beside the Thames at Hammersmith Reach and the demolition site at Norland Road, Shepherd's Bush.

Oh What a Lovely Whore
11 May, event performed at ICA London.

Any Play or No Play
7 September, event performed at Theatre Royal, Stratford East, London.

Boyle taught part-time at Watford School of Art for one year. His teaching duties included taking the film making course.

Moved from Lansdowne House to a flat in Advance House, Ladbroke Grove.

 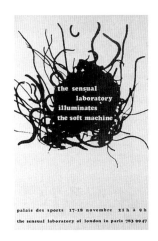

1966

Dig

6 February, Shepherd's Bush, London, event organised under the auspices of The Institute of Contemporary Archaeology. There was a second *Dig* the next day in Watford and then material from both *Digs* was exhibited at Boyle and Hills's new flat at 225 Holland Park Avenue.

May–June: First Beach and Mudcracks Studies, Camber.

Indica Gallery, London
Presentation by Mark Boyle (16 July – early August).

Son et Lumière for Earth, Air, Fire and Water
August, first performance at Jeanetta Cochrane Theatre, London.

Son et Lumière for Insects, Reptiles and Water Creatures
1 September: at the opening of the Destruction in Art Symposium (DIAS), Boyle and Hills performed at Jeanetta Cochrane Theatre, London.

30 September: burning slide projection as part of final day of DIAS, Africa Centre, London.

October: article by Jasia Reichardt 'On Chance and Mark Boyle' in *Studio International*.

November: formed the Sensual Laboratory, which included Mark Boyle, Joan Hills, Cameron Hills, Des Bonner, John Claxton and other friends and acquaintances who helped on film, slide and light projects.

Institute of Contemporary Archaeology, London
Here Today, exhibition at Boyle and Hills's flat of Shepherd's Bush studies and material from *Dig*.

23 December: Boyle and Hills / Sensual Laboratory performed *Son et Lumière for Earth, Air, Fire and Water* at UFO club, London and are then asked to provide light environments for Soft Machine for the first time, which they continued to do at UFO and other venues in London, Britain and Europe throughout 1967.

1967

Bluecoat Society of Arts, Liverpool
Exhibition 10–28 January and performance of two events: *Son et Lumière for Earth, Air, Fire and Water* (10 January)

Son et Lumière for Bodily Fluids and Functions
First performed 11 January, Bluecoat, Liverpool.

Bristol Art Centre
Son et Lumière for Earth, Air, Fire and Water: exhibition and performance (10 February).

Son et Lumière for Bodily Fluids and Functions and other projection pieces, Jeanetta Cochrane Theatre, London (March).

14-Hour Technicolour Dream, Alexandra Palace, London (29 April). All-night group event to raise funds for *International Times*. Collaboration with Soft Machine.

Festival sur la Plage de Saint-Aygulf, France: made light shows for Soft Machine in geodisc dome designed by Keith Albarn (1–5 July).

Festival of Free Theatre, Cogolin, France, organised by Jean-Jacques Lebel: Boyle and Hills collaborated with Soft Machine to provide overture for Picasso play *Desire Caught by the Tail* (for two weeks in early August).

Lullaby for Catatonics
Edinburgh Festival collaboration with Soft Machine and Graziella Martinez (1 September, later performed at Toulon Festival, Paris Biennale and in Holland). Also collaborated with Soft Machine on sound and light show for Traverse Players' production of *Ubu in Chains* at the festival.

Cinquième Biennale des Jeunes: Musée d'Art Moderne de la Ville de Paris (28 September – 3 November). Prize for painting.

Son et Lumière for Bodily Fluids and Functions, Roundhouse, London.

Premio Lissone, Milan: prize for painting.

Studies Towards an Experiment into the Structure of Dreams
Sensual Laboratory and Graziella Martinez performance at the Arts Lab, Drury Lane, London (seventy performances).

The Beard: John Arden play at the Royal Court Theatre, London. Boyle and Hills provided light environment for the overture.

Began *London Series* – 100 random studies of London.

1968

Zagreb International Exhibition: prize for painting.

January–April: toured USA producing light shows for Jimi Hendrix and Soft Machine. Approximately fifty performances.

22 March: produced light environment for opening of the new ICA at Nash House, The Mall, London.

Arts Lab., London, collaboration with George Brecht, Cornelius Cardew and John Tilbury.

August: began random selection of sites for the *World Series* (*Journey to the Surface of the Earth*).

1969

January: Moved from 225 Holland Park to 75 Addison Road, London.

ICA, London
Journey to the Surface of the Earth: An Exhibition to Launch and Earthprobe by Mark Boyle, The Sensual Laboratory and The Institute of Contemporary Archaeology (3 June – 20 July).

Body Work
Event at ICA, London.

Taste/Sight and Smell/Taste
Event at ICA, London.

24 June: Soft Machine played a concert at the ICA in Boyle / Hills / Sensual Laboratory projected environment.

Event at the ICA, London.

Began work on *Requiem for an Unknown Citizen* (performed 1971).

Joan Hills began making *Seeds for a Random Garden* (conceived 1966).

Made *Sand, Wind and Tide Series* (also known as the *Tidal Series*) at Camber Sands (1–7 November). Boyle, Hills and the family stayed at Camber working on the *Tidal Series* through November and then made the *Snow Series* on Camber beach.

1970

Gemeentemuseum, The Hague
Journey to the Surface of the Earth (16 May – 12 July).

Soft Machine played a concert at the opening of the exhibition with Boyle / Hills / Sensual Laboratory projections.

Made first of the *World Series* works, near The Hague.

ICA, London
Sand, Wind and Tide Series.

Bela Centre, Copenhagen
Second *World Series* work, Nyord in Denmark.

Began *Multi Human Being Studies*.

1971

Henie-Onstad Kunstsenter, Høvikodden, Oslo

Akademie der Kunst, Berlin

Paul Maenz Gallery, Cologne

The Sensual Laboratory London

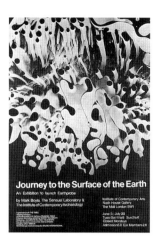

Journey to the Surface of the Earth

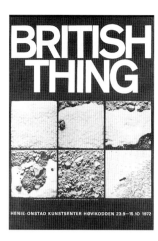

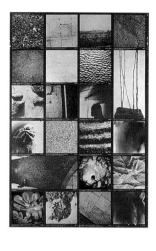

BRITISH THING

HENIE-ONSTAD KUNSTSENTER HØVIKODDEN 23.9–15.10 1972

27 February: Soft Machine concert at the Henie-Onstad Kunstsenter with Boyle / Hills projections.

27 March: Boyle and Hills collaborated with Soft Machine for the last time at a concert at the Deutschlandhalle in Berlin.

Requiem for an Unknown Citizen
Two performances at the De Lantaren Theatre, Rotterdam, by the Sensual Laboratory.

Stopped giving performances and light shows. The Sensual Laboratory disbanded and all collaborative work reduced to family members.

Began the *Rock Series*.

1972

Paul Maenz Gallery, Cologne

British Thing, Henie-Onstad Kunstsenter, Høvikodden, Oslo (23 September – 15 October).

Made four separate *World Series* works in Norway.

Thaw Series, Norway.

Urban refuse-fire project, London.

1973

Kelvin Hall, Glasgow
Mark Boyle: Journey to the Surface of the Earth (17–30 June).

McRobert Art Centre, Stirling

Gallery Muller, Stuttgart

Magic and Strong Medicine, Walker Art Gallery, Liverpool.

Skin Series: continuation of the body pieces begun in 1966 and *Body Works* of 1969. They are cytograms made of randomly selected parts of Mark Boyle's body.

1974

Paul Maenz Gallery, Cologne

Began *Lorrypark Series*, London.

Bergheim, Germany, *World Series* project.

Wallraf-Richartz Museum, Cologne, centenary exhibition.

Paul Maenz Gallery, Cologne.

Art as Thought Process (Arts Council of Great Britain Collection), Serpentine Gallery, London.

Moved to Red Lion House, Chiswick Mall, London.

1975

Serpentine Gallery, London
Mark Boyle: Journey to the Surface of the Earth (Continued) (4 October – 2 November).

British Art Mid '70s, Frankfurt and Leverkusen.

From Britain '70s, Helsinki.

Project 3 - Body and Soul, Walker Art Gallery, Liverpool.

1976

Arte Inglese Oggi 1960–76, Palazzo Reale, Milan.

Recent British Art, British Council touring exhibition to Greece, Yugoslavia, Austria, Iran, Poland, Scandinavia and Portugal.

Liverpool Series

Concrete Pavement Series

Red Causeway Series

Breakers Yard Series

Red Wall Series

1977

Photographs – Works at Felicity Samuel Gallery, London (31 January – 4 March).

Real Life, Walker Art Gallery, Liverpool.

English Contemporary Art, City Art Gallery, Bregenz, Austria.

Felicity Samuel Gallery, London
(17 October – 2 December)

Rock and Scree Series

Railway Series

1978

Sardinian *World Series* project.

British Pavilion, XXXIX Venice Biennale

Kunstmuseum, Lucerne
Mark Boyle und Joan Hills' Reise um die Welt / Mark Boyle and Joan Hills' Journey to the Surface of the Earth (5 November – 6 December). First exhibition as 'Mark Boyle and Joan Hills'.

Began Swiss *World Series* project.

Henie-Onstad Kunstsenter, Høvikodden, Oslo

Kulturhuset, Stockholm
Painters in Parallel, Edinburgh College of Art (16 August – 9 September).

Arts Council of Great Britain Collection Acquisitions, Hayward Gallery, London.

1979

Louisiana Museum of Modern Art, Humlebæk
Mark Boyle: at Opdage Virkeligheden (3 March – 29 April).

Museum Am Ostwall, Dortmund

Studies of Cliffs and Desert Terrain, Central Australian Desert.

1980

Kunstmuseum, Lucerne
Mark Boyle und Joan Hills' Reise um die Welt 3: Schweizer Serie / Mark Boyle and Joan Hills' Journey to the Surface of the Earth 3: The Swiss Site.

Adelaide Festival, Adelaide
Journey to the Surface of the Earth: Australia, Contemporary Arts Society Gallery (7–29 March).

Charles Cowles Gallery, New York

Richard Hines Gallery, Seattle, Washington

British Art 1940–80: The Arts Council of Great Britain Collection, Hayward Gallery, London.

From Object to Object, Arts Council of Great Britain touring exhibition.

1981

Seattle Art Museum, Seattle, Washington

Newport Harbor Art Museum, Newport, California

Approaches to Landscape, Tate Gallery, London.

Toyama Museum, Toyama, Japan (inaugural exhibition).

1982

Institute of Contemporary Art, Boston, Mass.

San Francisco Museum of Modern Art, San Francisco

Aspects of British Art, British Council tour of Japan to Tokyo Metropolitan Art Museum, Tochigi Prefectural Museum of Fine Arts, Utsunomiya, The National Museum of Art, Osaka, Fukuoka Art Museum, Hokkaido Museum of Modern Art.

Worked in Japan on projects in Toyama, Oya and Iwaki prefectures.

1983

Nishimura Gallery, Tokyo

1984

Moved to Hillside House, Crooms Hill, Greenwich, London.

1985

Dialogue, Calouste Gulbenkian Foundation, Lisbon.

Henie-Onstad Kunstsenter, Høvikodden, Oslo
Boyle Family Archives, September. First exhibition as 'Boyle Family'.

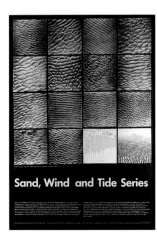

A Notional Gallery, London
Warehouse exhibition near Tate Gallery, London.

1986

Between Object & Image, British Contemporary Sculpture, Palacio de Velázquez, Madrid; toured to Barcelona and Bilbao.

Forty years of Modern Art, 1945–1985, Tate Gallery, London.

Studies of the Nude, Marlborough Fine Art, London.

Cornerhouse Art Centre, Manchester

Hayward Gallery, London
Beyond Image: Boyle Family (1 November – 25 January 1987).

Began *Broken Path Series, Westminster Series* and first *Chalk Cliff* studies.

1987

British Art in the 20th Century, Royal Academy London; toured to Staatsgalerie, Stuttgart.

Southampton City Art Gallery

Glasgow Art Gallery and Museum

Museum of Modern Art, Oxford

Museum Sztuki, Lødz and the BWR Gallery, Sopot, Gdansk, Poland

XIX Bienal de Sao Paulo, Brazil

Gardner Centre, Brighton

Warwick Arts Centre, Coventry

Turske & Turske Gallery, Zurich

Turske & Whitney Gallery, Los Angeles

1988

Galerie Lelong, Paris

Experience of Landscape, Arts Council of Great Britain touring exhibition.

Modern British Sculpture, Tate Gallery, Liverpool.

British Contemporary Sculpture, Musée des Beaux-Arts, Le Havre and tour.

Paco Imperial, Rio de Janeiro

Richard Gray Gallery, Chicago

Highland Shore project, Scotland.

Hiroshima project.

1989

Turske & Turske Gallery, Zurich

Terra Firma, Columbia University Gallery, New York.

Fire Series, London.

Scottish Art Since 1900, Scottish National Gallery of Modern Art, Edinburgh; toured to Barbican Art Gallery, London.

1990

Friedman-Guinness Gallery, Frankfurt

Gisborne, New Zealand *World Series* project.

Kyushu, Japan *World Series* project.

Began the *Japan Series* working in Nagasaki, Fukuoka, Saga, Kagoshima, Miyazaki and Kumamoto prefectures.

Auckland City Art Gallery, New Zealand
(11 September – 28 October)

Glasgow's Great British Art Exhibition, McLellan Galleries, Glasgow.

Team Spirit, Neuberger Museum, New York and tour.

Nishimura Gallery, Tokyo
Boyle Family: Japan Series (16 October – 10 November).

New York project.

1991

Docklands Series, London.

Runkle-Hue Williams Gallery, London
Docklands Series (31 May – 5 July).

1992

The Negev Desert, Israel *World Series* project.

1993

The Sixties Art Scene in London, Barbican Art Gallery, London.

Began the Barra, Scotland, *World Series* project.

1994

Georgia Boyle moved to St Stephen's Gardens, London.

1996

Spirit and Place, Museum of Contemporary Art, Sydney.

1997

Boyle and Hills designed and built Christmas House in Greenwich.

Reflection Studies project begun by Sebastian Boyle.

1998

Compton Verney Art Museum
Out of Actions: Between Performance and the Object 1949–1979, MOCA Los Angeles; toured to MAK Vienna, Museu d'art Contemporani de Barcelona, and Museum of Contemporary Art, Tokyo.

Transistors, Hashimoto Museum of Art, Morioka, Japan and Royal Museum of Scotland, Edinburgh.

In Our Time, Bayley Art Museum, Virginia.

1999

Sebastian Boyle opened a Boyle Family project space, 'Construction', at his house in London.

Construction, London

Construction, Edinburgh

Collaboration Art, Possibilities of Joint Production, Fukushima Prefectural Museum of Art.

Relic / Reliquary, Institute for Modern and Contemporary Art, Calgary.

2000

Boyle Family: a Documentary directed by Georgia Boyle and Fran Robertson for the BBC and the Scottish Arts Council.

Construction, London

Live in Your Head, Whitechapel Art Gallery, London; toured to Museu do Chiado Lisbon (2001).

Beside the Sea, National Maritime Museum, Greenwich, London.

Began Barcelona project from the *World Series*.

Sebastian Boyle and E-Sinn Soong married in New York.

2001

Construction, London

Les Années Pop, Centre Pompidou, Paris (Beyond Image film).

2002

Construction, London

Markers, McMaster Museum of Art, Hamilton, Ontario.

Blast to Freeze: British Art in the 20th Century, Kunstmuseum Wolfsburg; toured to Les Abattoirs, Toulouse (2003).

Began random sound study of London.

2003

Scottish National Gallery of Modern Art, Edinburgh
Boyle Family (14 August – 9 November).

Boyle Family live and work in London.

Bibliography

Books and Exhibition Catalogues

Beyond Image: Boyle Family, Arts Council of Great Britain (Hayward Gallery), London, 1986

Birrell, Ross, Finlay, Alec and Robb, Steve (eds.), *Justified Sinners: An Archaeology of Scottish Counter-Culture (1960–2000)*, Edinburgh, 2002

Boyle Family Archives, Henie-Onstad Kunstsenter, Høvikodden, Oslo, 1985

Boyle Family: Docklands Series – London, Runkle-Hue Williams Gallery, London, 1991

Boyle Family: The Japan Series, Nishimura Gallery, Tokyo, 1990

Compton, Michael, *Mark Boyle, British Pavilion, Venice Biennale 1978*, British Council, London, 1978

Down to Earth: Boyle Family in New Zealand, Auckland City Art Gallery, Auckland, 1990

Familia Boyle: XIX Bienal Sao Paulo, British Council, London, 1987

Hall, Douglas, *Traverse Festival Exhibition of International Contemporary Art*, Traverse Festival Gallery, Edinburgh, 1964

Hewison, Robert, *Too Much: Art and Society in the Sixties 1960–75*, London, 1986

Holubizky, Ihor, *Mapping: Curatorial Project #7*, Art Gallery of Hamilton, Hamilton, Ontario, 1991

Im Kunstlicht: Photographie im 20 Jahrhundert aus den Sammlungen in Kunsthaus Zurich [*In The Limelight: Photography in the 20th century from the Collections in the Kunsthaus Zurich*], Zurich: Kunsthaus Zurich, 1996

Journey to the Surface of the Earth, Institute of Contemporary Arts, London, 1969

Journey to the Surface of the Earth: Mark Boyle's Atlas and Manual, Edition Hansjörg Mayer, Cologne, 1970

Lacey, C., *Art Anglais D'aujourd'hui*, Musée Rath, Geneva, 1980

Ledlanet Nights Exhibition, Painting Sculpture & Things by Living Scottish Artists, Ledlanet, Edinburgh, 1963

Locher, J. L., *Mark Boyle's Journey to the Surface of the Earth*, Edition Hansjörg Mayer, Stuttgart, 1978

Lutgens, Annelie and Cremer-Bermbach, Susannah, *Fluxus und Nouveaux Réalistes: Sammlung Cremer für die Hamburger Kunsthalle*, Hamburger Kunsthalle, Hamburg, 1995

Mark Boyle und Joan Hills' Reise um die Welt / Mark Boyle and Joan Hills' Journey to the Surface of the Earth, Kunstmuseum, Lucerne, 1978

Mark Boyle und Joan Hills' Reise um die Welt / Mark Boyle and Joan Hills' Journey to the Surface of the Earth, Museum Am Ostwall, Dortmund, 1979

Mark Boyle at Opdage Virkeligheden, Louisiana Revy, Louisiana Museum of Modern Art, Humlebæk, 1979

Mark Boyle und Joan Hills' Reise um die Welt 3: Schweizer Serie / Mark Boyle and Joan Hills' Journey to the Surface of the Earth 3: The Swiss Site, Kunstmuseum, Lucerne, 1980

Mellor, David, *The Sixties Art Scene in London*, London, 1993

Patrizio, Andrew, *Contemporary Sculpture in Scotland*, Sydney, Craftsman House, 1999

Philpot, Clive and Tarsia, Andrea, *Live in Your Head: Concept and Experiment in Britain 1965–75*, Whitechapel Art Gallery, London, 2000

Schimmel, Paul (ed.), *Out of Actions: Between Performance and the Object 1949–1979*, The Museum of Contemporary Art, Los Angeles, 1998

Somerville, Lilian, *Cinquième Biennale de Paris*, Musée d'Art Moderne de la Ville de Paris, 1967

This Object, That Object: To Reveal the Hidden Meaning of Things - An Exhibition of Contemporary European Art from the Permanent Collection of the McMaster University, McMaster University Art Gallery, Hamilton, Ontario, 1994

Thompson, David, *Recent British Art [Britisk Nutidskunst]*, Nordjyllands Kunstmuseum, Aalborg / British Council, London, 1978

Wilson, Andrew, 'Everything: A view on a Developing Counterculture in the mid-1960s in London' in Henry Meyric Hughes and Gijs van Tuyl (eds.), *Blast to Freeze: British Art in the 20th Century*, Kunstmuseum Wolfsburg, 2002, pp.214–20

Woods, Gerald (ed.), *Art without Boundaries 1950–1970*, London, 1972

Articles

Anon., 'British Artists at the Biennale des Jeunes in Paris', *Studio International*, no.174, September 1967, pp.85 and 92–3

Anon., 'Journey to the Surface of the Earth', in *ICA Eventsheet*, May 1969

'Background to a Series of Events at the ICA', *ICA Bulletin*, May 1965, no.146, pp.6–7

Beaumont, Mary-Rose, 'Beyond Image', *Arts Review*, no.38, 19 December 1986, p.696

Benito, Eduardo de, 'Boyle Family Viaje por la Superficie de la Tierra' *Lapiz* 39, 1987

Bergob, Christiane [Hayward Gallery, London: exhibition], *Kunstforum International*, no.87, January 1987

Bloch, Mark, 'When the Dust Settles: Mark Boyle interviewed by Mark Bloch', *High Performance 4*, no.3, Fall 1981, pp.73–4

Boyle Family. 'Interview' [Nishimura Gallery, Tokyo: exhibition], *Bijutu Techo magazine*, February 1991

Boyle, Mark, statement in *Control Magazine, no.1*, July 1965

Boyle, Mark, 'Two Statements by Mark Boyle', *Studio International*, vol.172, no. 882, October 1966, pp.196–7

Boyle, Mark, 'This Rock, This Street, This Earth', *Art & Design*, no.9, May / June 1994, pp.80–3

Brett, Guy, 'Objects, Space and Identity', *The Times*, 9 December 1970

Cendre, Anne [Hayward Gallery, London: exhibition], *Tribune des Arts* 14, 3 December 1986

Clothier, P. [Newport Harbor Art Museum: exhibition], *Art in America*, no.69, December 1981, p.150

Coia, Emilio, 'Journey to the Surface', *Scotsman*, 25 June 1973

Compton, Michael, 'Mark Boyle', *Louisiana Revy*, no.19, February 1979, pp.27–31; and F. Edwards, 'To Discover Reality', pp.33–5

126

Cork, Richard, 'End of the Soft Sell: Hamilton and Boyle', *Evening Standard*, 30 October 1977, p.22

Cork, Richard, 'Mystery Tour', *The Listener*, 11 December 1986

Cork, Richard, 'The Boyle Family', *Kunstforum International*, no.107, April / May 1990, pp.232–4

Czerny, S., 'Boyle Family', *Architektur & Wohnen*, August / September 1987

Debecque-Michel, L. [Galerie Lelong, Paris: exhibition], *Opus*, May / June 1988

Devlin, Polly, 'A Family Journey…', *International Herald Tribune*, 22 November 1986

Edwards, Folke, 'Structure – Energy – Materials: About Mark Boyle [Struktur – Energi – Materia: Om Mark Boyle]', *Paletten* 2, 1977, pp.6–9

Edwards, Folke, 'To Discover Reality', *Louisiana Revy* 19, February 1979, pp.33–5

Feaver, William, 'Carnival of the Animals: Venice Biennale', *Observer*, 9 July 1978, p.24

Feaver, William, 'Beyond the Image', *Art News*, no.86, January 1987, p.99

Fehlau, F. [Turske & Whitney Gallery, Los Angeles, exhibition], *Flash Art*, no.139, March / April 1988, pp.116–17

'Felicity Samuel Gallery, London', *Art News*, no.77, January 1978, p.132

Fischer, Peter, 'die verboylte Welt' [Hayward Gallery, London: exhibition], *Hannoversche Allegemeine Zeitung*, 13 December 1986

Foschini, A.C., 'The radical search for time and truth' [Sao Paulo Bienal exhibition], *O Estado de Sao Paulo*, 30 September 1987

French, C., 'Journey of Exploration', *Artweek*, no.13, 20 November 1982, pp.1ff

Gardner, C. [Turske & Whitney Gallery, Los Angeles, exhibition], *Artforum*, no.26, March 1988, pp.146–7

Gibb, E., 'A Family Affair', *Sunday Herald Magazine*, 19 March 2000

Godfrey, T. [Hayward Gallery, London, exhibition], *Burlington Magazine*, no.129, January 1987, p.47

'Good earth: Wanting to Isolate the Aggregate', *Art and Artists*, no.4, June 1969, pp.24–5

Hackett, R. 'Paying homage to nature with earthy works' [Seattle Art Museum: exhibition], *Seattle Post Intelligencer*, 19 April 1981

'Happenings', *ICA Bulletin*, June 1965, no.147, p.14

Hare, Bill, 'Boyle Family: Unmapping Cartography', *Contemporary Visual Arts*, no.31, 2000, pp.58–63

Henry, Clare, 'Boyle Family's Journey', *Glasgow Herald*, 4 November 1986

Irwin, David, 'Edinburgh Festival Exhibition', *Burlington Magazine*, no.106, October 1964, p.474

Jaques, Richard [Kelvingrove Art Gallery, Glasgow: exhibition], *Scotsman*, 23 March 1987

Johnstone, Isobel, 'Animal Crackers: Venice Biennale', *Scotsman*, 17 July 1978, p.10

Joyce, C. [Runkle-Hue Williams Gallery, London: exhibition], *Flash Art*, no.160, October 1991, p.144

Lydiate, Henry, 'The Boyle Family', *Art Monthly*, no.101, November 1986, pp.6–9

Lynton, Norbert, 'Boyle Family: Real Images', *Cimaise*, no.35, January / March 1988, pp.81–4

Lyttelton, C., 'Journey to the Surface of the Earth', *Evening Standard*, 20 March 2000, p.62

Martin, H., 'Venice Biennale: Back to Nature', *Art International*, no.22, October 1978, p.70

Martins, A. [Sao Paulo Bienal exhibition], *O Globo*, 20 January 1988

Mertens, S. 'Thin skins of reality' [Seattle Art Museum: exhibition], *The Vancouver Sun*, 13 May 1981

Morch, A. [San Francisco Museum of Modern Art: exhibition], *San Francisco Examiner*, 1 November 1982

Oakes, P., 'Welcome to your World', *Sunday Times*, 27 September 1970, p.26

Oliver, Cordelia, 'Boyle's Laws', *Guardian*, 25 June 1973, p.10

Overy, Paul, 'Venice Biennale', *The Times*, 4 July 1978, p.15

Packer, William, 'Art from the Earth', *Financial Times*, 20 November 1986

Pincus, R., 'Works by Boyle and Hills at Newport Harbor Art Museum', *Los Angeles Times*, 17 August 1981

Pouchard, Ennio, 'Oltre l'immagine…la famiglia Boyle' *L'Umanita*, 17 March 1987

Pouncy, Edwin, 'Light Laboratories', *Frieze*, no.46, May 1999, pp.56–9

Quantrill, M., 'London Letter', *Art International*, no.21, December 1977, p.58

Reichardt, Jasia, 'La jeune génération en Grande Bretagne', *Aujourd'hui*, 9 July 1965, p.75

Reichardt, Jasia, 'On Chance and Mark Boyle', *Studio International*, vol.172, no. 882, October 1966, pp.164–5

Reichardt, Jasia, 'Boyle's Objective Topography', *Architectural Design*, no.39, August 1969, p.39

Rosen, N., 'The Boyles, Waging Art', *Washington Post*, 1 March 1987

Rouve, P., 'Hamilton and Boyle', *Arts Review*, no.27, 17 October 1975, p.589

Russell, John, 'Charles Cowles Gallery, New York', *New York Times*, 18 April 1980

Saez, Diana, 'Representation Beyond Image', *Art Journal*, January 1990

Sevcenko, Nicolau, 'A arte e a terra da familia Boyle', interview with Mark Boyle, *Folha de Sao Paulo*, 27 June 1987

Sewell, Brian, 'Baffled by a Family Secret', *Evening Standard*, 2 December 1986

Spurling, J. 'Terra fibreglass', *New Statesman*, 28 November 1986

Stapp, D., 'Charles Cowles Gallery, New York', *Arts Magazine* 54, June 1980, p.28

Sweet, Matthew, 'Home Territory', *Independent on Sunday Review*, 9 May 1999, pp.42–7

Tarzan, D. [Richard Hines Gallery, Seattle: exhibition], *Seattle Times*, 29 June 1980

Taylor, S. [Richard Gray Gallery, Chicago: exhibition], *Art News* 88, March 1989, pp.185–6

Tisdall, Caroline, 'Hamilton and Boyle', *Guardian*, 10 October 1975, p.8

Thompson, David, 'Object Experience, Drama', *Studio International*, no.177, June 1969, pp.276–9

Vaizey, Marina 'One Man's Road Towards Reality', *Sunday Times*, 30 October 1977, p.38

Vaizey, Marina and Compton, Michael, 'Mark Boyle', *Arts Review*, no.30, 21 July 1978, pp.371–4

Vaizey, Marina, 'Eight from England: Images That Make Themselves', *Art News*, no.79, January 1980, pp.75ff

Warner, Marina, 'Pavement Artists at the Hayward', *Independent*, 9 November 1986

Wheatley, Jane, 'Four Feuding Autocrats', *Sunday Times Magazine*, 12 October 1986

Wirth, G. 'Galerie Müller, Stuttgart: ausstellung', *Kunstwerk*, no.26, November 1973, p.47

Wright, B., 'Felicity Samuel Gallery, London', *Arts Review*, 28 October 1977, p.652

Zwerin, Mike, 'Mark Boyle's trip to earth's surface', *International Herald Tribune*, 30 April 1986

Public collections

Aberdeen Art Gallery and Museum

Art Gallery of South Australia, Adelaide

Arts Council of Great Britain

Basle Art Museum, Switzerland

Bayly Art Museum, Charlottesville, Virginia, USA

Bochum Museum, Germany

The British Council, London

The Carnegie Institute, Pittsburg, USA

Dundee City Art Gallery and Museum

Fukuoka Art Museum, Japan

Gemeentemuseum, The Hague, Holland

Glasgow Art Gallery and Museum

Glasgow District Council

Guildhall Art Gallery, London

Henie-Onstad Kunstsenter, Høvikodden, Norway

Hiroshima City Museum of Contemporary Art, Japan

Huddersfield Art Gallery

Huntsville Museum, Alabama, USA

Iwaki City Museum, Japan

Kaiser Wilhelm Museum, Krefeld, Germany

Kunstmuseum, Lucerne, Switzerland

Los Angeles County Museum of Art, USA

Ludwig Forum für Internationale Kunst, Aachen, Germany

McMaster University Art Gallery, Ontario, Canada

Musée d'Art et d'Histoire, Geneva, Switzerland

Museum of Contemporary Art, Chicago, USA

Museum of Modern Art, Toyama, Japan

Museum of Modern Art, Wakayama, Japan

Museum Moderna Kunst, Vienna, Austria

National Film Archive, London

National Gallery, Berlin

National Gallery of Australia, Canberra

National Museum of Wales, Cardiff

Newport Harbour Art Museum, USA

San Francisco Museum of Modern Art, USA

Scottish National Gallery of Modern Art, Edinburgh

Seattle Art Museum, Seattle, USA

Stadtische Kunsthalle, Recklinghausen, Germany

Stuttgart Staatsgalerie, Germany

Tate, London

Tochigi Prefectural Museum of Fine Arts, Japan

Tokyo Metropolitan Museum, Japan

Toi o Tamaki Auckland Art Gallery, Auckland, New Zealand

Toledo Museum, Ohio, USA

Ulster Museum, Belfast

Von der Hoydt Museum, Wuppertal, Germany

Walker Art Gallery, Liverpool

Washington State University Museum, USA

Westfalisches Landesmuseum, Munster, Germany

Wiesbaden Museum, Germany

Artists' Acknowledgements

Boyle Family would like to thank Patrick Elliott, Bill Hare, Andrew Wilson, Janis Adams, Christine Thompson, Robert Dalrymple, Agnes Valenčak-Krüger and everyone at the Scottish National Gallery of Modern Art who has worked on this exhibition and catalogue.

We would also like to thank all the lenders for their support and cooperation, as well as those who have helped us with this exhibition including: Peter Bessant at Hedleys Humpers; Theresa Simon and Lucy Wilson at Theresa Simon Communications; Kit Man at Vertigo Design; Metro Imaging Ltd; Nick Hawker at John Jones; Joel Piggott at J.P. Repro; Julia Jacques; Peter Mackertich and Terry Major. Many thanks to family and friends for their help and support especially: E-Sinn Soong; Cameron Hills; Olly Daniaud; Avril and Richard Jaques; Deborah and John Landis; Eileen Little; Hans Locher; Annie McTavish; Camilla and Lindsay Masters; Ole Henrik Moe; People Show; Elizabeth Petrie; Fran Robertson; Michael Sandberg; Soft Machine; Sasha Speed; Chris Townsend; and everyone at the Westbourne.